VISUAL CONCEPTS
FOR
ADVERTISING

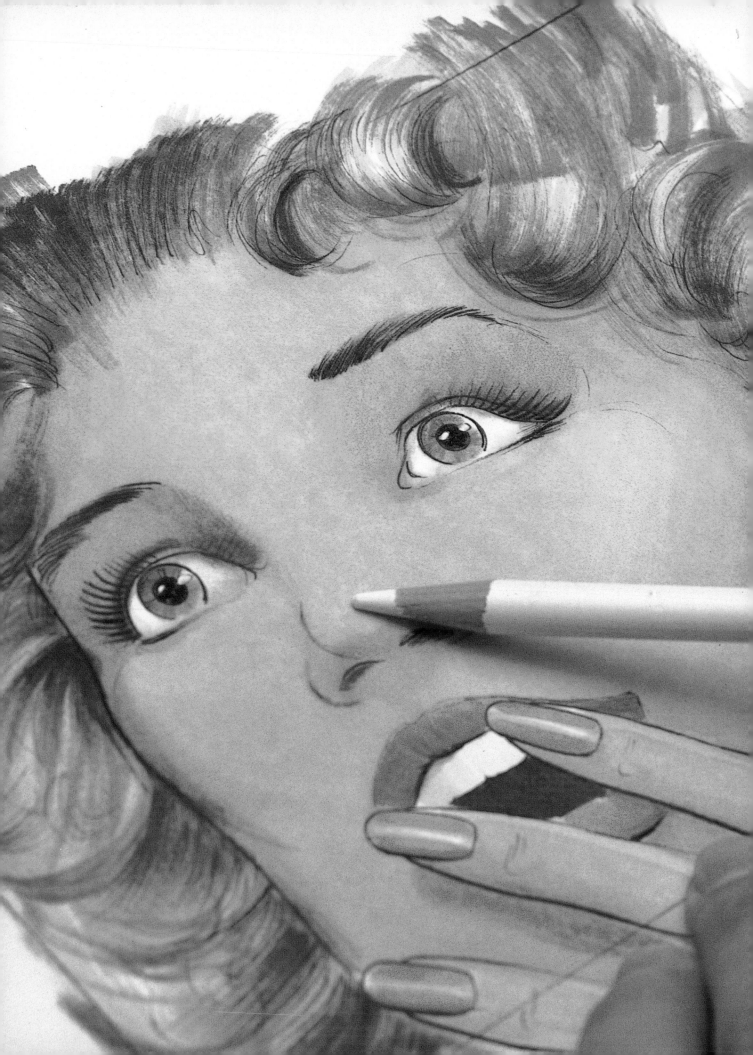

VISUAL CONCEPTS
FOR
ADVERTISING

JAMES FOGLE and MARY E. FORSELL
Photographs by TONY CENICOLA

COLUMBUS BOOKS
LONDON

A RUNNING HEADS BOOK

Copyright© 1989 by Running Heads Incorporated
First published in Great Britain in 1989 by
Columbus Books Limited
19-23 Ludgate Hill, London EC4M 7PD

British Library Cataloguing in Publication Data

Fogle, James
 Visual concepts for advertising.
 1. Advertising. Graphics. Design.
 Illustrations
 I. Title II. Forsell, Mary
 741.6

 ISBN 0-86287-894-2

VISUAL CONCEPTS FOR ADVERTISING
was conceived and produced by
Running Heads Incorporated
42 East 23rd Street,
New York, NY 10010

Editor: Sarah Kirshner
Designer: Sue Rose

Typeset by David E. Seham Associates
Color Separations by Hong Kong Scanner Craft Company Ltd.
Printed and bound in Singapore

ACKNOWLEDGMENTS

Sarah Kirshner at Running Heads guided this book to completion with enormous patience and intelligent editing, all of which has been greatly appreciated. Sue Heinemann at Watson-Guptill also provided truly invaluable advice on structure, content, and style. Artist Lilla Rogers offered excellent suggestions for the manuscript and graciously offered information on how she set up her own freelance business. And also at Running Heads, thanks go to Marta Hallett, Ellen Milionis, Michelle Hauser, Roseann Martinez and Ellen Watson for their contributions and Jill Herbers for her early involvement with the project. Book designer Sue Rose did a wonderful job as well. The Volunteer Lawyers for the Arts and Angela Babin, director of the Center for Safety in the Arts, also provided valuable services. And at Charlex, Ellen Olbrys and David Rothenberg offered their expertise and patiently answered numerous questions. Artists Polly Law and Lisa Emmett Arnold, Ross Hudson of Ogilvy & Mather Promotions, and Marc Italia of The Freelance Store are the voices that shaped the final section of the book, and to them we're also extremely indebted.

We would like to thank Selime Okuyan and the Graphic Artists Guild; Barbara Bradley, Bill Sanchez, Melinda Sullivan, Frank Lanza, and Howard Brodie of the Academy of Art College in San Francisco; and Neal Adams and everybody at Continuity in New York. Special thanks to John Fogle and Jean Montgomery and to Jean Klarich. Thanks also to Tony Cenicola for his superb photography.

A.I. Friedman in New York generously supplied a wide range of high-quality art materials for the project. Thanks also go to The Stroh Brewery Company, The Dannon Company, Inc., Neutrogena Corporation, Levi Strauss & Company, and General Foods USA for permission to depict their products. These companies are the owners of the trademarks, logos, and designs for their respective products featured herein. Use of their trademarks in no way restricts the companies' rights of republications of the trademarks in any form by the companies or by others authorized by the companies and also shall in no way be deemed a sponsorship by the companies of the book.

CONTENTS

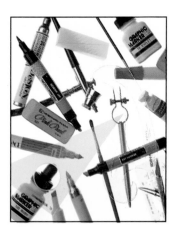

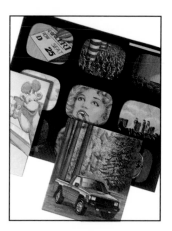

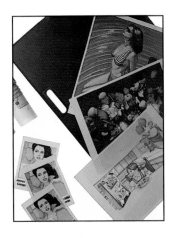

INTRODUCTION

I began working in this industry seven years ago as an in-house artist. I was immediately drawn to the fast-paced work and the challenge to my imagination. Because I was constantly presented with new problems, I had to innovate to find workable solutions—working at all times under deadline pressures. I found not only that the work got easier as I went along but also that I had developed color "formulas" for depicting particular subjects. Also, I had created a way of systematically approaching art, something that is generally not taught in art school.

I found that most of my coworkers fell into two distinct groups: people like me with an art-school illustration background and former comic-book artists. Each group had its own strengths. Comic-book-trained artists, for example, knew how to render bold visuals quickly that conveyed a great deal of action and emotion. The illustrators knew how to draw a wide range of objects accurately. Although I found my art-school background helpful in depicting various subjects, I was by no means prepared for the pace at which I was required to produce art, nor was I aware of how to use markers, the comp artist's primary tool, to their fullest potential. Working in a studio taught me a great deal about the industry, and freelancing—as I have been doing for the past four years—has helped me refine my own techniques.

This book is aimed not only at beginners who want to take up the challenge of comps, storyboards, and animatics but also at professionals who want to learn more about advanced techniques and get an update on industry practices. Part 1 looks at the many different materials and tools on the market and guides you to selecting those items that will work best for you. Art supplies are expensive, and this section will help you put them to optimal use. Part 2 takes you step by step through the crucial stages of comps, storyboards, and animatics, from art directors' thumbnail sketches to final product, ready for presentation to the client. Those artists who have concentrated on comps to the exclusion of other methods of presentation will find the information on storyboards and animatics particularly enlightening.

Part 3 looks at special subjects that comp artists need to master, showing how to render difficult yet commonly assigned subjects like water and food. It explains specific marker colors and techniques used to create such effects as reflections and cloudy skies. Part 4 wraps up the book with an industry overview, probing subjects ranging from building your portfolio to increasing your awareness of the health risks associated with some art supplies. Frank commentary by industry insiders from several backgrounds—including art and creative direction, animatic production, and teaching—gives insight into how the industry operates and why certain comp artists succeed while others fail.

Not every illustrator is suited for the advertising industry. The hours are irregular—sometimes involving nights and weekends—and the working conditions are pressured. Still, the pay is excellent, and if you enjoy rendering art quickly and constantly moving on to new projects, it can prove to be a very satisfying career.

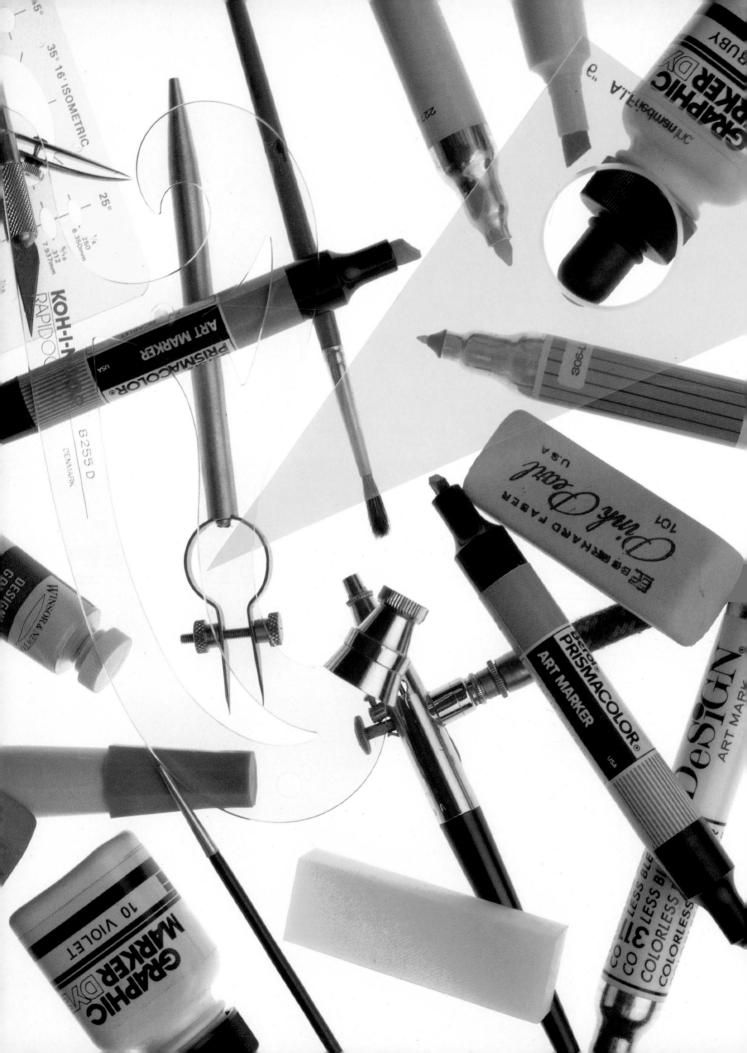

MATERIALS AND BASIC TECHNIQUES

Familiarity with your materials is imperative when you're working under tight deadlines. Spend some time experimenting with various products, processes, and media to find out what works best for you. Also, learn to use materials and tools in nontraditional ways to broaden their applications. For example, when you use markers to create color, you should realize that even with a set of one hundred markers, you cannot possibly represent all the tones, hues, and gradations of color that you need. The solution is to learn how to layer colors. The more you know about different media, the easier it'll be to quickly come up with solutions to problems. And in the advertising world, speed is essential.

All your materials and tools should be set up to facilitate your doing your work as quickly as possible, so be sure to organize your studio carefully. I prefer to keep my markers to the side of my working surface. I also recommend attaching a trough to the front of your drawing board to catch the markers and other items that tend to roll down it. I keep my reference materials in a conventional filing cabinet, although some artists may prefer a smaller, transportable file. I also keep a neatly organized bag of materials and tools in my studio, set up and ready to go in the event that I have to leave to do in-house work at a design house or agency.

THE WELL-EQUIPPED STUDIO

While the list of tools and materials in this chapter may seem extensive, the idea is to present a broad range of art supplies—some that are used every day, others that are employed less frequently.

Artists who skimp in the materials department limit their experimentation with new media and thus short-change their work. Moreover, sometimes you can save yourself hours of tedious work by having a few extra items on hand. While you may not use these more expensive tools or materials every day, when they are called for they'll be worth their price a thousandfold by adding that special touch to your work.

For costly tools such as airbrushes (which are covered in chapter 6, "Professional Tips") and high-quality brushes, opt for the best within your budget. Be aware of the latest innovations in tools so that you can purchase the ones that are best suited to your work. They will require a greater initial outlay of money, but they will also have a longer life.

Markers

Markers are the principal tools of the comp artist. Paints require drying time and wrinkle paper, whereas markers dry almost instantaneously, which allows you to render artwork quickly. Pastels flake away, making them undesirable for comp work, and colored pencils simply don't have the "punch" needed for advertising. Because so much current advertising is dramatic, comp art must have snap and sparkle, which can only be achieved with skilled use of markers. Markers—with their vast range of colors constantly being updated to keep pace with contemporary living—have a current look that evokes the high level of energy called for in advertising.

Marker is also a very forgiving medium. It allows you to repair mistakes easily by layering colors or applying colorless blender to thin out or remove color.

Despite the marker's popularity among working comp artists, there is a widespread perception that it is an amateurish tool—perhaps because it is a relatively new coloring medium and is not used in the fine arts. To add to the marker's amateurish reputation, many people associate it with their school days. In reality, the marker can be as sophisticated a medium as paint, capable of producing a range of very bold and very subtle effects—without the fuss of preparing paint and then waiting for it to dry.

Marker ink, however, dries rapidly, so you have to work quickly and recap the marker. Many solvent-based markers also emit toxic fumes (see page 150).

I find that most water-based markers, while safer to use than solvent-based markers, are a little too "rickety" for comp work—they tend to begin their life acting like dry markers even though they're supposed to be wet; therefore, they usually cannot produce clean sweeps. Water-based markers do have their place in comp work, however. If you want to do a tight comp of a product quickly, make a machine copy of the label. Then, rather than tracing the design onto another sheet of paper, simply color the copy using the water-based marker; it won't smear the copy as would many solvent-based brands. (Alcohol bases are a subcategory of solvent bases. I have found that some alcohol-based markers also smear copy ink.) Solvent-based markers, however, are the artist's best bet for everyday use. An excellent solvent marker for comp, storyboard, and animatic work is the Chartpak AD Marker. The felt inner core is very saturated with ink, making these markers long-lasting.

Art supplies courtesy of A.I. FRIEDMAN.

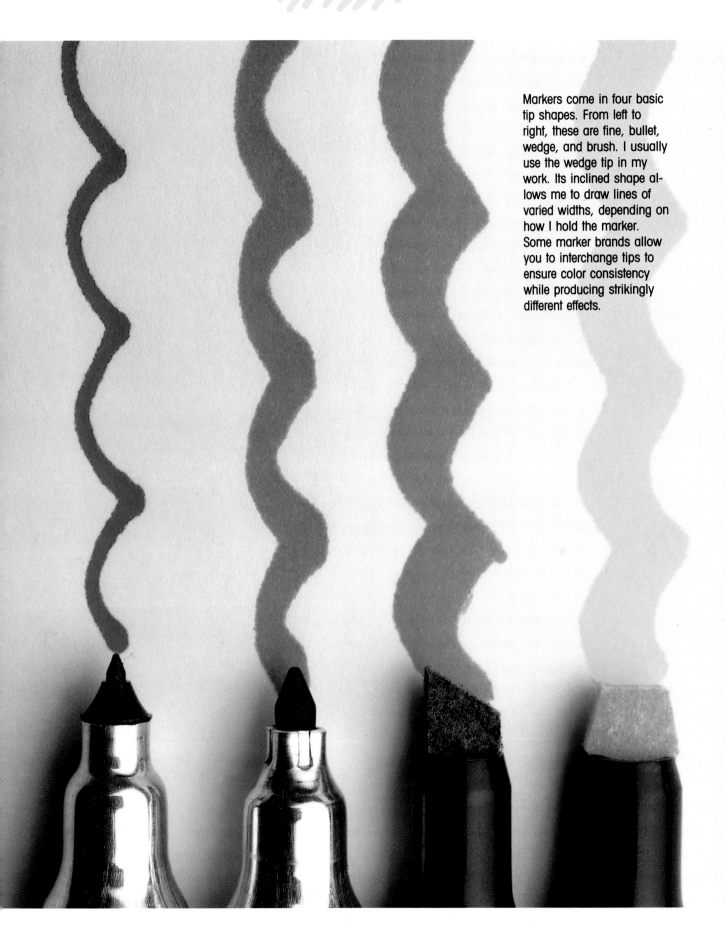

Markers come in four basic tip shapes. From left to right, these are fine, bullet, wedge, and brush. I usually use the wedge tip in my work. Its inclined shape allows me to draw lines of varied widths, depending on how I hold the marker. Some marker brands allow you to interchange tips to ensure color consistency while producing strikingly different effects.

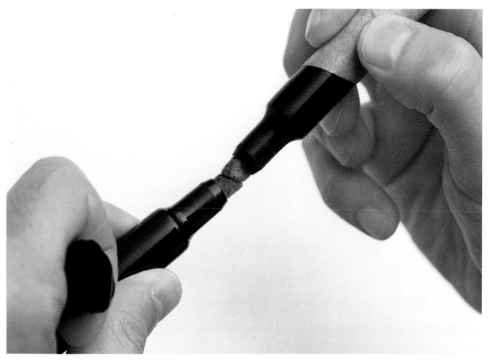

You can revive marker color easily by touching one wet marker to another dry one. If the ink color in either marker is muddied in the process, simply remove the color by streaking it on paper. However, the dry marker will never be quite as vibrant as it once was, so label it with a "D" for dry and use it for drawing linear elements like hair or grass.

Other brands offer their own advantages. The new Graphic Marker brand allows you to mix your own inks; its alcohol base is the least toxic among alcohols. The Design brand lends itself quite well to lettering. Pantone and Faber Castell offer airbrushes that can be used in conjunction with their markers (see also page 96).

When a marker begins to dry out, rather than throw it out, label the cap with a mark, such as a "D" for dry, to indicate that it has reached a dry stage. Dry markers have plenty of life left in them to create linear elements like hair and blades of grass; dark areas in the human face; and other features that don't require the brightness of wet markers. Dry markers are invaluable and therefore should never be disposed of—for example, burnt sienna, delta brown, peach, and cherry markers that have dried out are essentials for me because they are all used for creating hair colors.

If a marker dries out completely, there are a number of methods that are useful for giving it new life. Some techniques involve injecting the marker with lighter fluid or solvent using a syringe or removing all or part of the inner core and soaking it for several minutes in a bottle of solvent. However, much simpler to do, and perhaps most effective because of its speediness, is touching the dry marker to a wet marker of the same color. This instantly renews the color. All of these techniques tend to revive ink flow.

Create marker sweeps by steadily applying bands of marker color on paper in a wet-on-wet technique. You must quickly add more marker color to the foundation before it dries so that a smooth, unlined background results. I frequently create sweeps for such elements as skies, floors, and other planes that must have a seamless look.

These "loose sweeps" incorporate the same bold strokes that traditional sweeps do, except that they are deliberately applied in an irregular fashion so that some areas are darker than others. Creating loose sweeps is useful for depicting an irregular surface, such as a rain-covered street or a starry sky.

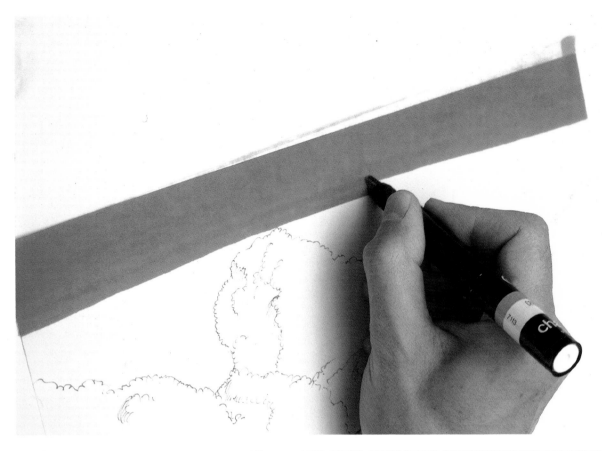

Using a colorless blender allows you to alter and lighten color. Here, I applied blender first and followed with flesh-colored marker, which lightens the marker color—the same general process used to create highlights on faces.

TIP SHAPES

It's important to have markers on hand in a variety of tip, or nib, shapes: wedge, or broad; bullet; fine; and brush. The wedge is used most frequently because it produces both thick and thin lines, depending on the angle. The bullet tip gives a consistent medium-width line. The fine tip offers control and precision—if you want, for example, to add color precisely to a small area. As its name implies, the brush tip simulates the looser look of a paintbrush.

Comp work calls for a variety of effects, so I recommend the Chartpak AD system, because it gives you the option of interchanging several tips on the same marker. Another great time-saver is the Berol Prismacolor double-nib marker. Each marker has two nibs, one broad and the other fine, so you can make different types of lines of the same color. I often use the fine tip for small details and then flip to the other end for broader strokes.

You can also alter marker tips to suit your needs with a razor blade. If your work requires large squares, for example, simply take a wedge-shaped marker and cut off the angle of the wedge so that the marker nib is flat. This will allow you to make squares when the marker is pressed directly on the page.

COLOR AVAILABILITY

No two marker brands are exactly alike. Each manufacturer offers its own line of colors. Even if two different manufacturers list the same color in their sets, chances are the markers won't even come close to matching. This can work to the comp artist's advantage. By purchasing full sets of several marker brands, you will broaden your color range considerably. This sounds like an expensive proposition, but you'll soon find that this broad color range will enrich your work and help you save time trying to "build" specific colors.

Using markers, you can create color by layering. When building color with markers, always work from the lightest to the darkest color. This is a fundamental rule applicable to comp, storyboard, and animatic work. Keep in mind that lighter colors can only be effective as an undercoating for darker colors; lights that are applied on top of darks tend to get lost. When applying dark colors on top, you may want to leave openings to allow the lighter colors to "peek" through,

To create halftones, begin with the lightest color you intend to use and work away from this center area with increasingly darker colors in the same family.

Applying a darker color to the edges of a color base is a technique used to create the complex colorations of hair and flesh tones. Of course, the colors should be in the same family so that the result isn't artificial looking. This process lends itself particularly well to curved elements because it captures the look of light striking rounded surfaces.

creating a complex coloration. Even if you don't leave openings, the glow of the lighter colors asserts itself, albeit subtly. Of course no rule is absolute; at times you may need to add a lighter color directly over a darker one to create a highlight after you have built the base color. If you muddy the lighter marker doing this, immediately drag it on bond paper to eliminate the added color.

While every artist has marker color preferences, grays are universal favorites because they can be used to render so many effects: They can represent the coldness of metal, evoke the ominousness of a stormy sky, and give dimension to black objects. A full range of warm and cool grays should be a staple of every artist's workspace. Use warm grays to alter colors—for example, to create a sepia tone in simulating turn-of-the-century photographs. Or use them to dull flesh tones in animatics. (When video cameras photograph animatics, they may register blush highlights on cheeks as dark red streaks. A final coating of warm gray on faces eliminates this problem.) For capturing the look of metal or creating a black-and-white comp, however, cool grays are best. (Print ads that are predominantly black-and-white and depict only the products in color are a recent trend.)

It is important to familiarize yourself not only with the cool and warm grays but with cool and warm grays of different marker brands. One line of cool grays may differ immensely from another. To give your work as much dimension as possible, try to integrate different brands of gray in your artwork.

As I've already mentioned, my personal preference is the Chartpak AD system. Thus references to markers by color or number alone in this book are to the Chartpak AD system. If I use another marker brand, I mention this specifically.

The organization of your markers is of vital importance. For example, if you're making a transition from one shade of gray to another, you simply can't afford to pick up the wrong marker. Always keep your markers well organized within their respective sets. I keep several sets at the front and side of my drawing table for easy access.

Another important point: when you work with markers, test them before use on the same type of paper that you will be drawing on to make sure their colors haven't altered over time.

COLOR CHARTS

Because you may be working with different marker brands, it's important to keep separate records of the colors in the different sets. Color charts provide a quick visual reference. To create a color chart, simply draw a grid on bond paper and fill in the colors of your markers to reflect how frequently and in what combinations you use them. For example, in the top row of my color chart for AD markers, I include all the colors I use in creating flesh tones. I group all warm grays in one area of the chart and cool grays in another area, because this is the way I position the colors in their marker stands in my studio. You may want to include a line beneath each row of colors on which you can insert the name of the color used. Laminate the paper. Make separate color charts for each brand of marker used.

Another type of color chart allows you to see how colors interact. To create this chart, divide a set of markers into two groups. One by one, create horizontal lines with one group—generally, the lighter tones—and then draw down over the lines vertically with the other group. The result is a grid that shows numerous color combinations. It will allow you to see at a glance how you might create unusual effects. For instance, you may notice a little-used color like willow—which is a nice beige-green—and discover that is a nice complement to flesh tones or sky-related colors because of its cool and muted qualities. Through using such a system, I have discovered that sapphire—traditionally a sky- or water-related color—interacts subtly with flesh colors to create a realistic-looking five-o'clock shadow. Most artists would simply opt for black to create this effect, with often heavy-handed results.

Color charts will help you keep your work lively and interesting because they keep you aware of all your choices. It's crucial that artists avoid the "out-of-the-can" look of the same markers repeatedly used in the same way.

Arrange color charts in order of the colors you use most for every marker brand you own. Notice how flesh tones are located at the bottom of the chart, indicating that they are positioned closest to me as I work. You can also keep yourself updated on what colors are available by collecting charts put out by marker manufacturers.

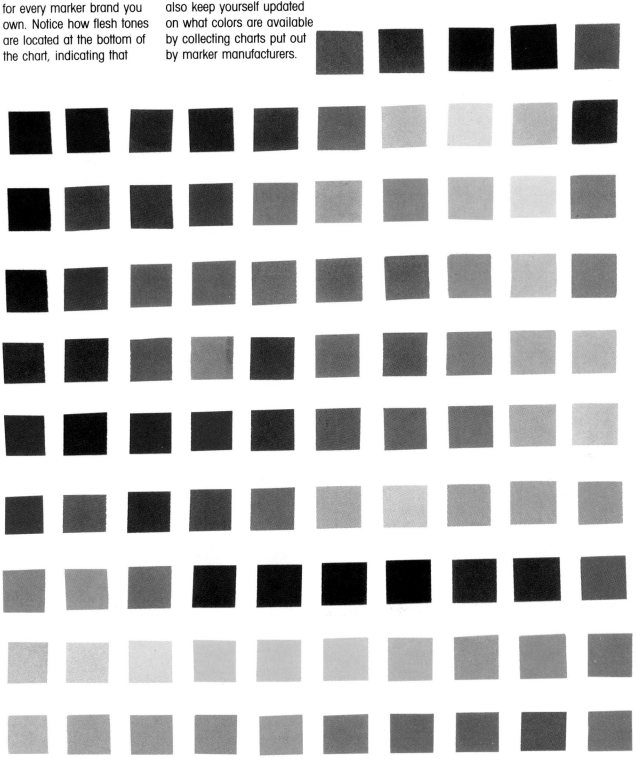

BLENDERS

An essential tool for the artist is the colorless blender marker. These markers contain pure solvent and are applied on top of marker color to drive it away. Both AD and Graphic Marker put out colorless blenders geared to their systems. Using a blender, you can thin and lighten color. It is particularly useful for flesh tones and out-of-focus backgrounds.

For those occasional slip-ups when you put down the wrong marker color, the blender comes to the rescue: Simply put tissue paper under the paper you are working on, apply the blender to the colored area of the paper, and the color will come out the back.

Blenders are available in a variety of tip shapes, but make sure you have a fine-point type on hand for removing color from small areas.

OUTSIDE THE STUDIO

When comp artists are just beginning their careers, they frequently have to work in clients' offices rather than in well-equipped studios. Be prepared by bringing along essential tools and materials. It is a good idea to have a set of markers compactly arranged for easy transport. I have a set of one hundred markers that I use whenever I work at a client's office—an ad agency, design house, or direct-mail house—where many artists are called in to work simultaneously and materials are stretched to the limit. I am always sure to include both "wet"—new and ink-saturated—as well as "dry"—older, less ink-filled—markers. Along with these, I carry such other essentials as templates, knives, colored and graphite pencils, and gouache in my portable "doctor's bag."

I keep everything within reach in my studio. Organization of the studio space is absolutely essential to the comp professional who often doesn't have extra time to spend searching for individual materials and tools. Note how different marker brands are set up in separate areas of the working surface and how the trough at the front of the desk captures loose materials before they roll off.

Paper and Other Surfaces

BOND PAPER

Ordinary bond paper works well for comp, storyboard, and animatic artwork. But different brands respond to marker ink differently, so you should determine how the paper you're using absorbs ink. I find that a good all-around brand for sketches and comps is Hammermill Bond. It strikes the balance of absorbing color while not bleeding excessively and is transparent enough to be used on a light box for tracing. You may prefer to use a "bleedproof" paper specifically designed for use with markers, but I find that these brands are not absorbent enough.

When working with bond paper, remember to place another sheet of bond paper underneath to protect the work surface from stains.

TRACING PAPER

Art directors very often use tracing paper on top of illustrations to show what changes they want made. Sometimes the art director will forgo this step, so you may need to record his or her instructions on your own tracing-paper overlay. Tracing paper can also be useful for reproducing elements of a photograph to be used in an illustration, although bond paper can be used. In any case tracing paper is always good to have on hand for tracing extremely fine elements that do not show through bond paper.

ACETATE

Acetate is used to mask areas of an illustration from airbrush paint. It can also be used as an overlay on art to add elements to your drawing. You can, for example, put lettering on acetate and then overlay it on your comp.

Acetate can also be used for animatics to create moving, somewhat transparent elements. For example, you might draw soft drink bubbles with a special marker suited to acetate and then add gouache highlights. A video house would lay the entire sheet of acetate on artwork and shoot it with a video camera. To suggest carbonation, the video house would drag the acetate sheet of bubbles across the artwork. For a different effect—to simulate the movement of helicopter blades—you might create two separate acetates showing oval blades in two slightly different positions. The video house would shoot separate frames of the two acetates overlaid on the art and then dissolve between the two positions for the animatic, creating a shimmering effect of rotating blades.

COLOR-CODED AND METALLIC PAPERS

You can save time and ensure professional results by using color-coded papers. These are available in a number of colors and also come in rainbow and gradated patterns. Use colored paper whenever you can rather than creating a solid background with marker sweeps. But I suggest not using markers directly on colored paper, although you may want to apply airbrush to add interest to a background. Instead, create marker subjects on separate sheets of white paper, cut them out with an X-Acto knife, and use an adhesive—such as Scotch Spray Mount—to attach them to the colored paper.

Using colored paper, you can pinpoint a product's trademark colors—a big help for producing comps quickly. You may develop unique uses for colored paper through experimentation. Experiment with different brands to expand your choices.

I find the Pantone brand of colored paper very useful. The papers are part of a color-coordinated system of markers and overlays. This ensures a precise match among different media and makes it possible for you to use the same colors in backgrounds that you use in smaller areas of your art.

Metallic papers—usually in gold and silver shades—are good choices for simulating package design. For example, if you are assigned a comp for a product that has a metallic coating, like aluminum foil or household cleaner, you could use metallic paper to make the comp look virtually identical to the product. This realistic touch goes a long way in helping advertisers' clients envision an ad for their product.

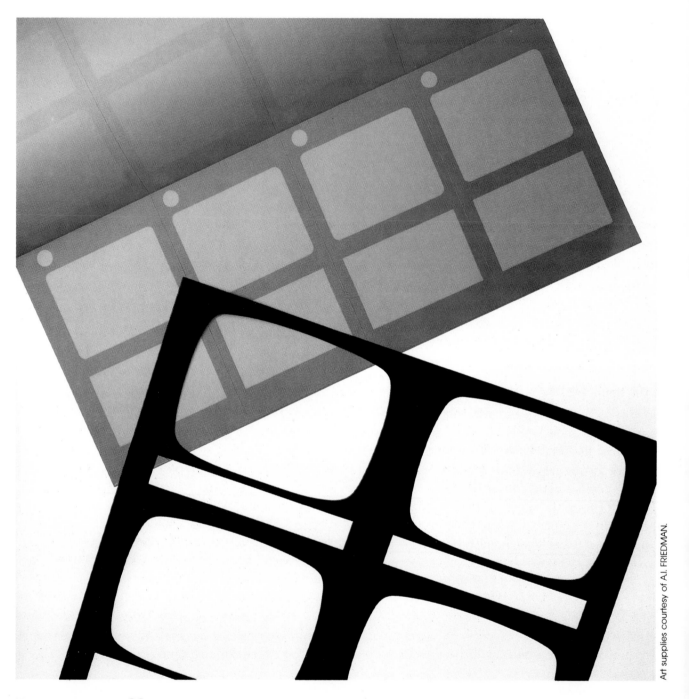

Art supplies courtesy of A.I. FRIEDMAN.

PRESENTATION MATERIALS

There are a number of materials to choose from when presenting ad work to clients. The most commonly used presentation material is foam-core board, which is covered with white paper. Because foam-core is lightweight, it is easy to cut. However, it also resists warping, making it perfect for comp presentation. Mounting boards, which are cardboard covered with paper, are usually used to present storyboards in conjunction with storyboard masking.

TV pads, or storyboard pads, are sheets of paper separated into small "television screens" and are used, principally by art directors, to work out a storyboard. The paper is not of good quality, but it's useful for churning out plenty of ideas.

Storyboard masking is overlaid on storyboard illustrations for final presentation to clients. It generally accommodates nine 5 x 7 inch frames, with a cutout area beneath the frames for voiceovers and dialogue. Larger and smaller sizes are also available.

Other Drawing and Painting Aids

PENCILS

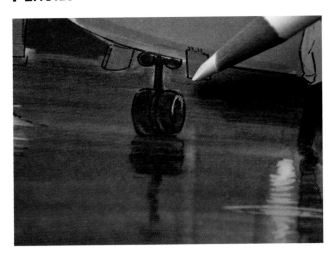

You may not need to use the full range of colored pencils depicted below in your work, but it's nice to have a broad selection on hand. I use white most frequently to create subtle highlights, as with these airplane wheels, but I also often use other reddish and purplish colors to render makeup effects on faces.

Graphite pencils are used for rough and final drawings for comps, storyboards, and animatics. They are available in varying degrees of hardness. You should experiment with different hardnesses, but I find the standard No. 2 pencil does the trick in most cases. After you have inked over the pencil lines, erase the pencil before applying marker to your art.

Colored pencils also vary in hardness but are used primarily to create halftones. Halftones are characterized by a graduated coloration; they show how color interacts with light, deepening in slight gradations as it moves farther away from a light source. By using a marker in conjunction with a colored pencil, you can render halftones more quickly than you could using marker alone.

Colored pencils add subtlety to artwork that you simply cannot achieve with markers. For example, if you wanted to create eye makeup on an illustration of a woman, a wet marker would produce a blobby, overpowering effect, while a dry marker would simply be too linear. Paint would also be inappropriate, because it would be too bright.

When a colored pencil travels across the surface of paper, it does not completely cover the paper's texture but produces a subtle, grainy effect—this can be the perfect touch if, for example, you wish to show a spotlight or streetlight on a dark background. A colored pencil will effectively create the misty look of light traveling through air as well as the effect of light hitting a surface. If you are indicating a reflection on the ground, however, you may wish to use gouache for more drama because it is brighter than colored pencil.

GOUACHE

Opaque watercolor (gouache) is used primarily to create prominent highlights on artwork. Ninety percent of the time, your work will call only for white gouache; still, it's a good idea to have a complete set of colors because you may occasionally need to use another color. You can also apply markers over opaque watercolors to tone down or change highlights.

You can use gouache on many surfaces—but proceed with care. Use the gouache sparingly and only in limited areas to prevent the paper from wrinkling. A good brand is Winsor & Newton Designers Gouache, but you can also use other brands or acrylics. Even Liquid Paper can be a good substitute for white.

While colored pencils are suited to subtle, diffused highlights, gouache is good for sharp, dramatic effects. It effectively captures the drama of edge-lighting—an effect that has come into vogue of late in the advertising industry. It also suggests reflection; you might, for example, use gouache to depict a slick, rainy street or to show flames from a welding torch. Gouache also works well for depicting liquid spraying from a bottle or water splashing.

BRUSHES

Good brushes are usually made of natural hairs, such as sable. The best brushes come to a point after having been completely submerged in water and even after most of the paint has been used. The hairs of lesser-grade brushes—usually the synthetic varieties—begin to splay after some of the paint is used. Of course, the best brushes are the most expensive ones, so don't think you can get by with a cheap brand. I recommend Winsor & Newton.

As with marker tips, the shapes of brushes vary; they are generally classified as being round or flat. You will mostly be using small round brushes to paint highlights or do lettering with gouache. The small size allows you to control the amount of paint you're applying and thus minimize wrinkling. Flat brushes are effective for covering broader areas with gouache.

TECHNICAL PENS

Generally, comp artists employ such familiar high-quality felt-tip pens as Pilot Fineliners and Pentel pens. However, if you wish to achieve particularly precise results—for lettering, for instance—you might want to use the Rapidograph pen, which is made by the Rotring company. In comp work, this sophisticated technical pen is best used to render colored lettering and numbers on dark backgrounds, such as the writing on VCRs, stereo equipment, and car dashboards. The Rapidograph gives you the flexibility of changing tips to achieve different line widths, and you can use inks of different colors.

Like the Rapidograph, the ruling pen is a precise instrument for tracing lines. It tends to create lines that are not as fine as those made with the Rapidograph. There are now inexpensive, disposable ruling pens available in various sizes.

Other pens on the market resemble traditional calligraphy pens in that they have a wedge tip. These are generally referred to as lettering pens. They are particularly handy when used on comps for "greeking," that is, squiggling in mock body type in an ad (see page 97).

The drawback to using technical and lettering pens is that you have to clean and maintain them because you are filling them with different inks and changing the tips. Moreover, the pens are usually expensive. Most comp artists prefer the freedom of using a good-quality fine-point pen that gives them professional results without the burden of maintenance.

UNUSUAL TOOLS

By experimenting with materials not traditionally used for creating art, you are bound to find surprising artistic uses for everyday objects. One of my favorite effects involves a hard-bristled toothbrush dipped in white gouache. As you run your finger over the bristles, they release the paint in an irregular pattern. When you spatter the gouache on a dark background, you can create a starry effect that captures the look of the night sky better than airbrush or traditional brushes could. A toothbrush can be used in a similar manner to depict liquid spraying out of a bottle or can—a popular motif for soda ads—or to show water splashing.

Even something as common as a paper towel can help you produce stunning effects. By soaking a paper towel in lighter fluid or another solvent, it is possible to blend or remove color—depending on the concentration of solvent—to create soft effects. If you look at common objects with a fresh eye, you will no doubt invent uses for them that will enhance your artwork.

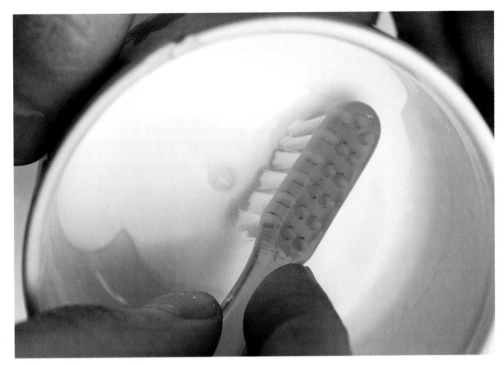

Sometimes you can achieve unusual effects with unconventional materials. I like to create the effect of a starry sky with a toothbrush by using its bristles to spatter gouache onto a black background. I start out by mixing gouache with water and then dipping a toothbrush into the gouache.

To create the starry effect, I hold the gouache-covered toothbrush in my hand and release the bristles with my thumb. I do this several times, spattering dots of paint in an irregular, complex pattern. This toothbrush technique can also effectively simulate the look of a spray of water. It's quick, fun to do, and gives work a professional polish.

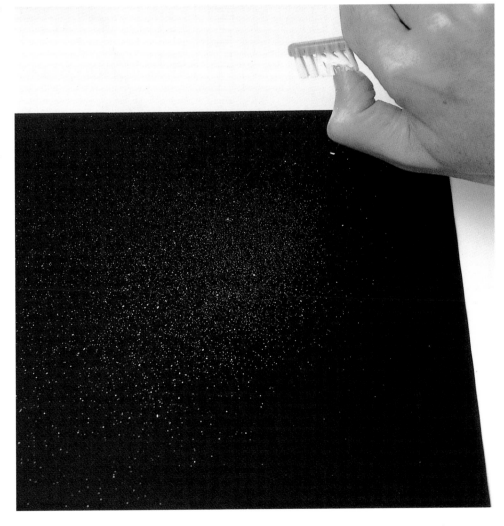

Helpful Accessories

MASKING AIDS

Masking shields areas of artwork from wet media. Liquid frisket, a protective film, is a popular choice. Simply apply it with a brush in the area you want to mask, let it dry, spray color around it, and peel it off. You can use rubber cement in the same way. There are many methods and unusual tools and techniques that can be employed to make odd-shaped masks.

Acetate is another masking option. You can create shapes on acetate sheets using an X-Acto knife. Two masks are produced: the cutout shape and the acetate sheet from which the cutout was removed. The two masks both have their uses, depending on how you apply the airbrush paint. If you simply want to dust lightly along the edge of the mask, the cutout should be used. If you want to fill in an area, use the acetate sheet and apply the paint in the cutout area.

Of course, when you need to create a mask very quickly for one-time use in a job, you can simply use bond paper. Like acetate, it can be cut to a desired shape or simply used as a straightedge.

In comp work, masking tape is not used so much for masking as for creating shapes that are actually part of the art. You can actually "draw" with masking tape. While it is mainly used for straight lines, use an X-Acto knife if you want to create an irregular shape. Colored and metallic masking tapes can also be used as part of art.

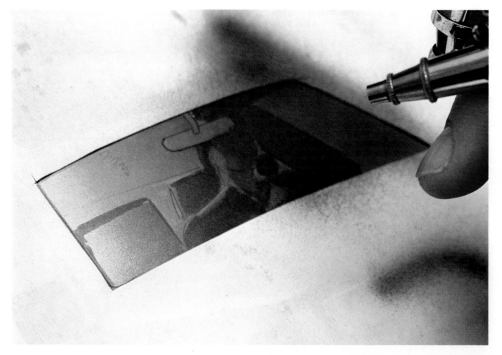

Spray adhesive is a helpful and easy-to-use tool, especially when applying finishing touches to artwork. The light bonding of spray adhesive can be easily pulled apart without damaging the art, making it a convenient way to keep a cutout mask in position while you use an airbrush on a portion of your artwork.

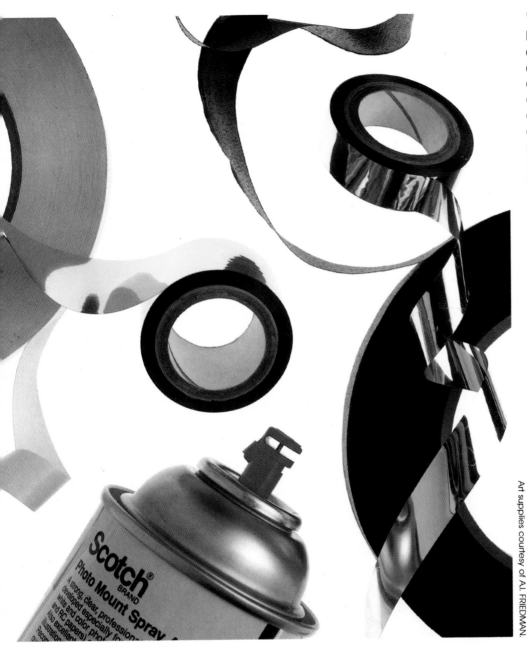

Masking tape in both colored and metallic finishes can be a great timesaver especially in depicting products because you can literally draw with it. You can either use strips of it for straight-lined vertical elements or cut it into irregular shapes with an X-Acto knife.

Art supplies courtesy of A.I. FRIEDMAN.

ADHESIVES

Use spray adhesives to attach separate sections of an illustration to one another—for example, a background that was created with an airbrush and a cutout figure that must go on that background. Although spray adhesives do not affect inks, they can remove some of the color of solvent-based markers. Therefore, you must use these adhesives sparingly and allow for drying time between applications. Remember to regularly clean the nozzle of the spray adhesive if you are working at home. If the nozzle gets clogged, hold the can upside down and spray it out a window. In an art studio you probably won't face this problem because the adhesive will be getting a lot of use.

Rubber cement will tend to make inks run but does not affect solvent-based markers. Use it to create permanent bonds between two pieces of art. Adhesives in stick form are used to attach small pieces of paper to backgrounds and to patch tiny errors. You can also use bar adhesive in conjunction with spray adhesive if you want to double-back patches. Scotch Magic Transparent Tape is virtually invisible and when it is used to repair damaged or torn areas it should be carefully applied from behind.

ERASERS

The type of eraser you use depends on what types of lines need to be eliminated. Hard erasers are used for eliminating dark lines; kneaded erasers are less likely to tear paper and should be used for light erasures.

Airbrush erasers actually remove paint from a surface using an abrasive. They allow you to remove color from specific areas of artwork with great precision, but they're also messy. It's wise to use a respirator to protect yourself from hazardous airborne pigment.

COMPASSES

Compasses are useful to have on hand for many reasons. Depending on their size, they allow you to draw circles with diameters ranging from ½ inch to 21 inches. Sometimes you will want to create many circles of the same size, one after another; this calls for a bow compass, which has a threaded center wheel that locks in the size of the circle. Other times you will want to create circles of many different sizes; this is when you'll need a nonlocking compass.

It's useful to have a compass on hand that allows you to attach knives as well as writing and drawing instruments to it. This gives you the capability not only

to draw very precise curved lines but also to cut out perfect circles. You'll find this feature useful for animatic work, which uses loose pieces of art. If you need to depict a beach ball, for example, you could use your compass first to render and then to cut out a precise circular shape.

TEMPLATES

Whenever you need to create a perfect curve, draw a straight line, or add identical geometric shapes in your artwork, it's wise to use templates and other drawing aids. These tools allow you to produce shapes more precisely than you could if you were drawing them freestyle.

The triangle is the most essential template shape. You should have both 30°/60° and 45°/90° triangles. To render other geometric forms—squares, circles, and ellipses—you should purchase a variety of templates suited to specific shapes. Particularly useful is the French curve, which can be used to create fine curving lines and can also act as a mask. The flexible, or continuous, curve is also a handy tool, because it can be easily manipulated by the artist to form either shallow or extreme curves.

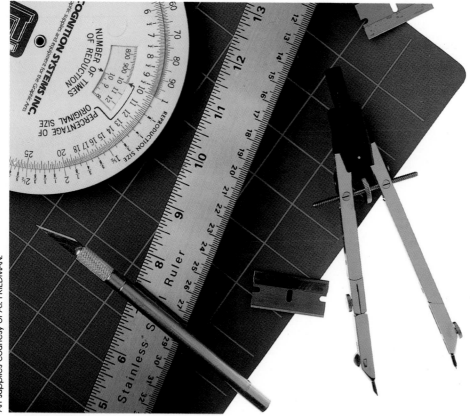

Art supplies courtesy of A.I. FRIEDMAN.

Staples in my studio include, clockwise, a high-quality compass, razor blades, a ruler, an X-Acto knife, and a proportion wheel. A cutting mat is another indispensable item that allows you to make cuts without damaging the surface below it.

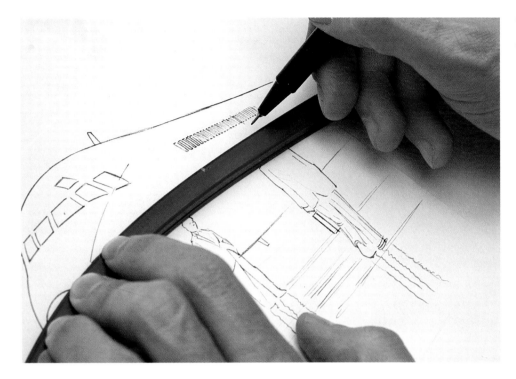

A flexible curve is shown here being used to draw the body of a jet plane. Like the "ship's curve" used in drafting, the adjustable drawing aid enables you to render a subtly curving line to create the aerodynamic shape of the airplane.

KNIVES

A sharp knife is an essential tool. You can work with single- or double-bladed knives or even with razor blades. The Olfa and X-Acto brands are particularly useful. If you use the double-bladed knife, you can make two cuts simultaneously, which ensures precision and accuracy should you need to cut out equal-width strips of bond.

To test the blade for sharpness, scrape it away from you on your thumbnail; if light dust appears, the blade is sufficiently sharp. If a blade isn't sharp enough, it could ruin your artwork by not cutting completely through the paper and possibly causing damage when you try to recut.

If you use razor blades instead of knives for cutting, remember to cover the edges with masking tape when they are not in use—especially if they are being transported—or before you throw them in the garbage. Should anyone reach into a trash can to find something that was discarded, they could suffer a nasty cut if their fingers are exposed to blades.

PROPORTION WHEEL

The proportion wheel is used for calculating the percentage change when you are increasing or reducing the size of an original piece of art. For instance, if you're enlarging a comp by several inches and want to compute the percentage change, you can match up the original length and the changed length on the inner and outer wheels; the figure that appears in the window is the percentage change.

Proportion wheels are best used along with a copying machine. Because proportion wheels provide you with percentage changes, you can plug these figures into copying machines to actually adjust the size of an image. This allows you to assess how artwork will look with different dimensions *before* you have actually done the work. You can then change details in the artwork so that they will hold up when they are reduced or enlarged.

It's also possible to use a projector to reduce or enlarge artwork, but it's more efficient to use a copying machine, especially if you don't have time to retrace the art and need to use marker directly on top of the reduction or enlargement.

SPECIAL TOOLS

To be recognized as a pro, you must have that extra edge that working with special tools gives. This chapter focuses on how to increase your visual resources by using such items as Polaroid cameras and reference files and how to expand the possibilities of your reference materials and artwork with copying machines and projectors. You are encouraged not only to draw on the ideas presented here but also to invent new techniques.

Of course, if you are a freelance artist, you may not be able to afford such luxuries as a light box or a high-priced projector. But there are ways to save money and still achieve professional results. In this chapter, you will find instructions for creating your own light box at a considerable savings over commercial models.

As a visual artist, especially one working in advertising, you never really stop working. You're always observing the world around you—how things look, how they operate—and subconsciously adding this information to your mental reference file. At the same time you have to constantly add to your actual visual reference file as you get new jobs. It is this challenge of visual choices that this chapter addresses.

Visual References

As a comp, storyboard, and animatic artist, you will often be asked to draw scenarios and subjects that seem familiar but are nearly impossible to call up with any degree of accuracy in the mind's eye. In such situations you might use slides and a projector, but there are many other forms of visual reference available.

A Polaroid camera is useful to have on hand so that you can create your own instant reference. If, for example, you need to depict a woman reaching for a product on a shelf, just ask a nearby person to simulate such a situation, take out your camera, and snap the photo of the pose. Similarly, if you need to depict what a burning cigarette or sunlight streaming through trees looks like, you can have this reference instantly.

More reliable, however, is the photo-reference scrap file. To start one of your own, simply create a list of categories and make up files for each one. Categories should include vehicles and transportation, plants and animals, and people.

To maintain your photo-reference list, you should subscribe to a number of specialty magazines and always be on the lookout for interesting photography.

In addition, subscribe to mass-market magazines, if only to keep yourself up-to-date on fashion and product trends so that your work will have a current look. While you will use some of these magazines for your reference file, also keep a varied selection of uncut magazine and book references on shelves so that you'll have material readily available to flip through when you don't know exactly what you're looking for. My studio reference shelf is stocked with periodicals: *Gourmet,* for food and table settings; a full year of *Vogue,* for clothing ranging from furs to bathing suits, as well as *Bride's, Glamour,* and *Elle,* for depictions of women and women's fashions; *GQ,* for men and men's fashions; *Metropolitan Home,* for the latest in interiors; and *Child* magazine, for pictures of children. Among the useful books on my shelf are *Gray's Anatomy* and *Encyclopedia of Animals.*

It's also a good idea to have a few standard catalogs, such as Sears, Roebuck or Spiegel, on hand so that you can have depictions of a full range of household goods and electronic products at your fingertips. I even have one wonderful 1902 edition of the Sears

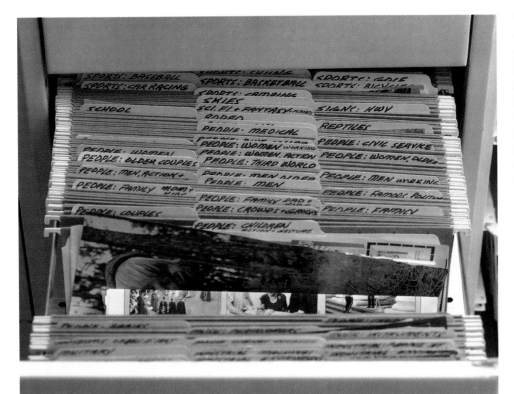

I use a traditional file system to hold the library of images that I refer to when I create artwork. Sometimes I'm not sure exactly what kind of image I'm looking for, and having the ordered, alphabetized filing system allows me to examine a wide range of categories.

catalog that is very useful for depicting old-fashioned items. Department store catalogs in general are other staples on my reference shelf.

The Fairburn system is another option. This topical series of books contains photographs of different poses and scenarios. Basic categories include men, women, and children, and some books show people in varying poses. This type of reference is indispensable for the comp artist.

If you're ever completely perplexed by a job and can't find any visual reference, head down to the local library and thumb through books or specialty periodicals that depict the subject in question. Even when I worked in a large agency with an extensive visual reference file, I was called upon to do this—for subjects ranging from exotic plant species to beauty-shop hairdryers. You can make a copy on the library's copying machine and take notes regarding color. Above all, be resourceful—I regularly collect material from travel agencies to put into my reference file under "foreign scenes."

In general, the better the scrap material the better the art. When I was first starting out as a comp artist, I often tried to "fake" things, drawing objects with which I was unfamiliar using only my imagination. Needless

to say, this artwork is not among my best efforts. Remember, too, that often the client is more knowledgeable about visual matters than you think. You can't assume that people will have less of an artistic eye than you just because they aren't artists, so you must either know your subject matter or have a good scrap file when creating art. But don't hesitate to ask the client to provide visual references for particularly obscure subjects. After all, you can't be expected to be a computer bank of images.

One final note: remember that television—or at least video—can be good for you. Buy a high-quality stop-action VCR so that you can tape commercials and examine them frame by frame. This will not only provide you with a long list of subject-matter references but also help you analyze different types of commercials and how they get their messages across. For example, did you ever sit and count the number of images you are barraged with in a typical cola commercial? Try looking at each one individually to see how they interrelate. Imagine how the storyboard or animatic for the commercial might have been developed. Later on, after you've been working in the industry for a while, it can be gratifying to tape commercials that your artwork lent a hand in developing.

REFERENCE FILE CATEGORIES

Airplanes
Airports
Americana and American symbols
Amusement parks and fairs

Animals
> Amphibians
> Arctic
> Birds
> Cats
> Dogs
> Farm
> Fish
> Horses
> Insects and butterflies
> Reptiles
> Rodents
> Wild, African
> Wild, American
> Wild, miscellaneous

Appliances

Architecture
> Castles
> City buildings and cityscapes
> General homes
> Historic homes
> Miscellaneous

Boats
Bones
Bridges
Carriages
Cars
> American
> Antique and classic
> Imported
> Miscellaneous (race cars, trucks, buses)

Christmas scenes
Clocks
Color wheel and sheets
Costumes
> Children's
> Miscellaneous
> Period/historical

Dancers
Designs/symbols
Electronics

Farming
Flags
Food
> Beverages, including alcohol
> Christmas (holiday)
> Desserts
> Miscellaneous

Foreign scenes
> Africa
> Asia
> Europe
> Miscellaneous
> South America

Furniture
Guns

Heads

 Children
 Men
 Women

History, American
Industry and construction
Jewelry and watches
Landscapes

 Fall
 Spring
 Summer
 Winter

Makeup/cosmetics
Motorcycles
Mountains
Movies and theater
Music
New York City/other major cities
Parades
Patterns
People

 Babies
 Children
 Couples
 Crowds
 Families
 Famous, including legendary figures
 (Santa Claus, etc.)
 Men
 Men, nude and seminude (in bathing
 suits, underwear, etc.)
 Occupational, blue collar
 Occupational, civil service
 Occupational, medical
 Occupational, white collar
 Teens

 Third World
 Women
 Women, nude and seminude (in
 bathing suits, lingerie, etc.)

Perspective, unusual
Plants/flowers and gardening
Reflections
School
Sci-fi and fantasy
Shoes
Signs
Skies
Sports

 Baseball
 Basketball
 Bicycles
 Camping
 Car racing
 Equestrian
 Football
 Gymnastics
 Golf
 Hockey
 Hunting
 Jogging
 Miscellaneous
 Skiing
 Swimming
 Tennis
 Track and field

Tableware
Textures (alligator bags, leather, etc.)
Tools and equipment
Toys and dolls
Trains
War
Water

 Ice
 Ice cubes
 Oceans
 Rain
 Snow
 Waterfalls

Waterfronts and beaches
Weddings
Western, including South and Southwest
Wine

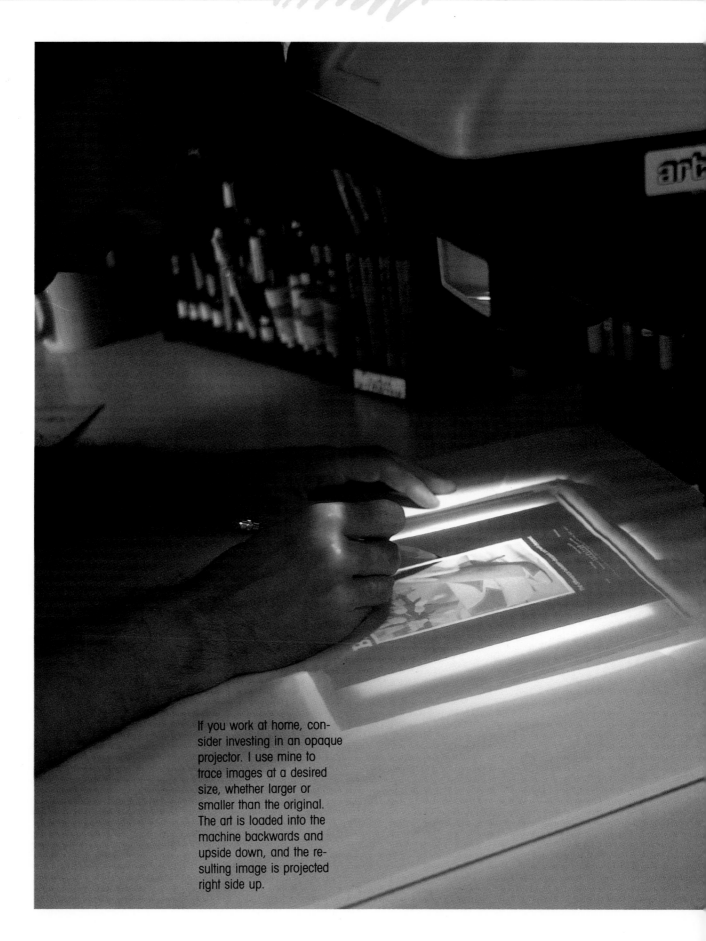

If you work at home, consider investing in an opaque projector. I use mine to trace images at a desired size, whether larger or smaller than the original. The art is loaded into the machine backwards and upside down, and the resulting image is projected right side up.

Projectors

Art projectors are used for tracing images at a desired size. Generally, these devices clamp onto the working surface, and original art is loaded in backwards and upside down to produce right-side-up images, either enlarged or reduced. These are projected directly onto the drawing surface, where they can be traced.

Opaque projectors are useful for projecting material onto a screen at a desired size. This allows you to see how artwork will look when enlarged and to study fine details. You may also want to purchase a slide projector so that you can maintain a slide visual-reference library on numerous topics and use it whenever your work calls for a topic that isn't in your photo-reference scrap file. For example, you can purchase slide art to use as visual references for a nominal fee from wildlife and horticultural organizations and museums. This vastly increases your visual resources.

Copying Machines

Copying machines have come a long way since their introduction and are now capable of reproducing color and enlarging and reducing to virtually any desired size. Some machines can reduce specific aspects of a picture, such as width or depth, without changing the other proportions.

While you might be able to afford a copying machine that uses only black inks, the topnotch color copying machines are probably out of your price range. Instead, use copy shops for color copies. For instance, if you need to depict bread in the same position in several frames in a storyboard or animatic, create an inked drawing of the bread, take it to a good copy shop, and request the number of frames needed with the bread colored brown. Then apply other media to the color copy. As mentioned before, machine copies can be drawn on with a water-based marker and can be used in conjunction with some alcohol brands.

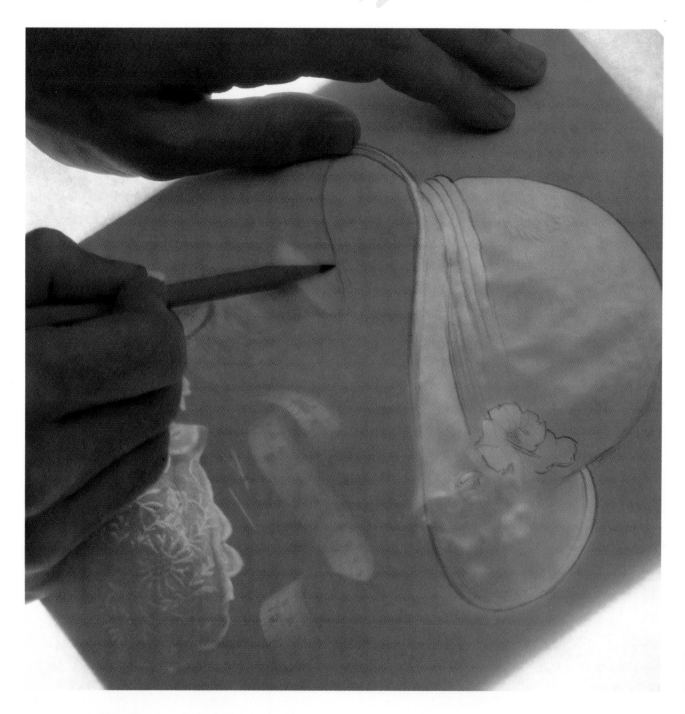

Another studio essential is the light box. Here I am using one that I built myself—using wood, glass, and paper—to trace a photograph. It's vital that you don't spend hours laboring over copying every detail of a photograph. Remember, a photograph is copyrighted material, so you should reproduce only elements that are pertinent to your work. In this case, I am tracing the hat only.

Light Boxes

The light box is another useful tool that allows you to trace a machine copy of a reference, whether it is the work of an art director or another visual reference that you wish to reproduce. Since light boxes are generally expensive, it is a wise idea to build your own. Light boxes are a quick way to copy the basic outlines of scrap from your photo-reference file. You should be aware, however, that unless material is copyright-free you should not make a direct tracing of entire photograph or drawing. Not only does it infringe on the original artist's right to reproduce his or her artwork: it makes your work look stiff and unoriginal. Instead, use the light box as a tool to help you create your own drawings from traced elements of other references.

BUILDING YOUR OWN LIGHT BOX

You can build your own light box relatively easily:

Go to a lumberyard and have cut to your specifications the following pieces of wood:

*two planks, each 24 inches long, 3 inches high, 1 ½ inches wide

*two planks, each 18 inches long, 3 inches high, 1 ½ inches wide

Also, have the lumberyard cut a ridge ⅜ inches deep and 1 inch wide, resembling a step in each piece of wood extending lengthwise along an edge. This ridge is created so that glass can rest upon it. If you want to be really thorough, have the lumberyard cut a chink wide enough for an electrical cord and plug to pass through widthwise along the bottom (not the ridge side) of any one piece of wood. Determine which side should get this cut based on how the light box will be positioned in relation to electrical outlets.

Next, head over to a glass shop that will custom-cut glass and order the following:

*one glass sheet 22 ½ inches long, 16 ½ inches wide, ⅜ inch to ¼ inch thick.

Glazed glass is unnecessary for your purposes. Clear glass will work just fine. Plastic is not an option because you can't use a knife directly on top of it and it will bow when you lean on it.

Next, obtain a piece of 18 x 24 inch white paper that will bounce light to your artwork. Then obtain one or two fluorescent bulbs equipped with an on-off switch and a plug-in cord for power. You'll also need four corner braces, 1½ inches or 2 inches long, to hold the wood together. You might be able to obtain these at the lumberyard; if not, go to a hardware store.

Decide on a permanent or virtually permanent location for the light box, since you do not want to be moving it around a lot. If you wish, paint the wood before assembly. To assemble the light box, arrange the wood in a rectangle, ridge side facing the ceiling: the 24-inch-long boards comprise the length and the 18-inch-long boards comprise the width. Attach the boards to each other with the brackets. Lay the white paper on the final resting place of the light box; add the fluorescent lights on top of the paper. If you had a hole cut for the light cord, thread this through the hole in the wood. If not, simply lay the wooden frame over the paper and lights, letting the cord pass under the bottom of the wood. Then set the glass in the ridge.

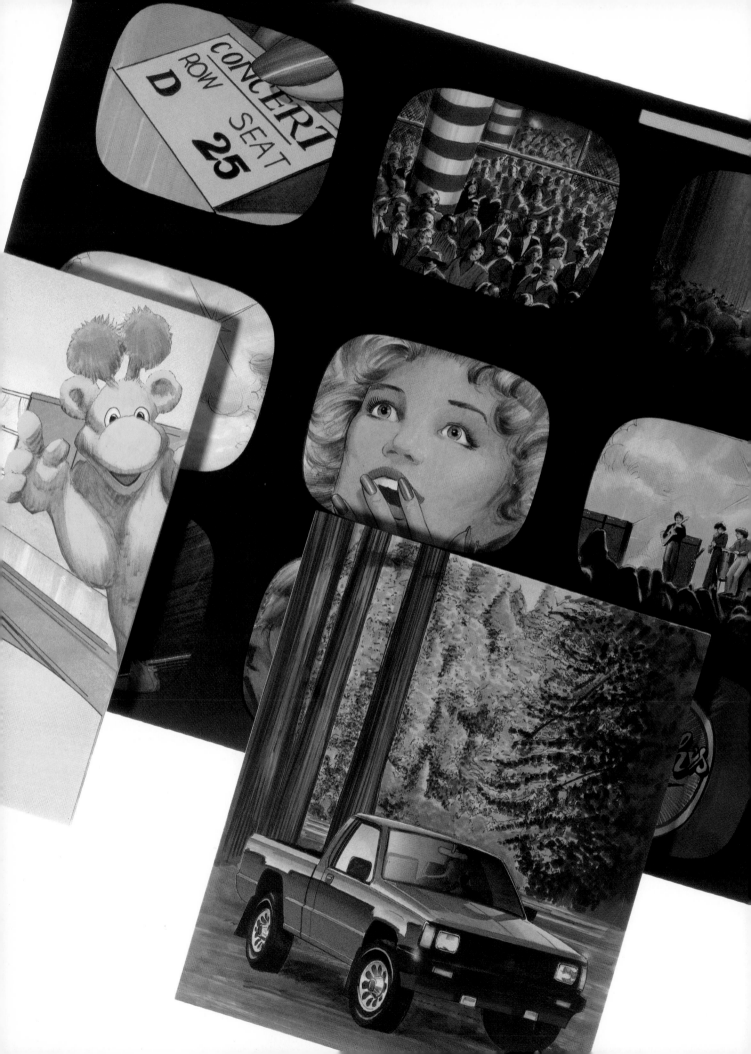

STEP-BY-STEP PRESENTATIONS

Comps, storyboards, and animatics—the three modes of presenting an advertiser's product—each have their own emphases and strengths, and yet they all share many of the same characteristics. They all are illustrated presentation pieces, created primarily with markers, intended to convince clients to give advertising agencies their accounts for products or services. All three depict how the final advertising will look. Comps, however, are used for print campaigns and usually result in magazine ads consisting of photos and type. Storyboards are the preliminary visual scripts for television commercials; they are drawings that show the key frames of the ad. If they are approved, storyboards go on to become animatics, which are illustrations with movable parts that show how a commercial will actually look in motion.

Although each chapter in this section describes the total process, moving from the art director's thumbnail sketches to the finished art, I've tried to avoid repetition and to focus on the distinctive aspects of each piece. First, I develop a comp, showing how to make a product look exciting and dramatic through a combination of marker, airbrush, and gouache. Next, I create a storyboard and present a full repertoire of marker techniques; here I emphasize the need for continuity from frame to frame. In the following chapter, on animatics, I do not show the coloring-in process in elaborate

detail but instead emphasize what is inherent to an animatic: its movable parts and usually oversize format. (Animatics can be smaller or larger than comps or storyboards, but tend to be larger.)

A critical aspect of all this work is speed. It's a good idea, whenever possible, to apply marker color freely beyond the edges of your artwork. This saves time because you don't have to worry about meticulously staying within the lines. For the truck comp in chapter 3 I worked freely outside the outline of the vehicle because I knew I would later detach it. For the storyboard in chapter 4 I also didn't worry about coloring beyond the drawings' edges because they would later be masked. And for the animatic of chapter 5 I was able to apply color very quickly to loose elements of the artwork because these would later be cut away from the paper they were drawn on.

In sum, these three chapters show the artist at work, bringing the techniques discussed in part 1 to life. You'll see how markers can be combined to "build" complex color gradations and how they are equally appropriate for depicting such diverse elements as billowing smoke and hard-edged chrome. Dry markers, gouache, colored pencils, and blenders—shown in isolated use in part 1—are all critical to the success of the comp, storyboard, and animatic in this section.

COMPS: THE ART OF QUICK RENDERING

A comp, or comprehensive, is the visual representation of an advertising agency's ideas. The essence of a print ad's message is represented in a comp. Comps are used by advertising agencies to present their ideas to clients, and therefore it is vital that you make the product or service being promoted look as good as possible. It is also very important that you faithfully interpret the art director's thumbnail sketch. For example, in the case of the truck comp depicted in the following pages, I had to reproduce exactly the visual perspective in the thumbnail.

If you're working in-house, you'll probably be expected to turn a comp around in half a day's time—about four hours. As a freelancer, you'll be given about twenty-four hours, although I always ask for more time than I think I'll need to ensure that the job gets done well. The complexity of each job varies.

Remember that comps are disposable art: If you add too many details to the basic outline, you can become overwhelmed. Comps are not finished illustrations; their purpose is to give a general idea of how an ad should look. Make sure that your comp will translate easily into a photograph for the actual ad.

The Process

First you must meet with an art director to obtain his or her thumbnail sketch for the comp. This is a crude representation of the comp, and you will probably need to ask questions to get a more concrete idea of what you need to depict and what the mood of the comp should be. The art director should provide you with specific instructions concerning the time of day, background, colors, and other elements of the comp. Details such as color are occasionally left up to the illustrator. Sometimes you will need to reduce or enlarge an art director's sketch to get it to the dimensions you're working within, which is generally on 8½ x 11 inch bond paper. Whether you have to reduce or enlarge the sketch or not, you will then have to trace that image off the paper; vague as it seems, the art director's quick sketch tells you where the image must hit the frame.

Following the tracing process, you must carefully devise your own pencil sketches, or "pencils"—you

don't have time for false starts, so think in very concrete terms about how you want to approach the comp. If you work in-house, you will probably have to do rough pencils and get approval before going on to final pencils. As a freelancer, you most likely will not need to create them.

If you are not working in-house and have a little extra time, it's a wise idea to consult your visual-reference files (see page 32) to aid you in depicting the subject at hand. Creating pencils is the most time-consuming aspect of comps, because it is at this stage that you are making all the basic decisions as to how much detail to include for different areas of the drawing.

Depending on your relationship with the art director, you may need to get your pencil sketches approved before going on to the inking process.

After inking in the outline of your pencil drawing, erase the pencil. Simplistic as it sounds, be careful when erasing. Hold the paper firmly with one hand

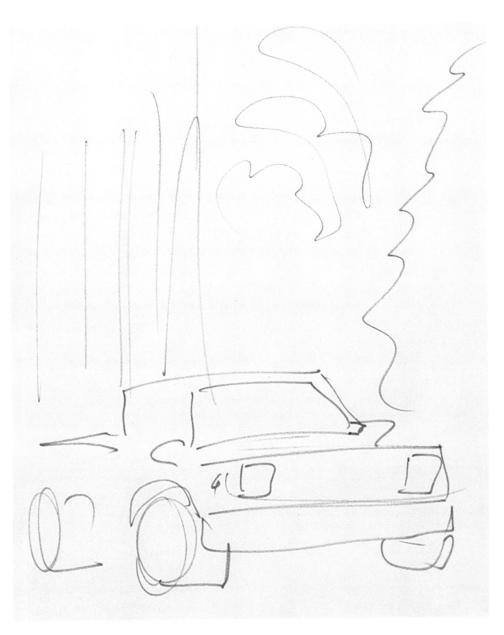

The art director gave me a rough drawing of how he wanted this truck comp to look. This sketch shows the most important elements of the comp and indicates where they should fall in the drawing. The art director should provide you with specific instructions concerning the time of day, background, colors, and other elements of the comp.

while erasing with the other, moving away from the hand holding the paper; erase completely, but don't get so enthusiastic as to damage the paper.

As you work on your comp, think about how it would realistically translate into a finished ad. Vanishing points in your work should match reality—or come very close to it. Should your comp become an ad, a photographer must be able to match the angle you have presented. Sometimes, in the interest of time, your perspective for a small element, such as a person's ear, may not be completely accurate. But keep the major elements of the comp, such as the overall size of the person's head, in perspective.

Whenever possible, draw freehand when working on comps; you don't always have the time to pull out ellipses or other templates. Should you make a mistake as you're coloring in your comp, don't worry; marker colors can be darkened, lightened, and even removed. And remember that such finishing touches as gouache, white pencil, and marker airbrush create a polished look that suggests a great expenditure of time, but is, in reality, quick to execute.

Step-by-Step Assignment

I chose a truck as the subject of this comp for several reasons. Vehicles, whether as principal subject or as background objects, are commonly depicted in print ads that require comps. Another reason for this choice is that many illustrators are daunted by the prospect of depicting anything machinelike or technical-looking. If you feel this way, you must change your attitude to that of a confident professional and approach "difficult" subjects as a challenge.

There are several key elements to keep in mind with car and truck comps. Reflections, for example, play a major role. The windshield is reflective; the body of the vehicle is reflective; the headlights disperse light; and the ground is often wet, in order to further reflect the vehicle and often to subliminally emphasize the superior road-handling ability of the vehicle even under adverse weather conditions.

Also, ad vehicles are usually red. Red connotes speed and contemporary qualities; it is *the* color for cars—because it is so bright, it commands attention. Lettering, too, is a key factor in bringing across an advertiser's message.

Another point is that, with car and truck ads, background plays a subtle yet important role—it suggests the milieu in which you might drive your car. Roomy, dignified-looking cars, for example, are often shown traveling city streets, which connote the executive workplace. Sporty cars are depicted on the open road.

Utilitarian vehicles, such as the one created in this comp, often have a background associated with ruggedness and natural terrain.

When dealing with complicated subject matter, you should break down the job into manageable work divisions. Try to enjoy your work as much as possible; you may find that by getting the most difficult aspects of the job out of the way first, you will be able to experiment a little more with the rest of the project.

I tackled my subject matter, a truck, by first recognizing that the most effective means of presenting vehicles in advertising is to exploit the numerous shapes that compose the body and show how they are all angled differently, making each distinct component of a car or truck like a mirror pointed in a different direction. Each section of the vehicle contains its own blending from light to dark, which makes rendering it appear complicated. However, because each section—the hood, the sides, the roof, the tires, the windshield—is broken down into discrete shapes, you can approach rendering them methodically. In other words, don't be intimidated by your subject matter. As you work on a comp for any product, think about how its designer conceived it and how its manufacturer wants the consumer to perceive it. In this case, I wanted to capture the qualities that made the truck seem fast and efficient; to do so, I worked with clean shapes and emphasized the shine of the vehicle.

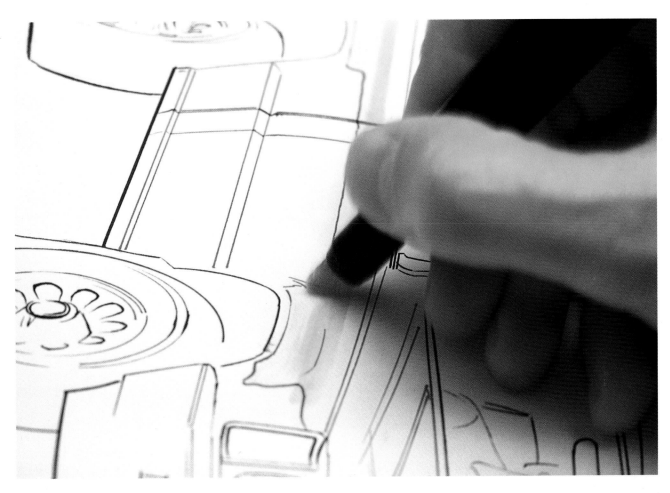

DRAWING AND INKING

I traced the art director's thumbnail sketch on a piece of paper and used this as my basis for the truck. From this, I worked on creating my own final pencil drawing, using material from my reference file and tracing over it on a light box. The whole process took about an hour. After I completed my pencil drawing of the truck using an ordinary No. 2 graphite pencil, I began to ink it in. While I used black for most of the outline, I employed a melon red fine-point Design marker to fill in the horizontal lines that I wanted to emphasize.

Based on the art director's instructions, I created my own pencils, inked them in (I used red ink for the most prominent lines of the truck), erased the pencil lines, and began applying color along the midsection of the car, the "horizon" line. I began by using blender along the inked-in red line and followed with a palette of reddish colors to immediately establish high contrast and create the effect of a shine.

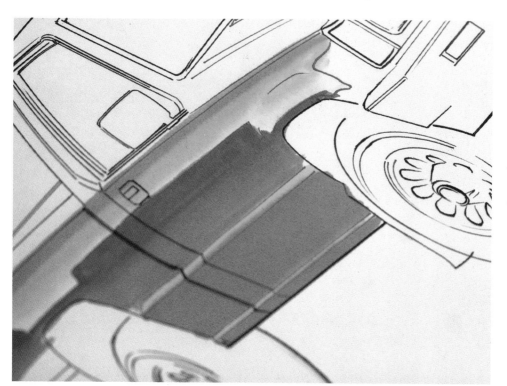

Working outward—both up and down—from the horizon line, I colored in a section of the truck, emphasizing the various angles and shapes that comprise the body. Notice how the colors above the line run subtly from light to dark; below the line, they progress from dark to light.

COLORING THE BODY

Then I moved on to the body of the truck. Although it was red, I couldn't just apply one color, as this would make the object illustrated look flat, and in this case, I wanted to create a shiny surface. Always try to add as many variations of color within a piece of artwork as possible to create visual interest, which translates into energy and excitement surrounding a product. For example, if you are called upon to depict a VCR

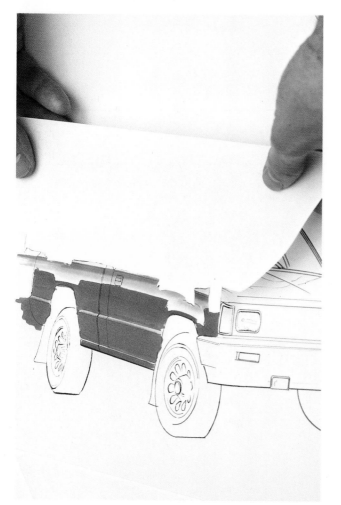

I took a marker airbrush and worked away from the mask to ensure that the paint would not disperse beneath it. I was careful not to apply too much marker color because I didn't want the purple to overpower the other colors. The result is vibrant, but not jarring.

I decided to add another dimension of color to the horizon line and opted to use a marker airbrush equipped with a purple marker. Using a light box to create a precise shape, I traced the outline of the horizon line and cut out a bond paper mask.

with black casing, use several cool dark grays.

As is often the case with comp products, the object was a "loose" piece—I would trim it from the paper I created it on, and the art director might test it on a variety of backgrounds other than the one I created. Therefore, I wasn't concerned about straying outside of the ink line with markers.

Vehicles in ads always have a "horizon" line running through them, that is, an area that is a point of departure for different related colors. Study photographs of cars in your reference file to get an idea of where this horizon line should go. It is usually located about halfway up the side of the car, a little below the windows. Above the horizon line, colors run from light to dark; below it, colors go from dark to light. This contrast of colors creates the vibrancy, or "snap," in a comp, which in turn produces the reflective quality. The horizon line establishes the angle of light for the comp. If you always follow the angle of light, you will be able to make natural-looking transitions from one section to the next.

To create the horizon line, I generously applied

blender to it and then applied pink directly over that. I continued adding colors, moving in a progression from light to dark, using salmon, coral, vermillion, cadmium red, wine red, and maroon, in that order. For the darker colors—cadmium red, wine red, and maroon— I used dry markers to better control the flow of color. I began coloring in the truck by working from the horizon line to the bottom of the vehicle.

With my first stage of work complete, I decided to apply purple along the horizon line for added contrast. I wanted the purple to be diffused yet not get lost among the other colors, so I applied it with a marker airbrush. To do so, I used a paper mask previously prepared on a light box to trace the exact shape of the truck, which I wanted to protect from the purple paint spray; I then cut out the shape using an X-Acto knife. After putting the mask in place, I moved quickly along the edge with the airbrush. Purple and red are analogous colors; this means that they are near one another in the "family" of colors and work well together while offsetting each other nicely. The effect is harmonious yet eye-catching.

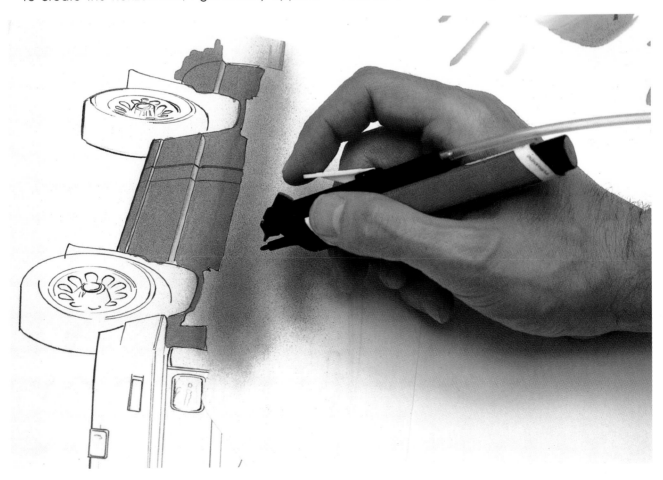

ADDING THE TIRES

I decided to tackle the tires next. I began with the tire that is farthest away first so that by the time I moved on to the front tire, I would know exactly which colors worked best. In general, when working on subject matter with repetitive elements, it's best to experiment with the least prominent aspects first. Another general rule regarding objects that are reflective and are shown outdoors is that the underside of an object is "warm" because it meets the ground and is therefore associated with earth; the top side of an object is "cool" because it faces and reflects the sky. In this case, the tires have both warm and cool elements, as reflected in the use of warm and cool grays as well as blues.

For the chrome hubcap, I used light blue—which is appropriate for any kind of metal because it looks like steel—followed by dry warm gray #3. For the rubber part of the tires, I used steel followed by cool gray #8; in addition, I applied dry cool gray #7 on top of the tires to give them a heavier look. I chose to go with grays even though tires are black; if you simply begin with black, you won't be able to show any detail effectively. Black was too strong a color to be used here; it would have created a "hole"—i.e., too much contrast—in the piece. I also highlighted the tires in two places: along the top and on the ground, where they bulge out slightly. For the highlights, I used sapphire blue followed by cool gray #7 and crystal blue to tone the brightness down a bit. Then I used a gray Pentel pen—equivalent to a cool gray #5 or #6 marker—to delineate the wheel slots.

Once a large percentage of the truck was colored in, I could assess how the colors of the tires and the side of the truck looked together. I decided to add even more color contrast to the side of the truck. I lightly drew with dry delta brown along the horizon line in order to establish high-contrast snap. To heighten the effect and add definition, I drew white pencil lines, using a template as a ruler. Gouache could have also been used here, but very sparingly.

FILLING IN OTHER DETAILS

For the windshield and the passenger window, which are reflective, I used blender followed by sapphire blue, drawing down the glass. Then I added dry crystal blue to enhance the reflection. For the passenger window, I also used cool grays.

Never begin with a black marker when you are rendering a black-colored object, as this makes it next to impossible to include any color variation in the depiction. For example, I used warm grays in some of the lower areas of the tires of this truck and some cool grays in their upper regions. I colored the hubcap light blue to simulate steel and overcoated it with a dry warm gray #3. After I had colored the tires with a range of cool grays (from #5 to #7), I layered several blues for highlights.

It's a good idea to stop every so often to assess your work. I was generally pleased with the way that the colors were interrelating but felt the horizon line still needed more snap, so I added dry delta brown marker.

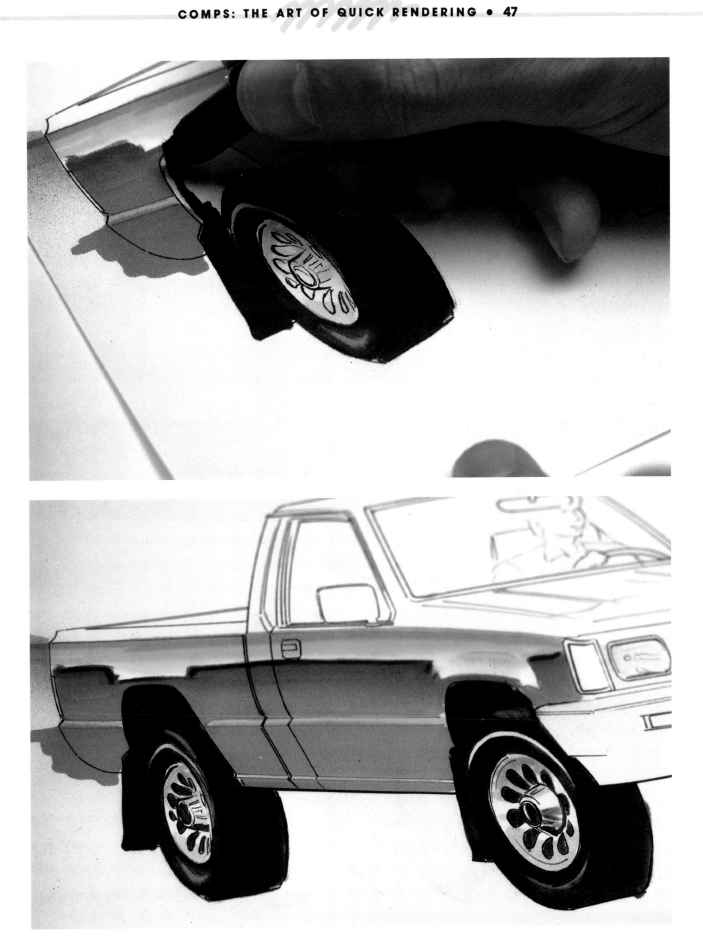

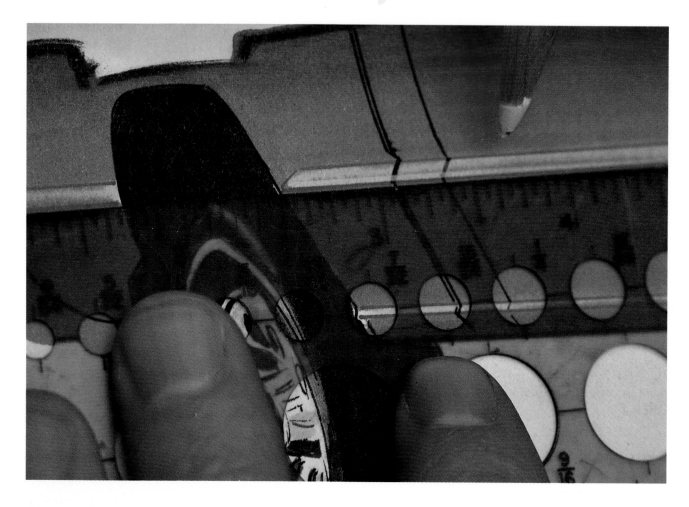

FINISHING TOUCHES

On a separate sheet, I created a dappled forest background in green—a complementary color to red, which meant the colors would really be eye-catching. I used a wet-on-wet technique, alternating markers with colorless blender, applying citron as an undercoating and allowing it to peek through in several areas. By using copious blender between color applications, it's possible to work wet-on-wet with markers, provided you work quickly.

My next work area was the hood and roof of the truck, for which I used the progression of colors previously delineated, as well as a melon red Design fine-point marker to get into the small spaces.

A consistent feature of vehicle ads is that car headlights are turned on whenever possible; again, this is to add as much visual excitement to the product as possible. The same principle applies to any product. For example, for ads for equipment like cameras, parts that are capable of being lit up usually are. In this case,

It's those little details that make your work really shine. Here I used a straight-edged template (or ruler) to draw thin white horizontal pencil lines along the body of the truck. Not only does this effect suggest that parts of the truck body are jutting out and reflecting more light from overhead, but also it gives the work needed sparkle.

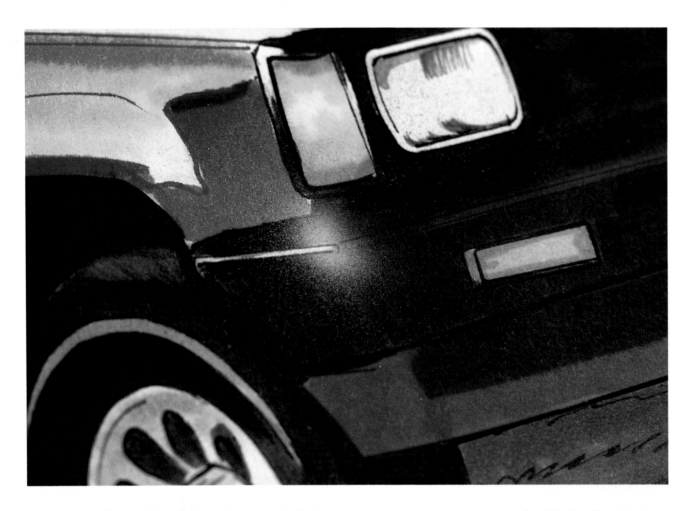

I illuminated the parking lights of the car, indicating twilight; this allowed me to draw on the light of the sky while also justifying showing lights on the car. I used maize in the center and goldenrod around the edges of the lights to create a luminous effect.

Next, I created a light source in relation to the truck and added marker colors based on the dispersion of light. I added a variety of colors in a subtle palette, ranging from light yellow to chartreuse, because I wanted the background to have less contrast than the foreground. To ensure this result, I squinted at the background and compared it with the truck to see how the color tonalities differed. I then detached the truck from the bond paper with an X-Acto knife and used spray adhesive to hold it in on the background.

A marker airbrush—which uses transparent color—is sufficient to use to create a gleam on most products. But comps for vehicles usually require more high-contrast vibrancy, in keeping with the bright colors of the automobiles depicted. This extra dimension of excitement warranted use of a traditional airbrush, which

A subtle blending of maize in the center and goldenrod around the edges creates the truck's luminous parking lights. I was particularly pleased with the interesting contrast created by the warmth of the red truck and yellow headlights juxtaposed with the cool colors of the tires.

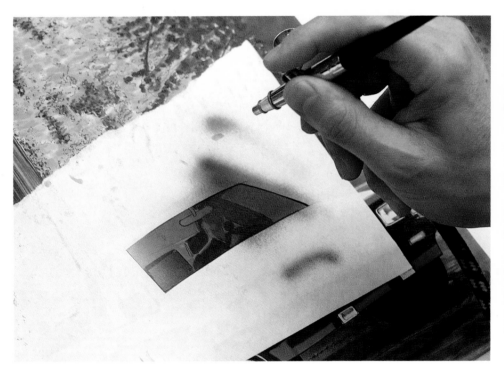

At this point, I felt that the car's windshield needed more emphasis, so I decided to give it airbrush highlights. I traced the windshield on bond paper, cut out the shape, and used the paper from which it was cut away as the mask. I used spray adhesive to attach the mask to the background temporarily. I used a traditional airbrush to apply white gouache very lightly on the left side of the windshield and darkened the right side slightly.

creates more contrast because it uses opaque paints.

I traced the shape of the windshield on bond paper and cut out the shape to create a mask—not from the cutout but from the paper it was removed from. Next, I lightly coated the back of the mask with a bit of spray adhesive to keep it in place. (Previously in this comp, when I used a marker airbrush, I didn't need to glue down a bond-paper mask because I was spraying away from the edge of the paper. Here, the mask encloses the space, so the paint will tend to disperse under the mask if it is not firmly held in place.) I used a Thayer & Chandler airbrush; however Iwata, Paasche, and Badger are all excellent brands.

I applied the airbrush to the windshield to create a glare effect. Then I lightly touched the front of the truck to give it a gleam. As you apply paint with an airbrush, do it subtly, with a light touch. Try taking the mask off during the process to check the color contrast.

PRESENTATION

For the final presentation, I attached the truck with background to yet another bond-paper background and applied mock lettering, called "greeking." The finished comp is usually mounted on foam-core board of an appropriate size before presentation to a client. Sizes range from as small as 5 x 7 inches to as large as 18 x 24 inches.

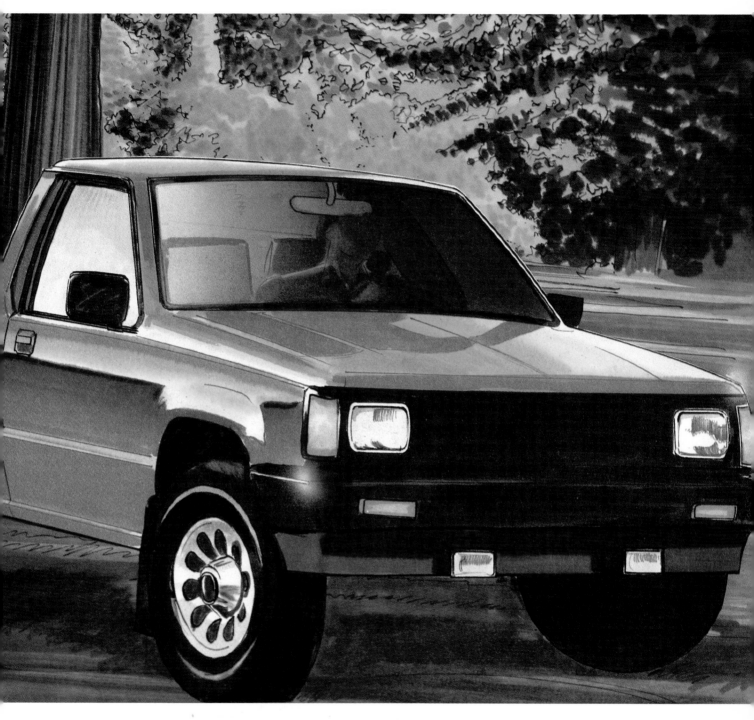

I detached the truck from the bond paper it was drawn on using an X-Acto knife and used spray adhesive to hold it in place on the background. When the artwork was applied to its background, the green forest scene really made the red of the truck stand out. The final comp has the bold, bright look that the art director was looking for.

STORYBOARDS: CREATING A VISUAL SCRIPT

A storyboard is a visual script for a television commercial. An art director will provide you with rough frame-by-frame sketches for a storyboard, which generally involves six to nine drawings. These renderings are meant merely to show positioning and to convey the overriding idea for each drawing using minimal detail. It is up to you, the artist, to accurately interpret what the art director and client are looking for.

Sometimes frames from your work will be used in the final commercial in conjunction with another artist's work. They can be drawn as "minis"—in 1 x 2 inch, 3 x 5 inch, 4 x 5 inch, and 5 x 7 inch sizes—or as key frames on standard-size 8½ x 11 inch paper. Some artists are comfortable working with a whole range of sizes. I prefer using 5 x 7 inch because it is a nice compromise between large and small.

For this storyboard for Stroh's beer, nine frames were specified by the art director. These roughs are meant to be used as guides for the content and for how the art should be cropped in the frames.

The Process

After the art director presents sketches, you must create final drawings, or pencils. As with comps, this is done with an ordinary graphite pencil. Following this stage and after receiving approval for the pencils, ink the lines in over the pencil and then erase the pencil. As mentioned in the previous chapter, you must be careful when erasing.

Thereafter, you have to apply marker, perhaps with touches of gouache or colored pencil for highlights. Sometimes an art director will want aspects of the storyboard to change—perhaps the color of a person's shirt or the height of a tree. In such cases, the art director would make machine copies of the frames of the storyboard and send them back to the artist with changes indicated on the copies. Such changes are then created through patching, a technique discussed on page 100. The final storyboard is presented with storyboard masking—cutout mats used to frame audio and video areas.

For an average storyboard of six to nine frames, creating pencils can take a full workday to complete, if you're working quickly. If the client is really in a crunch, you might be able to provide finished art by working in your studio for one day and one night. In-house work, which is often quite loose, usually needs to be produced even faster. The storyboard depicted here required a day to create pencils and two days to complete, but it is more detailed than most in-house work.

Step-by-Step Assignment

Using Stroh's beer as the featured product, I chose a rock concert scenario as the subject for this storyboard for several reasons. First, rock concert settings are very contemporary, involving up-to-the-minute fashion and demanding a general understanding of what's current. Second, because rock concerts are inherently energetic events for both the band and the audience, the illustrator must convey a sense of action and liveliness. Third, there are many concert-related elements that are particularly exciting to portray: close-ups interspersed with crowd scenes, as well as such special effects as high-contrast smoke-machine mist, spotlights, and colored lighting. Concerts also feature high-tech stage equipment and are an opportunity for the illustrator to display a mastery of depicting state-of-the-art objects, which is guaranteed to impress both the art director and the client.

Lucrative accounts for such products as alcoholic beverages, diet soda, and even fashion thrive on dramatic advertising incorporating elements like the ones in the storyboard. And the techniques shown here can be applied to many other subjects. Note, in particular, the information on creating hair and skin tones realistically, under different lighting conditions.

DRAWING AND INKING

Working from the art director's thumbnails, I found scrap from my reference file that was appropriate for the concert scenario. I drew and inked in the frames as described in chapter 3; in this case, however, the drawing took much longer because of the magnitude of the project.

The format I worked with is 5 x 7 inches, and there are nine frames in all. Frames 1, 2, and 9 of this storyboard sequence are not shown in step-by-step detail. This is to represent frames—often created by another artist—that might be added on by the art director to improve the selling power of the storyboard. Also, these frames either do not illustrate unusual techniques or depict techniques discussed elsewhere.

As you work on a storyboard or any other piece of artwork, it's a good idea to stop occasionally and squint at your illustration to see how the colors and values broadly interrelate. For example, you may be using colors that don't work together very well within one illustration or that don't interrelate from frame to frame. Be aware of this aspect at all times. If you find that colors aren't working together, you can easily remedy the situation by applying deeper or lighter markers directly over the old colors. You can also use a blender to remove color.

As I work, I sometimes make improvisational decisions regarding color, layering marker colors for several minutes to achieve the result I want. However, while I have the freedom to make color choices and decisions about fine details of the artwork, I keep in mind that it is not my prerogative to change major aspects of the art director's renderings, such as the action shown in a frame or the positioning of the people.

Another rule that guides me as I work is that within each frame, it's best to begin by coloring in the elements that I am most familiar with. Then I move on to the more challenging areas. I prefer to tackle problematic aspects last to build working momentum in the frame. Usually, the problems that I encounter aren't as great as I had anticipated because I have worked out color combinations while applying markers to the other, easier elements of the illustration. You may approach things differently, however; do whatever works best for you.

COLOR SELECTION

I decided on an appropriate grouping, or "family," of AD marker colors and planned how the light and dark colors would interact to give the storyboard color continuity as well as spark.

In crowd scenes—and in any setting that is artificially lit—the interplay of light and dark is particularly significant and is very challenging to create. You must produce thorough color contrast and a sense of perspective to convey the idea of a large area stretching beyond the frame. I have found that for a darkened theater, such effects can be achieved by using a relatively dark undercoating of a color like purple sage. I have also discovered that while pale indigo and mauve are good undercoat colors to evoke mood and create a sense of perspective, a fairly dark undercolor such as purple sage simply makes things

punchier and avoids the more mundane look of, for example, a department store. Achieving powerful results like this quickly is the essence of successful comp, storyboard, and animatic work. You want your art to look finished and professional, yet you don't have the time to do a meticulously rendered piece. Undercoating creates this finished look without the labor.

Based on the art director's roughs, I created nine pencils and inked over them. This drawing—representing the fifth frame of the storyboard—has just been inked in and the pencil lines have been erased. Notice how I captured the wide-eyed expression on the close-up drawn by the art director in the rough pencils, but also elaborated upon it to create a realistic-looking face.

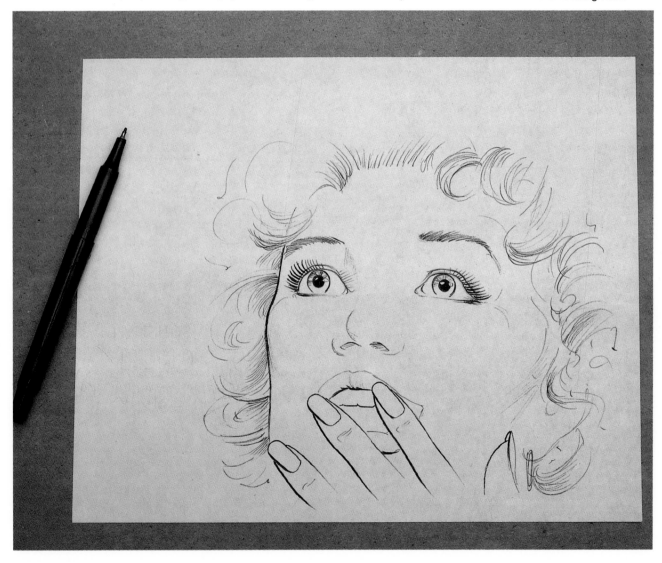

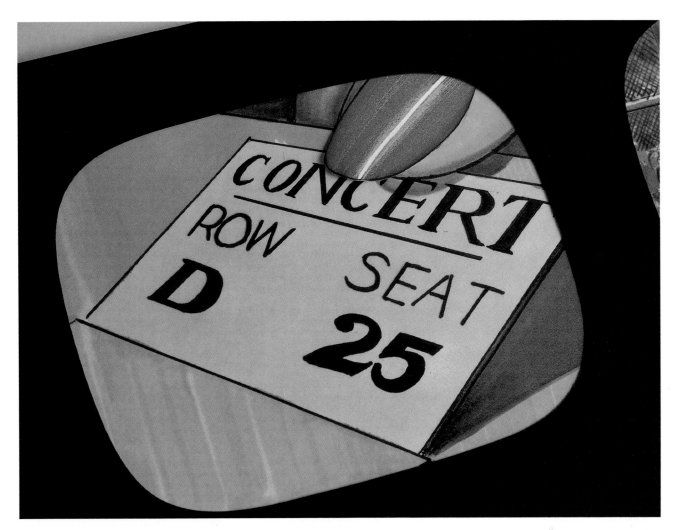

FRAME 1

In the spirit of modern television, the frames of this storyboard are intended to interact quickly, dynamically. The first frame depicts a concert ticket, which I lettered with a black Pentel pen. I created the skin tone on the finger with a wet-on-wet technique: pale flesh marker, followed by blender, flesh, blush, peach, salmon, and dry burnt sienna markers. I developed this standard formula for Caucasian skin and find that it works very well in virtually any piece of artwork. It can be toned up or down with light and dark shades and blender depending on the lighting conditions or darkness of the skin tone. I also added an undercoat of purple sage for the background. (For a discussion of how this frame was later patched to change the finger, see page 100.)

The first frame helps establish the scenario and color choices for the entire storyboard. I used a undercoating of purple sage followed by blue for the background: colors that are used prominently throughout the storyboard. I colored in the finger using flesh tones and created the sheen on the nails by allowing the white of the paper to show through.

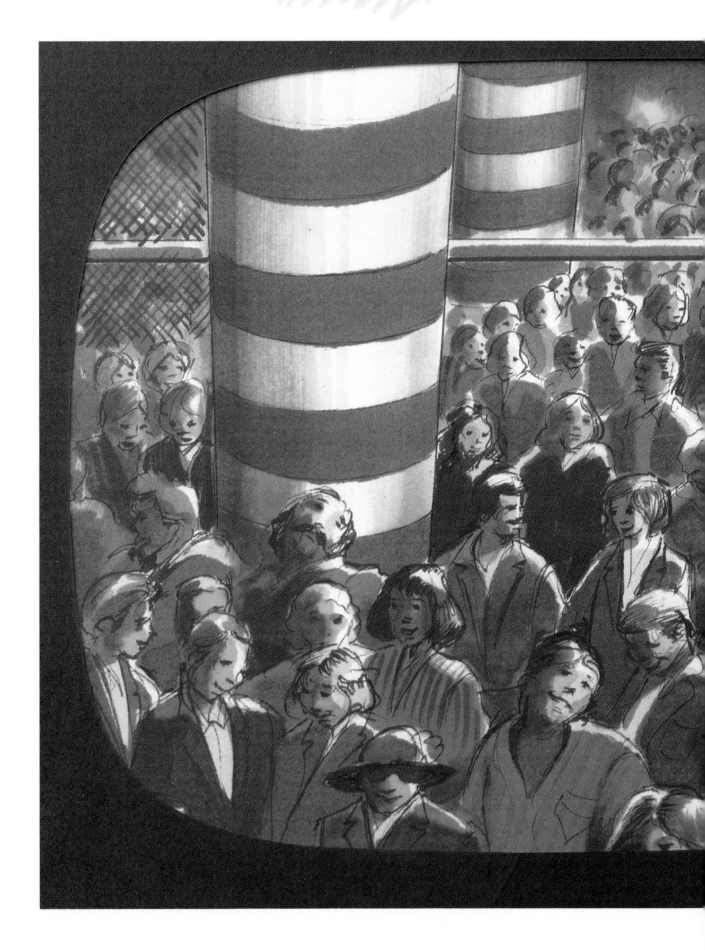

FRAME 2

The first frame segues quickly into the second, showing concertgoers filing into an arena. For the crowd, I added facial details with a black Pilot Fineliner. Then I undercoated the entire frame with dry purple sage in order to establish a deep-toned indoor-lighting mood. I added a variety of marker colors—blueberry for the crowd and slate blue (which actually looks green)—for the stripes on the columns.

This scene establishes the idea that a large crowd of people is attending the concert. I used dry purple sage as a background undercoating to create an indoor-lighting mood and shadowed the people's faces, making those farther back in the crowd less distinct. I used a lot of deep tones, such as blueberry, for the audience's clothing to indicate the low level of lighting. Use of deep colors also adds an element of mystery and excitement to artwork.

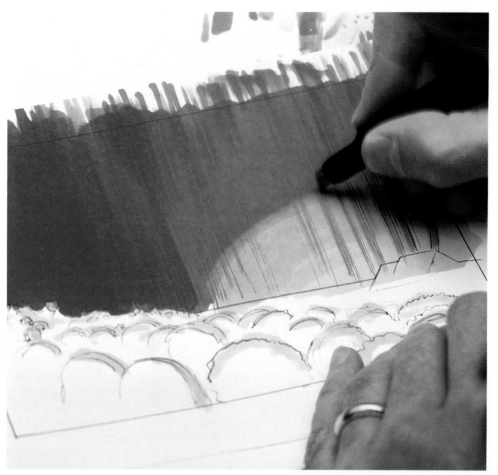

For this setup shot of the curtained stage and the audience in the foreground, I began with an undercoating of purple sage in the folds of the curtain and also on the tops of the heads of the members of the audience. Note how the individual layers of colors that comprise the curtain are visible at the edges of the drawing yet combine pleasingly on the curtain itself. I also added small areas of flesh tones in the left section of the drawing to indicate faces in the crowd. Then I created the spotlight on the curtain by drawing a semicircular outline of sapphire and ice blue with crystal around the edges. I also began to add vertical wet-on-wet streaks of ultramarine, crystal blue, and cool gray #6 throughout the rest of the curtain.

FRAME 3

For this frame, depicting an empty stage with a crowd in the foreground, the same two basic families of colors as in frame 2 are at work: blues and purples—colors that convey a feeling of mystery and excitement. I began with an undercoating of purple sage to show the folded areas of the curtain as well as to outline the heads of individuals in the crowd. For the stage curtain I created sweeps—overlapping wet-on-wet applications—of blues and grays.

To color the curtain, I focused first on the semicircular spotlight, drawing in half-oval sweeps with sapphire blue and ice blue markers; I went back over the outline with crystal blue to create a natural-looking transition from the spotlit area to the darkened curtain area. For the latter, I drew in vertical sweeps with purple sage, ultramarine, crystal blue, and cool gray #6 markers. Sometimes I drew down directly into the spotlight. There is an intentional bit of unevenness in the color application so as to create the linear effect of a curtain hanging in folds. Notice how the curtain is at its

darkest at the point farthest away from the spotlight. For the stage itself, I used a steel-colored marker. A darker gray would have been too strong and would have brought the stage into the foreground.

Then, I moved on to the crowd, which already had an undercoat of purple sage and added blueberry to indicate that it was in relative darkness compared to the stage. As I applied the blueberry, I followed the outlines of the heads as drawn in ink. Later, I increased the subtle differentation between heads with a white pencil, being careful to apply it only in places that the spotlight would illuminate.

The result of this combination of marker and pencil is a very shadowy, dramatic piece of art. Because of the deep tones and minimal detail in the crowd, it creates the sense of a very large concert arena.

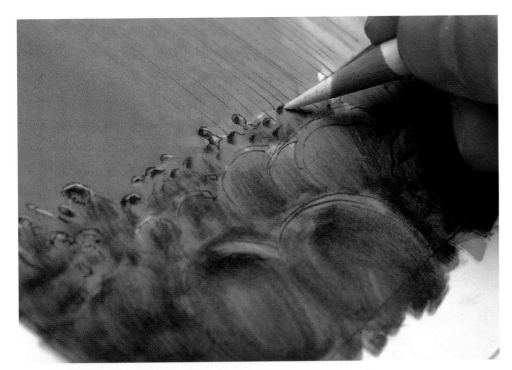

After I had completed the curtain and colored the stage itself with a steel-colored marker, I began working on the crowd. I filled in the entire audience area with blueberry. I also added brown marker to the heads of the people to the left of the stage. Then I added white pencil for highlights on the tops of the heads of the crowd. Not only does this add pleasing details to the crowd, indicating a great many people and differentiating between heads, but also it provides the realistic look of the houselights hitting the audience.

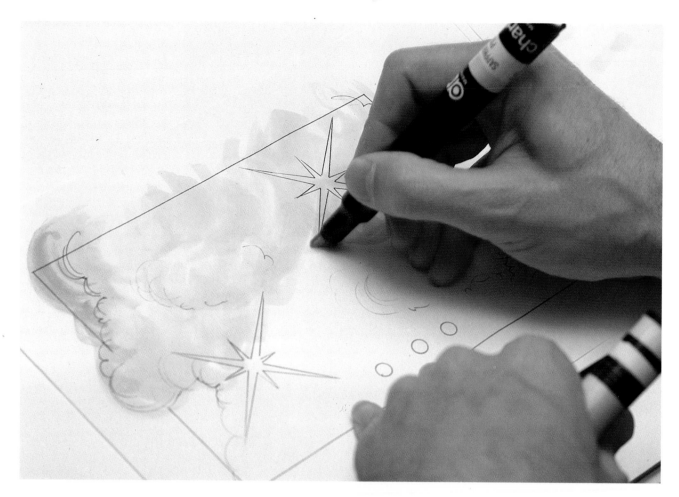

This frame is meant to build excitement, and so I needed to apply marker color in a spontaneous, energetic manner. You want your artwork to look lively if its subject matter is exciting and includes movement. In keeping with this rule, I applied purple sage, ice blue, frost, and sapphire in loose, "billowing" strokes to create the effect of a fog machine, with the smoke colored by spotlights. I also applied copious blender between colors so that there would be no harsh lines in this misty scene. For any type of scene that includes mist, smoke, or some other diaphanous element, you should always apply blender liberally.

FRAME 4

This frame shows a stage suffused in fog-machine smoke and flashes of light that herald the rock band's arrival on the stage. The smoke and lights reinforce the sense of mystery created by the purple and blue foundation colors of the storyboard.

To represent the clouds created by a fog machine, I put down blender to eliminate lines and help create a very soft effect and began to "billow around" with wet markers. To make elements of an illustration look realistic, you really have to feel what you're drawing, be it smoke or hair. Your marker strokes must be as loose or as controlled as your subject matter. In this case, I freely used purple sage and ice blue followed by frost blue and sapphire blue, adding liberal amounts of blender to retain the loose, misty quality.

To depict the flashes of light and the stage footlights—dots at the bottom of the frame—I applied white gouache with a small brush. I then smudged the paint lightly with my finger to obtain a misty effect; I could also have achieved this using a marker airbrush.

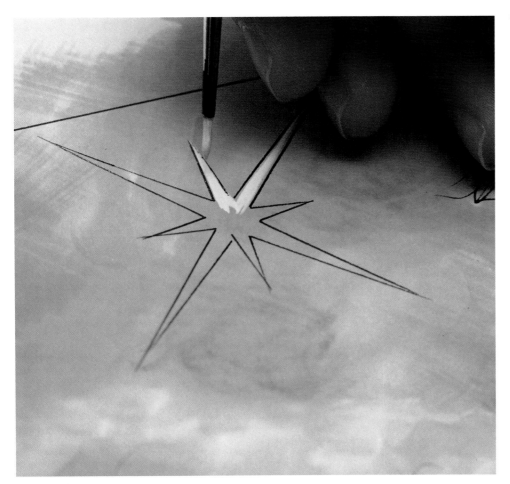

After establishing a cloudlike base of "rolling" color, I added gouache highlights to indicate flashes of light and stage footlights. I used a fine-tipped paintbrush to do so because I wanted to achieve very precise effects. Once I had applied the gouache highlights in very small areas, I smudged them slightly so there wouldn't be too sharp a contrast between the lights and the mist.

The completed frame is a combination of very different techniques, and they complement each other nicely. The looseness of the mist is punctuated by the relative precision of the light flash and the footlights. The overall effect of this technically complex frame is mysterious and evocative.

A nice counterpoint to the indistinct quality of the previous scene is this close-up frame of a woman reacting to the excitement of the concert. Although she is a relatively "warm" element compared with the cool blues and purples of the rest of the storyboard, I still wanted to coordinate her colors with the other frames. To do so, I undercoated part of her face and hair with purple sage. This provides the necessary—yet subtle—link to the rest of the storyboard. Afterward, I began rendering her skin color using pale flesh, blender (to highlight cheekbones), flesh, blush, salmon, and dry burnt sienna, in that order. I used the darker colors to contrast with the blender highlights.

FRAME 5

Shocked and delighted that the concert is beginning with such drama, the young woman in this frame embodies the high-energy mood of the entire storyboard. The challenge here was to realistically yet quickly render skin tones and hair color and texture in an extremely close-up shot.

I began with an undercoating of purple sage around the hair and face. While this frame is highly detailed and lighter than the others, it still must carry undertones of the previous and successive frames to reinforce the feeling that all the action is taking place within the same concert environment.

Next, I established flesh tones, using the color progression for skin tones outlined in frame 1. I used a lavender pencil to create highlights around the cheekbones and eyes, just the way a woman would use makeup. This woman's face needed a very contemporary look, and I consulted several fashion magazines to recreate the colors of the current makeup palette. I applied coral and vermillion markers fol-

lowed by the lavender colored pencil for the color of the woman's lipstick and coral and vermillion marker for her nail polish. Then I began coloring in the hair.

I swept a dry marker around the woman's head, whisking it in several different directions so as to avoid the "helmet" look that often mars otherwise good illustrations. Hair has to look like it's growing out of the head, not perching on top. I also wanted to depict the complex color combinations that constitute dirty blond hair: I began with a dry light yellow shade and used dry brown and dry cherry as accents. Because I used dry markers, I achieved a linear, wispy effect, as opposed to a "blobby" wet marker effect.

Finally, I went back to fill in the fine details: I applied a steel marker to color the iris and the eye and further enlivened the eye with a blue colored pencil. I colored the back side of the paper with a maize marker, which dramatically warmed up the skin tone. Then I lightly applied a white pencil to the highlighted areas of the woman's face.

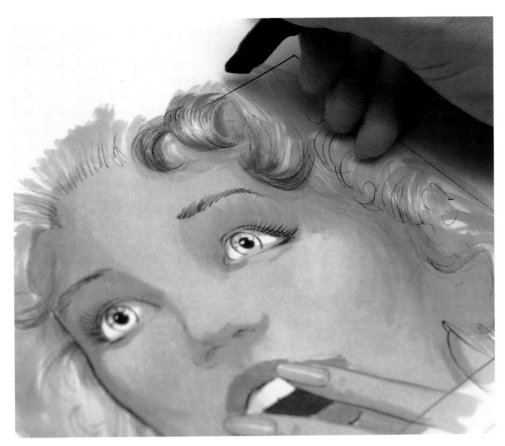

The woman's hair was challenging to render because of its color and texture: It is both dirty blond and curly. I had to choose the combination of markers carefully to achieve the complex coloring of her hair. I also had to make her curls look as if they grew naturally from her head and didn't just sit on top. I accomplished this by sweeping a dry yellow marker around her head, being sure to draw *into* and *out from* her forehead and cheeks. I also began adding loose swirls of dry brown and dry cherry markers around her head, leaving some white spaces to create highlights.

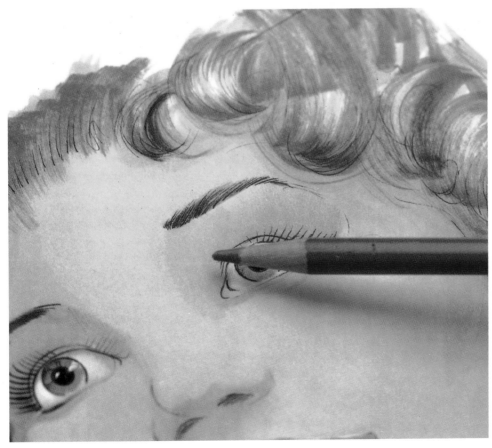

I wanted the woman's face to look contemporary, so I consulted my reference file to better acquaint myself with the current makeup palette. Drawing on my reference, I decided to apply a lavender colored pencil around her eyes and cheeks, in the same way a woman would use makeup. Her makeup colors also harmonize nicely with her blue eyes.

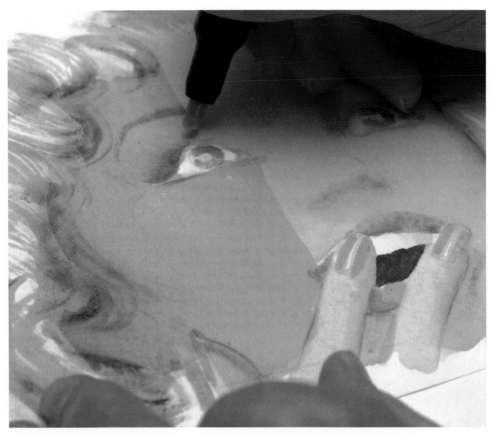

With most of my work complete, I scrutinized this frame to decide whether it needed any additional touches. I decided to warm up the woman's face, so I turned the art over and colored the back of the paper with a maize marker.

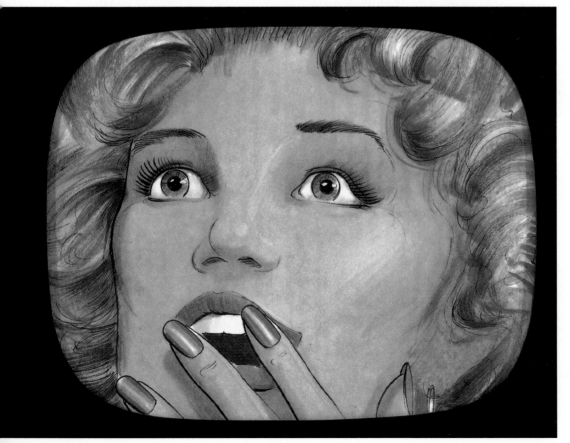

I also completed her lip color—coral and vermillion markers followed by the same lavender colored pencil used on the eyes and cheeks—and nail color, which is also a combination of coral and vermillion markers. I colored her irises with steel marker and blue colored pencil. I further brightened her face and gave the frame a finished look by applying white colored pencil highlights.

FRAME 6

This frame depicts the event that the crowd has been waiting for: The band has finally taken the stage.

To provide continuity with the color values of the previous frames, I gave the stage audience an undercoat of purple sage. Mist from the fog machine continues to billow around under constantly shifting concert lighting, so I didn't have to exactly match the smoke with the previous frame. I did want to maintain the wispy effect, however, so I added a background ice blue color to soften the scene. I also coated the amplifiers and other audio hardware with crystal blue. On top of this I added a cool gray #7 marker. This combination produced an industrial gray color that not only was realistic but also related to the purple colors of the crowd.

To create the color of the stage, I diverged from the gray I used in frame 3. Because there is more light in this frame, I used flesh and cream; while the latter was still wet, I added cherry, a hardwood color that combined with the previous colors to create a shiny effect. To bring the stage closer in value to the rest of the frame, I added crystal blue, which toned down the

cherry color while allowing the shiny effect to remain intact. Notice how the light hits the stage, producing vertical streaks of shiny color.

I moved on to the audience, which for this frame at least would remain a shadowy presence. I coated them with blueberry, which is dark but not so dark as to obscure the crowd completely. As I applied the blueberry, I tried to avoid filling in areas directly above the crowd: these are the light, edge-lit areas that enhance the effect of a large gathering of people. This technique is called "holding"—reserving areas so that colors can be played, or "popped," off of one another. In this case, the crowd's heads and the stage action are popped off one another.

Next I began working on the center of attention: the musicians and their instruments. For the conga, I used an undercoat of blender and purple sage heightened by a wine red color, with some maroon added on the outer areas for a shadow effect. Thereafter, I used buff and red to impart some color variety to the guitars.

For the musicians' skin tones, I used an undercoating of purple sage, followed by flesh. I used peach in the shadowy areas to create contrast with the lighter

This frame incorporates a number of diverse elements: the crowd, the band, and the equipment. As with all previous frames, I began with an undercoating of purple sage on the crowd. I moved on to the stage and used crystal blue and cool gray #7 on the equipment, which creates a steely, high-tech look. The small portion of the stage that is depicted is a result of vertical streaks of flesh, cream, and cherry red, with white space left between strokes to create a reflective, shiny effect. I used ice blue in the background so that the foreground really pops. For contrast and drama, I applied blueberry to the crowd, leaving some white space on the tops of their heads.

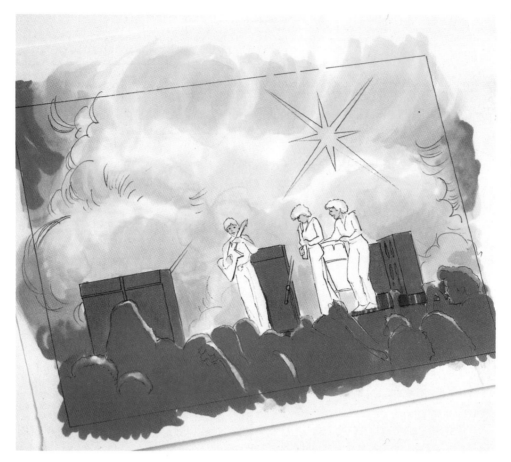

Having reached the midway point in the coloring process, I stopped to assess my work. The blueberry-colored crowd provided sharp contrast to the light background, but I still felt that it needed more punch and decided to deepen it after I had done more work on the rest of the elements.

areas. Working from light to dark marker colors will produce halftone effects.

I varied the musicians' clothing to create visual interest. For the pants of the musician on the left, I put down a blender undercoat and then added ice blue, blue green, and dry cool gray #6. To create the jeans effect for the pants of the musician on the right, I used an undercoat of blender immediately followed by ice blue and crystal blue; then I added dry electric blue and a bit of white pencil, which works quite well to simulate the weave and faded quality of denim (for a more in-depth discussion of denim, see chapter 7). The musician on the left got a coating of blueberry for his pants and more blueberry followed by dry cool gray #8 for his jacket. I varied all of the shirt colors and later applied white gouache on the top areas of the shirts to heighten the lighting effect. Sometimes clothing colors are specified by the art director; other times it's up to you, so you should think about which colors are appropriate to the artwork.

For the band's hair colors, I chose variations of brown, applying dry delta brown and even some dry redwood to indicate that spotlights were playing off their heads. I also used a black Pilot Fineliner to add some details and individual strands to the hair. But whatever color I used, I always was careful not to completely fill in the top edge of the head to produce the edge-lighting effect. I used the fine tips of Berol Prismacolor markers to create the details of the band members' faces.

Keeping in mind the colors I had applied to the stage and musicians, I returned to the crowd to finish assigning them color values. I applied delta brown, which added depth of color, and cool #7 and #8 gray markers and more blueberry to differentiate heads and create shapes. The effect is one of light bouncing around the venue.

I always like to use gouache last as a finishing touch, and here I applied it to the stage equipment to indicate a chrome reflection and create a spotlight. As mentioned previously, I also applied it to the musicians' shirts. I completed the crowd by mottling white pencil along the tops of the heads, a softer effect than that of gouache. The pencil effect also indicates that the band is more brightly lit than the audience.

I moved on to the musicians and their instruments. I used an undercoat of blender and purple sage enlivened by a wine red for the conga and then applied buff and red to the two different guitars. I also varied the colors of the musicians' clothing using a few simple marker combinations. I consulted my reference file when choosing their clothing colors to give the band a consistent look. The hair and skin tones of the musicians are variations of dry brown and flesh, respectively. After I had completed these elements, I opted for a combination of markers to deepen the audience: delta brown, cool grays #7 and #8, and more blueberry to delineate individual heads.

To finish the frame, I applied a bit of gouache to the musicians' equipment and filled in the flash of light in the same way I did for frame 4. I also created an edgelit effect in the crowd with a white pencil. The overall effect of the frame is striking and believable.

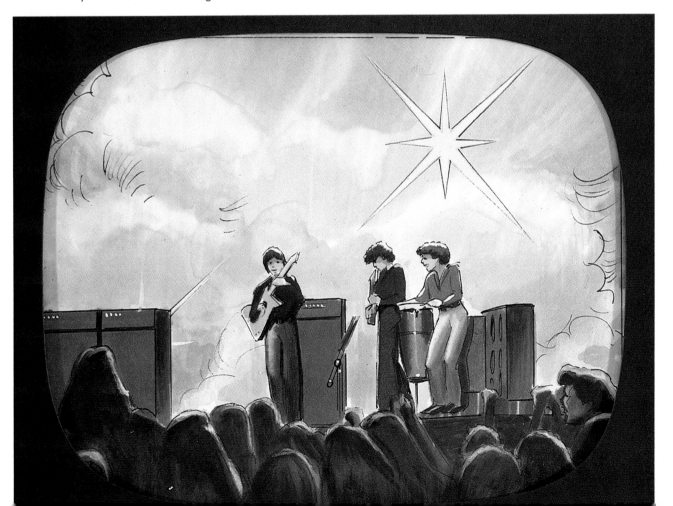

Unlike edge- or toplighting that indicates white light, colored edgelighting must be created from the start in your artwork; you can't simply leave a space uncolored as you would for white lighting. To indicate edge-lighting, I began by applying a red marker to the right side of the musician's body. I moved on to his skin tones next because I wanted to see how they would interact with the stage lighting. I applied a base of flesh, pale cherry, golden tan, cherry, and chocolate, which realistically simulate black skin tones. Chocolate is used in the same way as blush or peach would be for white skin tones: to create shadows, contour the face, and indicate cheekbones.

FRAME 7

This frame offered a good opportunity to show edge-lit concert lighting and to convey the feeling of excitement surrounding the guest musician's performance. Edge-lighting is a popular trend in advertising.

Creating black skin tones is challenging, but if you stay with the following colors in the order given, you can't diverge too far from reality: flesh, pale cherry, golden tan, cherry, and chocolate. For this frame, the farther I moved away from the musician's face, the less color I used. On the arms, for example, I began with golden tan. As I progressed in the drawing, I applied delta brown over the skin tone to darken it. However, I needed to temper this effect, so I turned the paper over and applied vermillion to the back for warmth.

I created his hair with the color chocolate; for black hair, a dry marker is unnecessary. The musician's hair is edge-lit, and he is backlit principally by red lighting, with some purplish blue lighting also subtly apparent. To help capture the lighting effects, I added ultramarine as a base background color and purple sage

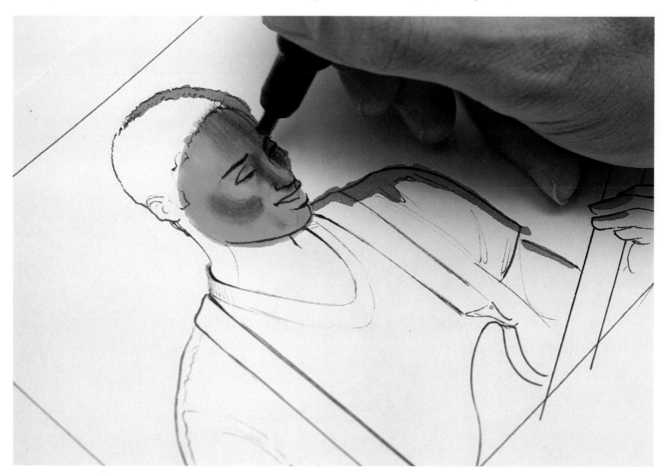

I continued working on the musician's skin tones, forgoing the usual base of flesh marker for his arms because they are in shadow. Then I decided to add more red edge-lighting to the left shoulder region of the musician. I moved on to his hair and applied the color chocolate, which I later darkened with black marker. There is no need to use dry markers when rendering black hair. I also applied an undercoating of purple sage to the musician's shirt.

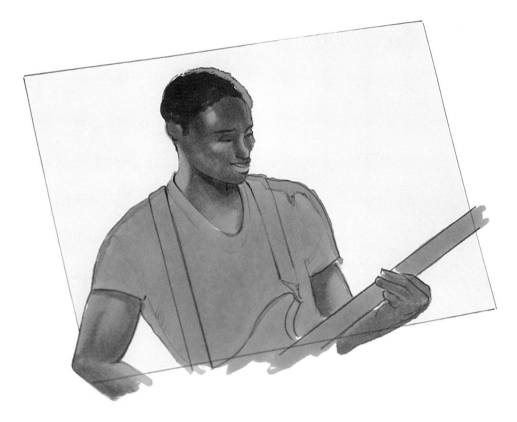

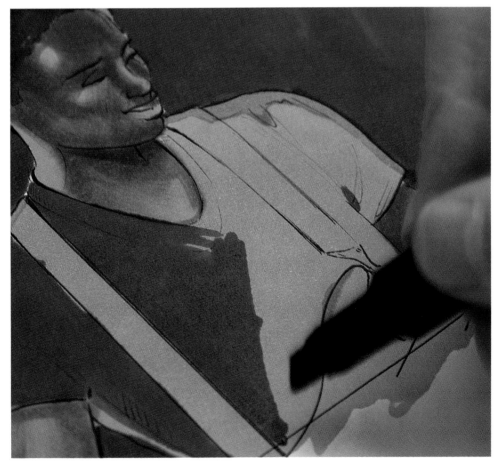

I added a base background color of ultramarine and followed with Dutch blue. I then applied the same Dutch blue to the musician's shirt, but preserved the edge-lit color and let some of the purple sage show through. The similarity of color between the background and his shirt gives the edge-lighting more punch.

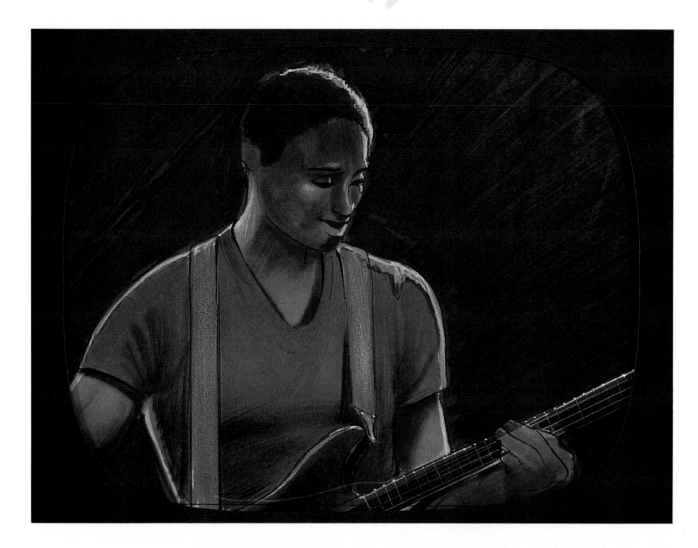

as undercoating on the musician's shirt. Next, I added Dutch blue over the background color, allowing a little ultramarine to peek through, suggesting a curtain. To interrelate colors further, I applied Dutch blue over the musician's shirt as well.

To draw attention to the guitar, I coated it with midnight blue. In order not to color in the guitar strap, however, I used bond paper as a mask. I followed this with white gouache at the edge-lit side for a crisp accent. White pencil provided highlights in the darker guitar areas; a very sharp white pencil—applied using a ruler edge to keep lines precise—provided a medium-strength reflection along the guitar strings. To heighten the edge-lit effect on the musician, I added white pencil to the other halo of edge-lit colors. Gouache would have been too bright for such a subtle, blended effect. To give the frame more depth of value, I added dry cool gray #9 marker in shadowy areas. The result is warm and cool, dark and light.

As I worked, I continued to alter the musician's skin tones slightly to make them work better with the background and his shirt color. I darkened his skin a bit with a delta brown marker but warmed the effect by turning the paper over and applying vermillion over the skin areas. Also, I applied a light-purple-colored marker to the left area of the musician's body, along the edges. I then colored the guitar midnight blue—a nice contrast to the other blues. To make the guitar look more realistic, I drew precise lines with white pencil, using a ruler as a guide to indicate strings. For final dramatic accent, I followed with a touch of white pencil on top of the guitar and some dry cool gray #9.

As I did with the woman in frame 5, I needed to undercoat this musician's hair and skin with purple sage so that these elements would not look too brightly lit. I decided to also undercoat the microphone and guitar so that everything in the frame would have the same base color. Then I turned to the skin tones, beginning with flesh and moving on to blush and peach. I didn't start with pale flesh because the lighting is so subdued compared to sunlight or ordinary indoor lighting. I also added blender on the cheekbones.

With this musician's skin tones well under way, I moved on to his hair. I gave it a glossy, highlighted look by drawing in a linear style with dry wheat, cherry, redwood, burnt umber, and delta brown and leaving uncolored, white areas—this creates the sheen. Then I coated the background with ultramarine and violet on both sides of the paper, being careful to dot the color around the musician's head so as not to create an unnatural-looking break between it and the rest of the scene. On the upper areas of his clothing, where the light hits, I used ice blue.

FRAME 8

This frame zooms in on the musician situated on the left of the stage. His hair color and the background have shifted slightly as a result of the concert lighting, which is constantly changing. The background is a deeper color, while a bright spotlight on the musician lightens his hair color slightly.

As before, I gave the scene an undercoat of dry purple sage. I didn't bother with undercoating for the microphone cord, however, because it is simply a dull black. Then I moved on to the musician's skin tones. But this time I didn't start with the pale flesh marker because he was under very artificial light. Instead, I began with flesh and worked up to peach; at that point I applied blender to his cheekbones to create highlights. I used dry burnt sienna to show features on his face. Later, I went over his face with flesh, then blender, and then peach to warm the tones.

For the microphone, I used a dry black marker, which imparts a softer effect than a wet black marker. I then drew wisps of black in the midsection of the microphone and left white space around the edges to indicate that this object is metallic and reflective. To further this illusion, I applied a touch of blue.

I coated the back side of the paper with ice blue—as used in frame 4—to simulate concert lighting and also because I wanted to darken the entire scenario slightly, including the face.

Five dry markers played a role in the musician's hair: wheat, cherry, redwood, burnt umber, and delta brown. As before, I drew the hair in linear fashion to achieve a layered look. I created highlights by drawing toward the light source. The use of several colors added complexity to the hair and made the highlights all the sharper. In addition, when I laid down the background colors, I was careful to dot along the area surrounding the hair, again to avoid a smooth line that would impart a helmet look. For irregular elements such as hair, the background should always look a little imprecise.

To create the background color, which has deepened as a result of the spotlight concentrating directly on the musician to the exclusion of all else, I used ultramarine and violet on both the front and back sides of the paper and then coated the front side with navy.

I moved on to the clothing, applying ice blue to the parts of his clothing meeting the light source and then overlaying blue violet to create a gentle lighting effect. Then I went back over the clothing with the same colors to bleed out the blue violet a bit.

Next I worked on the microphone. Because shiny materials like metal require high contrasts—dark areas next to light areas—I colored the microphone a dry black to create a "feather" effect. (In general, matte things show more color gradation, which means that the transition from one color to another is more subtle; this doesn't necessarily mean that you need more colors to depict matte objects—you simply use colors that are more closely related.) I also applied a hint of blue on the microphone to indicate reflection light.

For the finishing touches, I opened the musician's mouth a bit using the black Pilot Fineliner. I then applied white pencil on his teeth because white gouache would pop too much against the dark background. I moved on to the microphone cord to apply a few more white pencil highlights, small yet attractive touches that really made a difference. Using gouache, I also added finishing touches to the guitar.

I deepened and added complexity to the musician's skin tones by indicating facial features with dry burnt sienna. Then I warmed the entire face with flesh, followed by blender and peach markers. I also colored the microphone cord black and used a black pen to open the musician's mouth a bit more. I followed with a touch of white pencil on his teeth, in the spotlights, and on the microphone to create a subtle shimmer throughout the frame. I opted to use gouache on the guitar, however, as the light is hitting it directly and is creating a more intense shine.

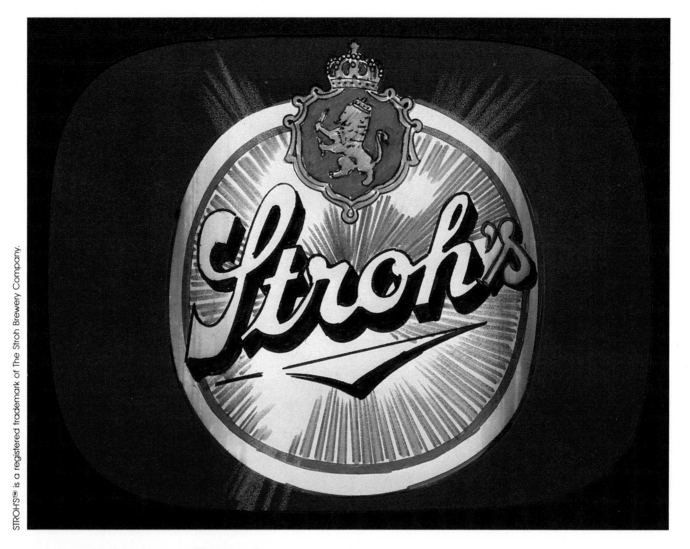

Whenever you need to create a replica of a product label, it's a good idea to make a machine copy and apply water-based or some brands of alcohol-based marker directly on the copy. However, you can also use a light box to trace the machine copy so that your choice of markers isn't limited. I chose the latter option for this frame. I used a black pen to fill in the lettering details and colored the other elements red and gold. To unite the frame with the rest of the storyboard, I used deep-toned blues for the background.

FRAME 9

Having grabbed the viewer's attention with this variety of images, the advertiser now presents its product. This frame boldly gets its message across simply by showing the Stroh's name.

For this frame, I made a machine copy of the Stroh's label and traced it on a light box. I filled in the details with a black pen and created the product crest next with red and gold. To create the radiating streaks of color surrounding the lettering, I used a gold marker and extended the lines beyond the product with a white pencil. The background is ultramarine tempered with midnight blue. The cool blue colors and the warmth of the red-and-gold crest interact pleasingly.

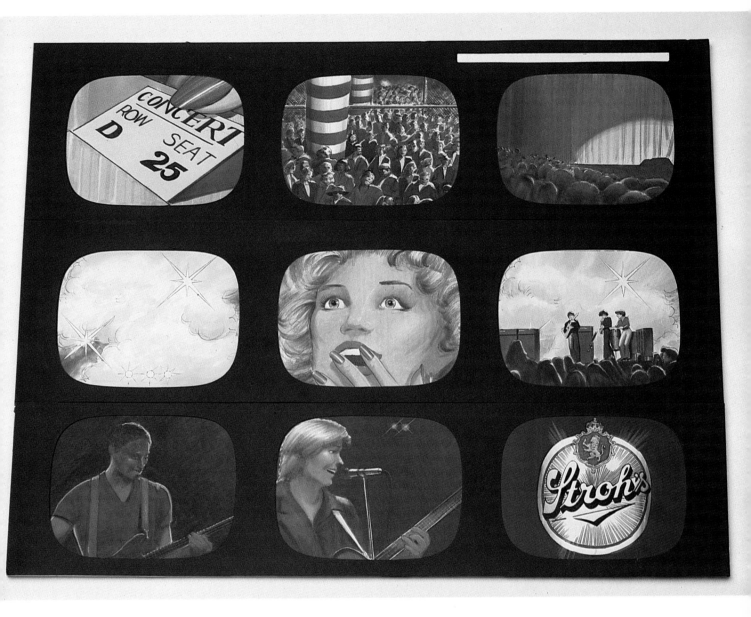

The completed storyboard is mounted in a storyboard frame. When viewed together, the frames have even more vitality than they did individually. This is because the images vary so greatly in content but were all created in the same spirit. Variations of color between frames pop off of one another, and yet the whole is united by use of the same general family of colors.

ANIMATICS: MAKING DRAWINGS MOVE

An animatic is artwork, made up of loose pieces and often several backgrounds, that is used in conjunction with a video monitor to show how a commercial will actually progress in terms of movement. It is shot with a video camera. Usually, the camera stays stationary or simply moves up and down to zoom in on the art, and the animatic art moves on an art stand—a horizontal surface beneath the camera that is able to roll back and forth. Animatics are accompanied by soundtracks and announcer voice-overs in order to simulate commercials as closely as possible.

They differ from storyboards in that the artwork is not static and is capable of being viewed in a number of positions against various backgrounds.

Animatics are particularly challenging to the artist. Not only must you quickly create artwork that depicts a product and several scenarios but you must also imagine how a camera pan will interact with the art; you must envision your art in cartoonlike motion. While the techniques for creating the art are the same as for comps or storyboards, there are additional sets of rules that you must learn that have to do with the technical aspects of filming and editing with video.

The Process

For animatics, a camera must pan across the art in order to create several scenes in one; in other words, your art becomes a "set" that can be shown from a variety of distances. The size paper you use is based on how the camera must interact with the art. For the project depicted in the following pages, the paper is 5 x 7 inches; in general, the art director will specify the art size for you, or the video house you are working with will tell you their maximum and minimum sizes. For example, Ellen Olbrys, a producer at Charlex—the New York-based commercial, special effects, and animatics specialists—says, "The largest you really want to go is 18 x 24. Camera area is usually 5 x 7 bled up to 8 x 10. If you need to do a long pan, maybe you want 11 x 14.... The smallest artwork we can shoot is about 3 x 4. But that means we have very little room to move on it. The artwork is not going to hold up that well—most people's lines don't hold up if they're blown up. The [closer] you go in on [the art], the more you

see the breakup in the pen line, so you don't really want to go smaller than 4 x 5."

Just as with comps and storyboards, an art director will provide you with thumbnail sketches showing what elements to include in your artwork and how they should generally look, or you may receive a final storyboard (created as described in the previous chapter), though oftentimes the same artist will be selected to do the animatic and the storyboard. After you trace the art director's sketches or receive the storyboard, you are ready to do your pencils. Your visual reference library comes in handy at this stage. For the animatic in this chapter, which was based on an art director's sketches, I consulted several sources to find the right facial expressions for the little girl and to establish the right looks for the supermarket and kitchen.

As you create your pencils, mentally rehearse how you are going to color in your animatic to depict such elements as light sources and to achieve a pleasing

balance of warms and cools. Also keep in mind that too much white tends to "flare" out under a television camera, so you should avoid creating areas of white. Olbrys cautions, "Burnt sienna and salmon are colors that make people's faces turn really red under the camera, and sometimes for the highlights on their cheeks [artists] go back and blend out all the color so it looks [too] white." This means that for animatics, the artist has to make flesh tones that are not as deep and dramatic as for storyboards and comps. Olbrys recommends coloring most of the face with pale flesh and flesh, with a little shadowing done with peach or some blush, and then returning to the face and blending again with flesh and pale flesh to eliminate hard lines—just as a woman might put on makeup.

The camera tends to simplify artwork, producing unintentional color contrasts that may end up looking unnatural. Film has a very wide gray scale, capable of faithfully capturing many color nuances. Videotape, by contrast, has a much shorter gray scale and can't as readily accept sharp contrasts. This presents a problem for artwork. Charlex solves this problem by changing the artwork in-house. Says Olbrys, "We do a lot of altering of artwork once we get it here. We have pastels, markers, pencils, and grease pencils—we've saved a lot of artwork once it's come in."

Another major pitfall for animatics artists is the choice of colors in the art. The primary colors used in video systems are usually red, green, and blue. The artist must keep one of these colors in reserve and not use it—or any color close to it—for pieces that have to be keyed, or matted, on the background that the artist has drawn. Pieces that move must be keyed; such pieces are photographed separately on a background of Pantone-type colored paper. For example, if the arm of a person in an animatic moves, the arm has to be shot in varying positions against colored paper. If the sleeve on the arm has the colors green and red in it, then blue paper is chosen for this background. When the arm is keyed to the artist's drawn background (such as the kitchen or supermarket in this chapter's example), an animatics editor activates a video-generated signal, called "chrominence keying," to drop away the blue background. Not only does the blue background drop away, but *any* blue in the keyed piece (in this case, the arm) drops away; if the sleeve had blue in it, the blue would also drop away.

David Rothenberg, an editor at Charlex, explains, "There are several ways of compositing images, which is basically what you're doing. You're taking different levels of artwork—backgrounds, midgrounds, foregrounds—and putting them together." Rothenberg offers a solution for the problem of artists using the wrong colors. "We give the artist a piece of our green, red, or blue [Pantone] paper and say, 'Just don't use these colors. Do a green that's far away from this green and a blue that's far away from this blue.' " Rothenberg points out that it is at this stage that the producer's input is crucial, because he or she will have to ensure that colors aren't too close so that the art can be properly matted.

As you work on an animatic, think about how a camera might approach your art and be sure to add enough details to make each area of your animatic distinctive. To give your animatic a realistic look, make sure you establish a vanishing point for each scene. Because you are working quickly, you might violate the laws of perspective ever so slightly, but try to adhere to the vanishing point.

Scale is another important factor to keep in mind. Even an untrained eye will notice when something is out of proportion. If a product is out of scale in an animatic and no additional camera moves are needed, then scaling is not a problem. But problems arise when an editor has to match two camera moves, which is often the case. Olbrys offers the following as an example of the importance of proper scaling. If a box stands alone on a video-generated background, it doesn't need to be in scale. But if a woman has to hold it in her hand, that product needs to be in scale with the hand. If the art director were to decide to have a wide shot followed by a tight shot on the product, a dissolve would be the solution.

If the art director objects to a dissolve, however, that's when the production house must take extra, time-consuming steps. One camera would have to shoot the woman, while a second would shoot the box in a scaled-down size by pulling the camera back to make the product look smaller. Then, the editor would have to key over the woman's hand and make a mat. Next, the editor would fit the box into the hand and put the fingers back over the box.

Because scaling is so time-consuming it is also very costly. For this reason, artists should always make an

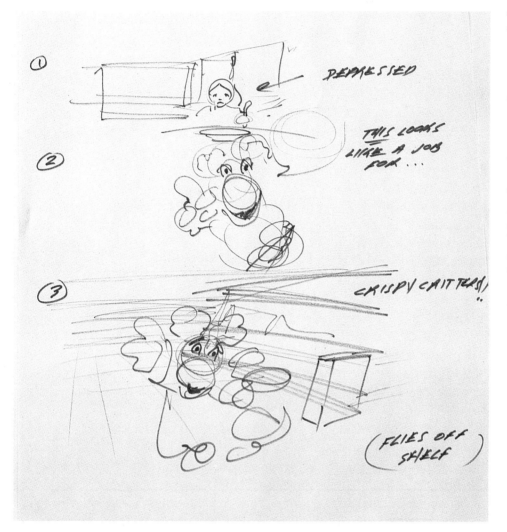

DEPRESSED

THIS LOOKS LIKE A JOB FOR . . .

CRISPY CRITTERS!

(FLIES OFF SHELF)

This art director's rough series of sketches for an animatic shows in a numbered progression the order of the action in the artwork. Sketch 1 shows a little girl sitting in her kitchen and apparently unhappy with her breakfast cereal. Sketches 2 and 3 switch to another location. The second drawing shows in general how the critter's head should look. The third sketch places the critter in the supermarket, where he is apparently removing a box of cereal to come to the girl's rescue.

attempt to draw the different elements of art in scale. Sometimes a product might have to be drawn in several different sizes to fit in at different points in the animatic. You might have to do as many as eight drawings of a product. For example, a very tight camera shot of a product is known as a "beauty shot" and usually comes at the end of an animatic to show the product up close. An illustration done for this purpose would have to be fairly large and detailed. Meanwhile, you might also have to create a number of other depictions of a product, some very tiny and crudely done, and others scaled to the proper size for a person to be using the product.

Rothenberg points out the importance of timing dissolves exactly right in animatics, something that creates persistence of vision, the illusion that motion is actually taking place. Dissolves soften motion, while cuts from one frame to another and back again produce a jerkier, more rigid motion.

Another aspect to consider is the use of video manipulators such as Ampex Digital Optic, or ADO. Such a device can take video and manipulate it in a way similar to the way a camera or a live object could be manipulated—but it's prerecorded. It is able to make a smooth motion or any motion desired. You can create the effect of a shadow of a bird following a bird on the ground, for example. First you create a mat of the artwork. As you move the bird, or the fill, you can have a silhouette, or the mat, of the bird do the same move so that it can then be composited. Two signals are being manipulated simultaneously by the ADO—the bird and the silhouette. They move together.

Animatics are valuable because they show exactly how a commercial is going to look without the need

for actually producing one. Says Olbrys, "Most animatics are a tremendous learning experience for art directors to see how their commercials are actually going to look. You think you know what it is going to look like, but until you actually see one scene cut next to the other one or dissolved into the next one, you don't know what [the result] is going to be. And it really makes you structure your thoughts and see the flaws or the plusses in your idea. They're a really useful tool."

After they are completed, animatics are tested in malls or in focus groups. For example, a group of people might watch a reel filled with a number of things, including television shows, and the animatic in lieu of a commercial. Afterward, the group is asked about the commercial and the purpose of the product or service advertised. If the message of the animatic is conveyed, it stands a good chance of going on to become an actual commercial. If possible, visit an animatics house to see how the final product looks.

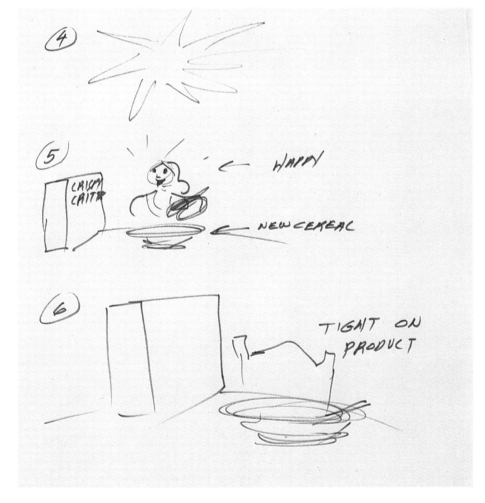

The art director's fourth sketch represents the sudden appearance of the critter in the girl's kitchen. Sketch 5 depicts the girl with a happy expression in response to the appearance of the critter and the new cereal. The final sketch indicates a tight shot of the product sitting on the kitchen table. When an art director gives you rough sketches for an animatic, he or she must also specify how many and what types of pieces of loose art you must create. Of course, the more pieces of art you create for a job, the higher your fee should be.

Step-by-Step Assignment

I have chosen to present an animatic created for Post Crispy Critters breakfast cereal because it is lively and involves two very different environments: a kitchen, which is a warm, cozy space, and a supermarket, which has a very open, unbounded quality. Many of the trendy, high-energy commercials seen on television today shift between two or more contrasting scenes like these.

For this animatic, there are two background scenes and several pieces of loose art: the little girl's head, with two expressions; her body, which is connected to the table so that an art director can move the entire foreground at the same time; the bowl, before and after; the critter; the critter's head; and the cereal box.

The heads of the girl and the critter are not connected to their bodies, so they can be moved separately to further the sense of animation.

The commercial begins with the little girl sitting in her kitchen looking depressed because she doesn't like her breakfast. Then the scene shifts to the supermarket, where the yellow critter, which is depicted on the cereal box, has apparently taken a box of cereal from a well-stocked shelf and is catapulting it into the air. In the next scene, back in the kitchen, the critter appears, followed by the box and the cereal. The expression on the girl's face changes from sad to joyful, and her cereal changes to the advertised product.

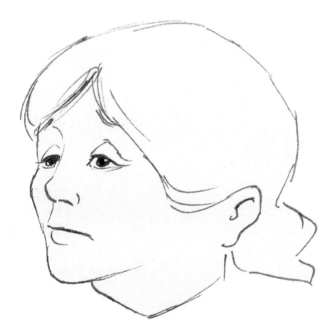

This inked-in drawing shows the little girl's expression when she is depressed at the beginning of the animatic. It was necessary to draw this head separately from the happy face so that one can be substituted for the other without the artist redrawing the entire body.

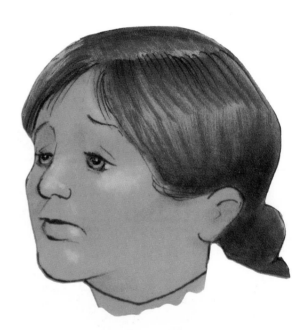

Colored in with markers, the depressed faces takes on an even more expressive look. To render the girl's skin, I used pale flesh, blender, blush, and peach—eliminating the flesh marker normally used for adults so that her skin would have the pinkish cast, characteristic of children.

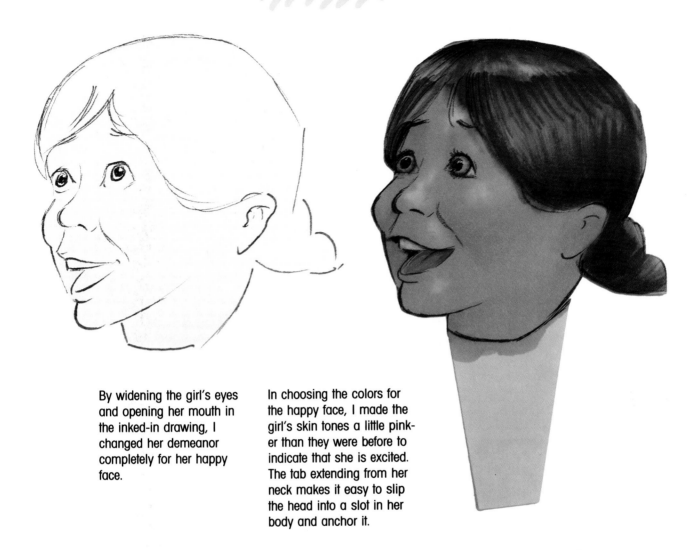

By widening the girl's eyes and opening her mouth in the inked-in drawing, I changed her demeanor completely for her happy face.

In choosing the colors for the happy face, I made the girl's skin tones a little pinker than they were before to indicate that she is excited. The tab extending from her neck makes it easy to slip the head into a slot in her body and anchor it.

The little girl's body and the tabletop are connected so that they can easily be moved together. Note the plain-looking cereal, which will later be replaced with the advertised product. Although it is difficult to discern, there is also a horizontal slot in the collar area of the girl's body into which the two different heads will be inserted.

COLOR SELECTION

My first consideration in bringing all of this together was the Crispy Critters cereal product. Because the packaging had red and yellow hues, I needed to work with related colors, while also adding a few cool colors to balance this warmth. Therefore, for the kitchen scene I created a blue tabletop, done with flat sweeps of marker, for the foreground. I gave the little girl a red outfit, and colored her face in with flesh tones and I chose sunny, warm colors for the kitchen. I used cooler colors for the supermarket to create a sense of vastness. The tiles on the floor and ceiling are cool gray, while for the most part the products, including the Crispy Critters boxes, are warm. The cereal box and the yellow critter had to interact with both these scenes; in the supermarket, their colors "pop," which excites the eye; in the kitchen, they harmonize with the surroundings, while the girl's overjoyed expression provides the needed measure of excitement.

I also needed to apply special techniques to create specific effects. For example, when I rendered the bowls of cereal, I used a pen with brown ink because it's more appetizing than black. With food, it's best to ink it in using the color closest to its actual color.

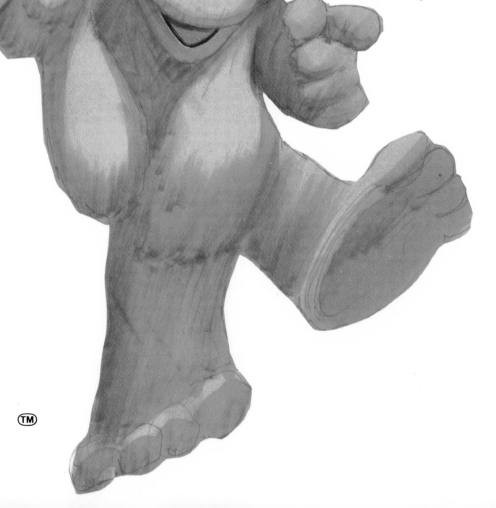

This drawing of the critter captures the main ideas of the art director, as presented in rough sketches, but is a more solid and complete version of the character. When colored in, the critter really comes to life. His sunny, bright, coloration works well in both the supermarket and the kitchen. In the store, his warmth really pops against the cool blue-gray background. In the kitchen, he is right at home with the yellow walls and the cabinetry.

(TM)

THE CUTOUTS

I cut out all the loose pieces using an X-Acto knife. When you cut out art for animatics, be sure to leave the pen outline on the loose art, as this creates a finished effect favored by art directors.

For the girl's heads, I extended the lines of the neckline to create triangular-shaped tabs. These allow the heads to fit snugly into the girl's body, creating a realistic-looking effect. I didn't bother to do a tab for the critter's head because his body is not anatomically proportioned and his head can be moved in a number of positions without detracting from the animatic.

I detached the critter's head with an X-Acto knife so that it could be moved to further the sense of animation.

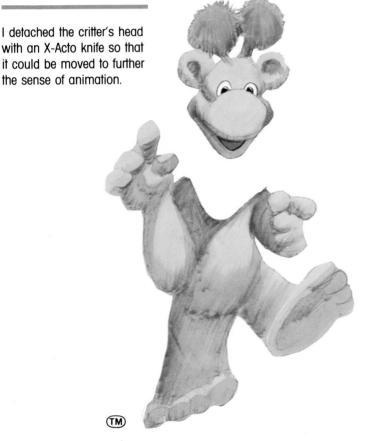

I didn't cut a tab for the critter's head because, unlike the little girl's, his body is not intended to look like a human one—for example, he has no neck—and his head need not move like a human one. Also, no complicated animation was planned; the critter's head was only required to make small, subtle moves such as looking back and forth between the product and the girl.

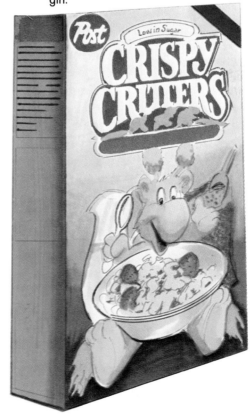

The artist's first consideration in rendering artwork is making the advertised product look appealing. In this case, warm colors—red and yellow—dominate the product box. These colors dictated which ones I used for the rest of the animatic. I chose a warm palette for the kitchen and a cool one for the supermarket to create a balance. Note that I rendered the cereal with brown ink rather than black to make it look as appetizing as possible. A range of beige and brown tones also gives the cereal dimension and makes it look crispy.

POST® CRISPY CRITTERS® cereal is a registered trademark of General Foods USA.

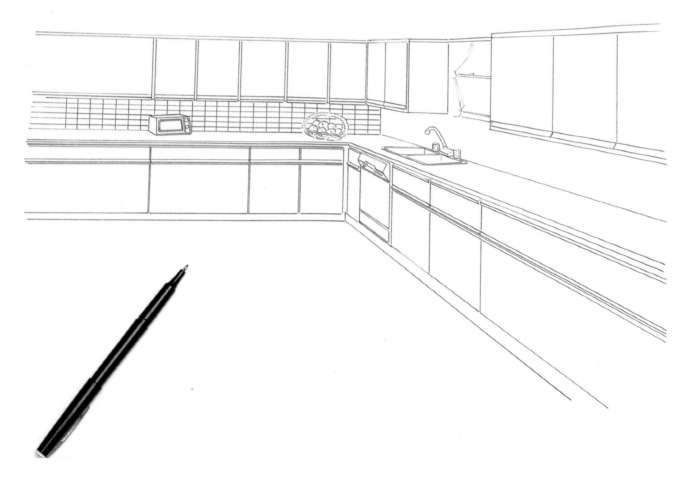

Without a carefully rendered drawing of a scene that puts all elements in perspective, artwork cannot possibly look realistic and convince a client. In drawing this kitchen background, I observed a consistent vanishing point. To make the scene look as authentic as possible, I also consulted my reference file extensively so that I had a selection of streamlined, contemporary kitchens to use as models.

BACKGROUND 1

I created a variety of surfaces for the kitchen scene. First, I established the light source at the window. I drew away from the light source with blender and then quickly went over it with maize to create smooth, even sweeps on the ceiling. Then I moved on to the cabinets; I wanted it to make them look like wood and at the same time indicate that light from the window was spilling across them. To create this illusion, I drew across them diagonally with blender, followed by maize, wheat, and pale cherry. The cabinets on the left side of the kitchen are shinier than those on the right because they are receiving more light.

By contrast, the tile work above the kitchen counter is even more reflective than the cabinets, so I allowed a little more white space to "shine" through. Moving on to the window, I laid down copious blender followed by frost blue to indicate the sky. So that the blue would not be too strong, I added more blender over it to remove some color. I didn't bother to complete the curtains because they are diaphanous and a fairly

I created the illusion of light streaming through a kitchen window by drawing diagonally away from it with a blender and then applying more maize directly on top of it. This creates smooth, even sweeps. I also added blender to the window area and followed with frost blue. As I worked, the colors of the kitchen began to interact more, and so I decided to go back to the window to blend out more color from it and the counter area.

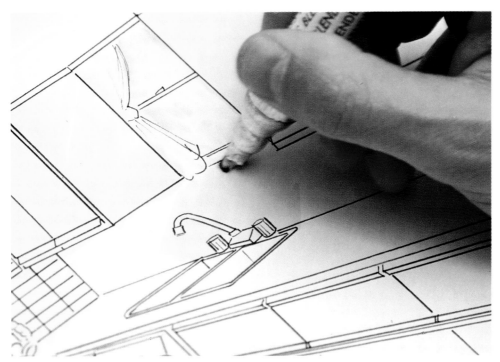

The strong use of blender around the window area followed by almost vertical strokes of maize both indicates a light source and illustrates the reflective properties of the counter. I added a bit of frost to the sink to emphasize its metallic quality. Always carefully consider how surfaces actually look when light is hitting them when coloring in your artwork.

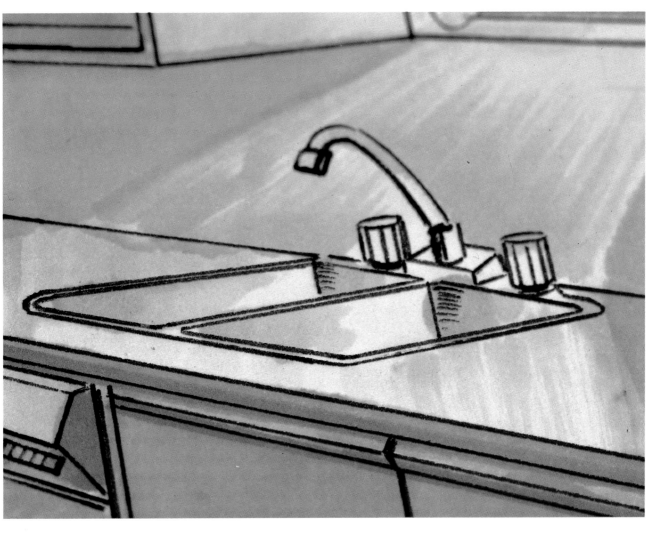

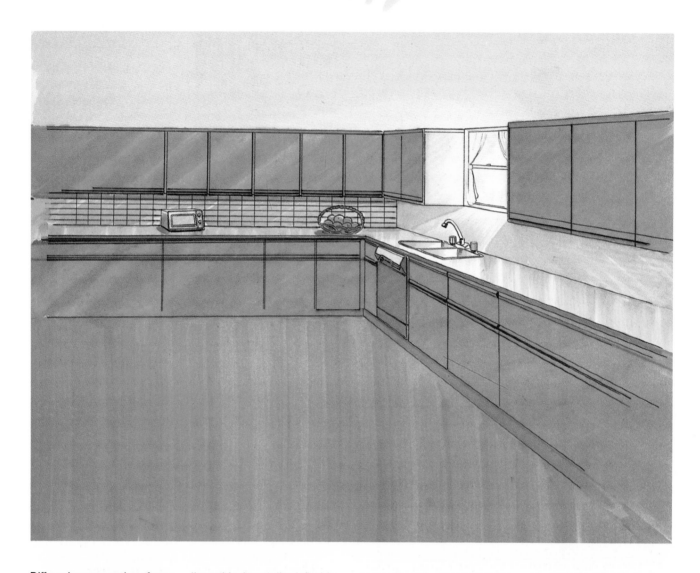

Different areas and surfaces of the kitchen received different marker treatments. The ceiling is composed of diagonal maize sweeps. The cabinetry, which must not only look like wood but must also look as if light were pouring over it, was created with diagonal strokes of blender followed by maize, wheat, and pale cherry. There are more open, "streaky" areas on the cabinetry on the left side of the kitchen because that area is receiving more light. The countertop is very reflective, with light areas between vertical streaks of color. The floor, which will be largely hidden by the tabletop, consists of vertical sweeps of the same colors used for the cabinetry. I kept the floor simple because I didn't want it to compete with the rest of the artwork.

insignificant element in the animatic that I didn't want to spend time rendering. I also added blender to remove color from the edge of the counter facing the window because that's where the light was hitting it. I was careful not to make the contrasts between dark and light too bright, however. I used vertical strokes of maize on the countertop to indicate both the light source and the counter's reflective qualities.

For the floor, I simply drew straight up-and-down sweeps of blender, followed by maize, wheat, and pale cherry. Although the floor is largely hidden by the tabletop, it was possible that the art director might move the tabletop, showing more of the floor; I thus drew a complete floor. I didn't make the kitchen floor as shiny as the supermarket floor, so that there would be more variety in the animatic. As a final touch to the kitchen, I added gouache to the faucet, followed by white pencil to diffuse the effect slightly.

BACKGROUND 2

The challenge in creating the supermarket was to work within an established vanishing point and add only as much detail as necessary for the products and the shelves. As with the crowd scene for the storyboard in chapter 4, the scene becomes less detailed as it moves farther back. Everything in this scene seems to explode from the vanishing point, which lends itself very well to animation. I also made the supermarket tiles quite shiny to liven up the scene and contrast with the kitchen floor.

This inked-in drawing of the supermarket background relies on a strong sense of perspective in order to look believable. The prominent positioning of the advertised cereal on the shelf to the right is juxtaposed with the indistinct look of the other products in the distance.

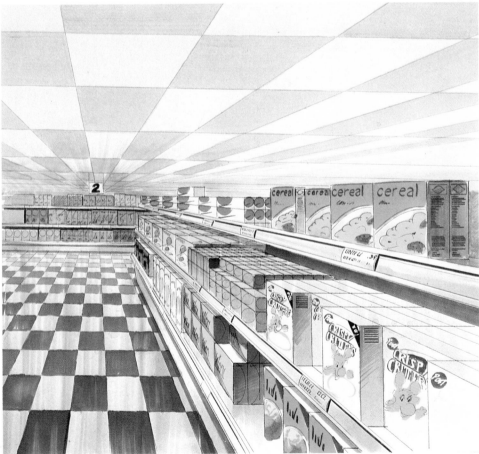

Cool grays as well as a distant vanishing point work together to create a sense of realistic space in the supermarket. Most of the products depicted have warm tones to balance the coolness of the grays. The shiny look of the floor is a result of the white spaces left between marker strokes.

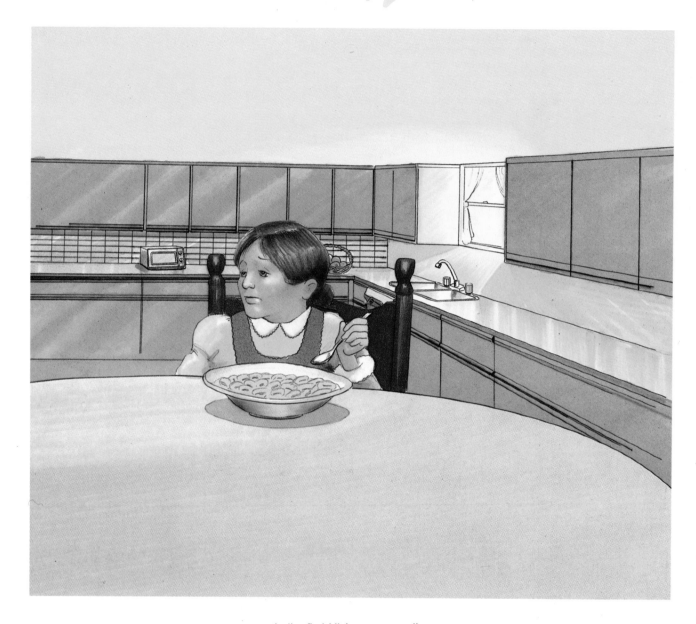

In the first kitchen scene, all the elements come together. The cool blue tabletop pops nicely against the warmth of the kitchen and the little girl. Note the positioning of the little girl relative to the light streaming through the window, a spotlighting effect focusing attention on her.

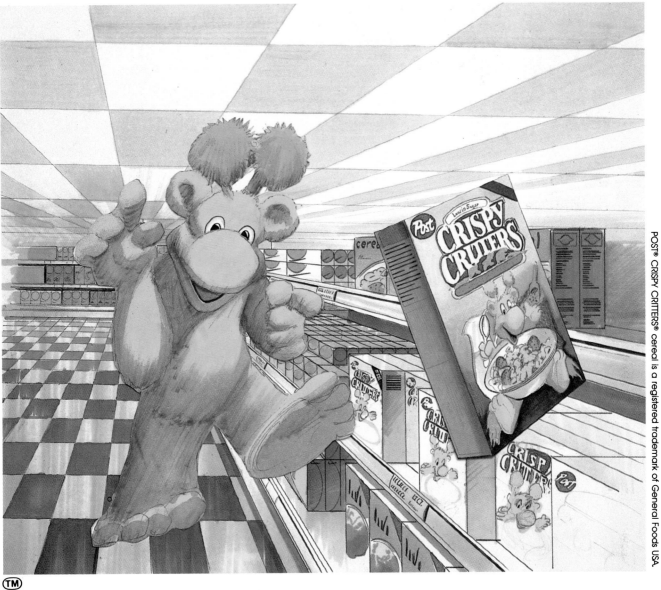

I drew the critter and the cereal box to fit in with the scales of both the kitchen and of the supermarket. Because the box and the critter are loose elements, they impart a believable, three-dimensional quality to the scene to be filmed and look as though they could literally fly out of the frame.

Back in the kitchen again, the little girl's frowning face is removed and replaced by a happy face. The tab allows the art director to bend the girl's head up into an anatomically realistic position. The two additional loose elements—the cereal and the critter—also fit nicely into the scene.

POST® CRISPY CRITTERS® cereal is a registered trademark of General Foods USA.

In the final scene, the little girl's happy face is in place and the critter's head moves to look at the product, which has made its appearance on the kitchen table. The simple sweeps with which the table was colored do not compete with the product and allow the warm and cool colors to pop.

ADVANCED TECHNIQUES

Once you have mastered a range of basic techniques, there are additional methods that you can learn to give your work a professional edge. It is important to keep growing and to expand your expertise so that you can handle diverse subjects. Although some of the seasoned pros do make a living rendering food or cars, most illustrators don't have the luxury of specializing in their favorite area—so you must be able to render a wide range of subjects quickly and accurately.

Most of this section is devoted to step-by-step instructions for some of the most frequently assigned subjects—ones that are often also the most problematic. How, for example, do you depict the comfortable feel and woven look of denim? Or convey a sense of satisfaction on a person's face?

Many artists looking into the advertising field think that depicting hair or flesh tones with markers is next to impossible. They believe that the only medium that can bring such subjects to life is paint. And while it is true that paint captures subtleties, it is also true that markers, when used skillfully, have the remarkable ability to do the same—without the drying time and other complications of using brush and paint.

After reading through the step-by-step descriptions, you may find it useful to make a photocopy of the list on page 135 of which markers to use for individual subjects. But do not rely on this list to make your art look professional: An understanding of how and why certain effects are achieved will help you go beyond your subject matter to create art that is all your own.

CHAPTER SIX
PROFESSIONAL TIPS

Many novice comp, storyboard, and animatic illustrators believe that doing a good job means expending as much time and energy as possible on an assignment. This is not only untrue, it is also counterproductive. This chapter focuses on how to add those few finishing touches to artwork to make it look professional without spending vast amounts of time on the perfecting process.

Another vital skill is the ability to alter art once the art director has decided to change a particular element. Again, this does not mean that you must rework the entire piece to get the result you want—all you have to do is patch one piece onto another, as described on page 100.

By learning and mastering the techniques outlined here, you will be able give your work that air of professionalism that sets it apart from the rest.

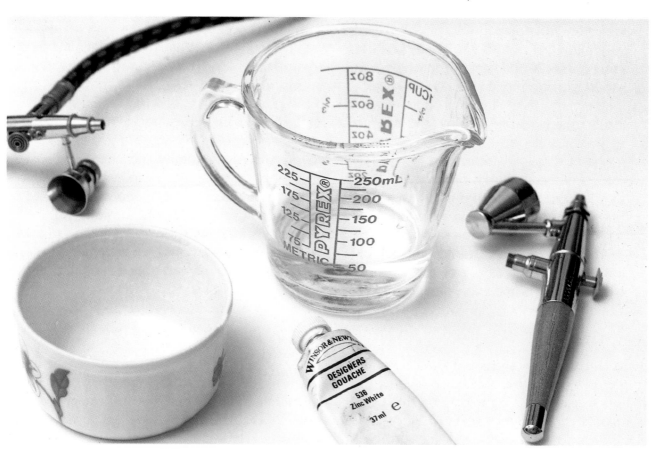

I sometimes use a traditional airbrush to color artwork. This extremely versatile tool allows you to apply gradations of colors—from a fine mist to complete coverage—by changing tips.

You must water down paint for use in an airbrush, and it is important to get the consistency right. It should be fairly thick, similar to heavy cream, but if it is too thick it will not flow easily through the airbrush. It cannot be too thin either, or you'll end up wrinkling your artwork with a stream of watery paint. By all means, test the paint flow on a separate piece of paper before applying it to your art.

Airbrushes

Although they require extra time for preparation of ink and cleanup, airbrushes are well worth the effort. They allow you to spray color, in the form of ink or paint, onto a piece of art. They are an extremely versatile tool: You can use them to apply subtle touches of color or to completely cover a large background. With some airbrushes, you can produce a broad or fine spray simply by changing the sizes of the tips and needles. You can also custom-mix colors to achieve the shade you want, which you can't do with most markers.

A drawback to using an airbrush is that paint can become airborne and you could end up breathing in hazardous pigment. To eliminate this hazard, I recommend wearing a respirator—available at most art-supply stores—when using an airbrush (or a marker airbrush, described below). Always keep your studio well ventilated and try not to breathe in the fumes.

When mixing paints for use in an airbrush, make the consistency similar to that of heavy cream. If it is too

thin, the airbrush will simply spray out water colored slightly by the paint; if the paint is too thick, it will clog the apparatus. Prepare as much paint as is necessary for the job. Don't skimp if you are going to cover a large area; mix plenty of paint to get consistent color.

Airbrushes operate by pumping a spray of ink or paint from a side or top cup. Simply put, you control the flow through a valve: As you press down on it, you release air; as you pull it toward you, you release ink. Airbrushes are usually powered by compressors, although some models are turbine-charged. But the freelance artist who just needs to add a few highlights or create a small background on artwork will most likely opt for the aerosol can. This device, which is specially designed to be hooked up to an airbrush, is easily transported and will provide power for about four hours of continuous use.

I also recommend owning a marker airbrush. It is less trouble to use than a traditional airbrush because

Marker airbrushes are easier to use than traditional airbrushes because you need not mix paint. All you have to do is attach a marker to the airbrush device. The main drawback is that you can't custom-mix paints to achieve a particular color. I always test my marker airbrush on a separate piece of paper from my artwork to get an idea of how ink is flowing through it. Here, I'm testing one before I use it to create a subtle shift of color from the horizon line to upper regions of a sky.

the color is drawn from markers that are hooked up to a special type of airbrush, eliminating the need to mix colors. The disadvantage is that you can't cover very large areas with it. If you use up one marker and try to complete the job with another that is supposed to be the same color, you may discover slight color variations between them. Therefore, marker airbrush is best used for small touches. Both Pantone and Faber Castell offer marker airbrush systems.

When used sparingly, airbrushes create a slight shift in color in a piece by adding a subtle spray of paint. I prefer to apply airbrush paint in small gradations so as to slowly build an effect. The results can vary. For example, for an effect like clouds, you want to create

soft edges. By applying white paint over a bright color, however, you are emphasizing color contrasts to produce a lively effect.

After you have prepared your paint for a traditional airbrush or hooked up your marker to a marker airbrush, do a sample spray on a piece of scrap paper. This allows you to assess whether the paint consistency and the shade are right. Press the valve and pull back at the same time—the pressure you apply in either direction controls the flow of paint.

Be sure to clean your airbrush by running water through it on a regular basis. Once in a while, you should dismantle it and clean it by hand.

Spray Color

Another option for quickly applying color is canned spray color. Like the airbrush, it allows you to quickly and efficiently apply color to oversize areas. Its advantage is that because most spray color brands aren't water-based, they won't cause the paper to buckle. As with the marker airbrush, color choice is limited because colors can't be custom-mixed, but it's less fuss to use than the airbrush because all the preparation

canned spray color really involves is pressing a button.

I use spray color whenever I can to save time. Many artists find white spray color very useful because it effectively creates gradations and highlights. Matte, glossy, and sparkly finishes are all possibilities. You can also use metallic colors; these are generally opaque and, like metallic paper, are ideal for creating the look of metallic packages.

Greeking

Often the art director will specify where type will appear in an ad and if it is to be flush, ragged, contoured around images, or spaced to indicate paragraphs. "Greeking" is the term for mock type used in comps to indicate the position of the lettering.

To greek a comp, first indicate in pencil the shape the type is going to take on the page. Next, draw pencil lines within the type space. For this demonstration, I used a ruler to draw lines in pencil every quarter inch down the left side of the paper.

Ad copy generally has two main elements: heads and body copy. To represent heads, you can create two parallel lines with a black fine-point pen and then add tight-looking squiggles with the same pen. Be sure to place a straight ruled edge along the bottom of the line you are greeking so that the ink does not dip below the line; be particularly careful not to draw beyond the top edge.

For body copy, you can draw randomly interspersed horizontal lines to indicate words, or you can simply draw one long line. Don't drive yourself crazy creating little letters; this is a time-waster. Greeking merely shows how much space the words will take up.

Sometimes wording is added across the actual artwork in white or some other standout color, either in the form of image-in-transfer (INT) type or with acetate, which gives artwork the look of a finished product.

For this ad copy with heads and body type, I began by drawing in pencil lines for rules every quarter of an inch. I inked these in and erased the pencil. Then I created two rows of squiggly heads with a black fine-point pen, being careful not to dip below the base line and not drawing beyond the top line. To indicate body type, I simply used my ruler as an aid in drawing random horizontal lines to indicate words of varying lengths.

Transfer Lettering

Prepared lettering, backgrounds, and symbols can be real time-savers if you know how to work with them properly. The transfer lettering products offered by Letraset are very useful for creating any kind of generic signage—highway signs, exit signs. You can choose from a wide range of dry-transfer typefaces—some standard, others ornate—as well as numerous logos and graphic symbols.

To use prepared type, make a copy of your art, press the type on the copy using a burnisher or ball-point pen, and make a copy of the copy. At this point, if you want to color in the art, use a water-based marker so as not to affect the copy ink. The effect is tight and sharp—and makes it look like you spent much more time on the artwork than you actually did.

Self-created transfer lettering is another option, and this becomes more useful as you go "upmarket." If you are in a hurry and the project has a big budget, it's more cost-effective for the client to reproduce type for a product by having it shot on acetate in order to produce an image-in-transfer, or INT. These come in a wide assortment of colors. The effect is professional and clean—particularly when applied over a white background—and the technique is quick and easy.

You can also reproduce a label from a product using a copying machine. Thereafter, you can use water-based markers to fill in color. Another option for coloring lettering is to use spray color or marker airbrush.

Transfer lettering provides a finished, realistic-looking touch on artwork. However, if done too hastily, it can ruin the effect you're looking for. Always apply transfer lettering on a hard surface; if you don't, you might break the letters. Apply a burnisher or ball-point pen on the opposite side of the lettering to remove it from the backing. You want to remove the lettering gently; don't bear down too hard—that's how letters get broken. Just pass over it lightly, three times or so, and the letters will go down uniformly without breaking.

For this project, I applied transfer lettering to bond paper, copied it on a copying machine, cut out a rectangle of lettering, and applied the piece over my artwork with spray adhesive. I then colored it in, using a Berol marker because it will not dissolve copying-machine lettering.

Here I used dry-transfer lettering to render a very common typeface quickly. I used a Berol marker directly on the copy and colored in the dressing room door.

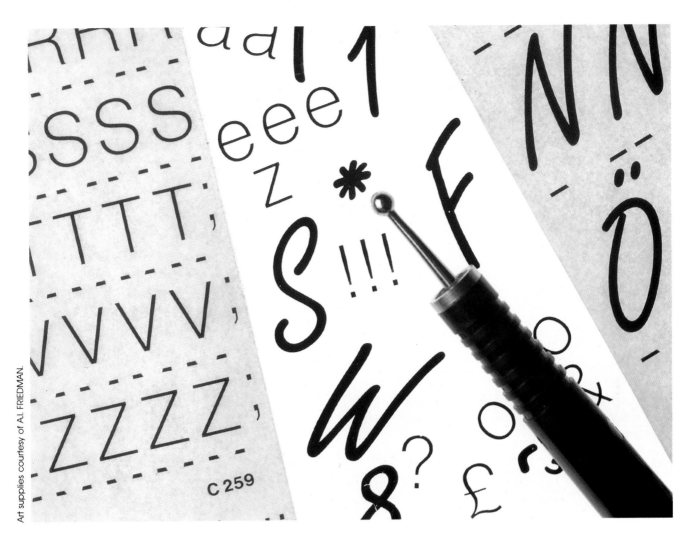

Dry-transfer typefaces are available in a range of shapes and sizes. To use them, make a copy of your art, press the type on the copy using a burnisher—as pictured here—or a ball-point pen, and make a copy of the copy. Then color with a marker that won't affect copy-machine inks.

Patching

After the storyboard frame showing a hand holding a ticket on page 55 was shown to the art director, it was decided that the gender of the ticket holder should change from male to female. Oftentimes such changes are called for—but they do not mean that you have to completely redo a piece. Patching allows you to make specific spot changes to artwork. In this case, I simply traced the image of a preexisting thumb over the art on a light box, applied ink over the pencil, elongated the nail and erased the pencil. I applied color using both marker and colored pencil to create highlights. Then I attached the nail using Spray Mount. The same technique can be applied to almost any element that needs to be changed.

Sometimes, artists make absentminded errors like making the shirt of someone holding a product the same color as the product advertised. Of course, the product gets completely lost in the artwork. In such a case, the art director would ask you to change the color of the clothing to make it pop off the product. Simply trace the outline of the shirt on a light box (or make a machine copy of the old art and trace that

on a light box); color the new art, or patch, another color; detach the art; and apply it over the old art. You may have to double-back the patch so that the color of the old art doesn't show through. To double-back a patch before you cut out the new art, apply Spray Mount on the back of the patch and lay it down on bond paper; then use an X-Acto knife to cut through both layers of paper.

If you are asked to change the expression on a face, you will probably need to patch the entire face, not just the mouth or eyes, because otherwise the patches become too small. Sometimes, you may be asked to change a daytime to a nighttime scene. In this case, you might simply darken the colors of the sky. But if you were asked to change the scene from night to day, you would be unable to bleed out so much color. Instead, you would have to make a copy of the artwork and work from that, if possible.

Most of the time, you will be able to change elements of artwork through patching. Only if a creative or art director decides to reconceptualize an ad will it be necessary to start from scratch.

The storyboard frame on page 55 actually started out looking like this. The art director decided to change the gender of the concertgoer— as reflected by the thumbnail—from male to female.

To make the switch from a male hand to a female hand, I traced the thumb on the light box and lengthened the nail. Then I colored it in with various red markers in bold linear strokes. I left white space in the center of the nail to further the sense of shininess. Using an X-Acto knife, I cut out the nail from the bond paper.

I applied Spray Mount to the back of the nail and attached it over the preexisting nail. Patching saves you the trouble of having to redraw and recolor an entire page of artwork, so whenever possible, try to accommodate an art director's changes with this technique.

SUBJECTS

Knowing how to depict a variety of visual subjects and qualities—from light and reflections to hair or wood grain or even cuteness—will help set you apart from other comp artists. Have samples of a wide range of techniques in your portfolio. Even a mastery of balancing warms and cools or simply being able to bring a new visual twist to an old topic will capture an art director's attention.

Drawing is key to your ability to depict diverse subjects. Do not assume you know how to draw something because you see it often; instead, reexamine everyday objects and phenomena with a scrutinizing eye.

Understanding color is also critical to your success in portraying different materials and textures. For example, shiny, reflective things like metal have sharp color contrasts and highlights; matte objects are more graduated in color. Every color is made up of many hues. A sky is not simply sky blue. Hair is not just brown, black, red, white, or yellow. You must learn how to mix colors to create realistic-looking art. Also, as you work, pay attention to how colors interact. I frequently turn my art upside down as I'm working to see objectively if any one color jumps off the page and, if so, to make sure that this is the color I want to emphasize.

Although I provide step-by-step instructions for the subjects rendered in this chapter, you will find that with experience comes an intuitive understanding of how to render objects in terms of color and line. I often carry a small pocket-size sketchbook around with me in which to make quick drawings of people and environments. Whenever I'm in a situation in which I am kept waiting for long periods of time, such as in an airport, I find that sketching is a good way to pass the time while polishing artistic skills. If you sketch on a regular basis, the body of work will add up, and it can be used as reference for your professional work.

For artists who are truly comfortable with what they're drawing, an understanding of how things are put together comes across: Something is seen, understood, and conveyed almost effortlessly. There is no wasted effort—not one wasted marker stroke. Certain subjects become rather routine; it is up to you to know when to improvise within basic formulas.

Skies

Knowing how to depict skies is extremely important. They are ubiquitous in advertising, although you may not particularly notice them because they are rarely the focal point of ads.

Because you see the sky every day, you might simplify how it looks in your mind, thinking that it is just a flat color, perhaps dotted with white clouds. Actually, rendering the sky—which is virtually never completely cloudless—is similar to rendering smoke or mist. Your hand must move loosely, to create misty, swirling elements. You must also recognize that the sky itself has color variations.

For this depiction, I began with pencil and inked it in. Then I applied sapphire blue and pale indigo markers, making horizontal sweeps across the sky. I immediately followed this up with blender to soften the sweep lines. The technique was wet-on-wet, so I had to work quickly. I followed up with sweeps of crystal blue. When I had worked my way down to the clouds, I used sapphire blue on the edges of the sweeps, not coming directly up to the edges in order to set up the color transition to the clouds.

As I moved into the clouds themselves, I put down a base of blender and followed it immediately with

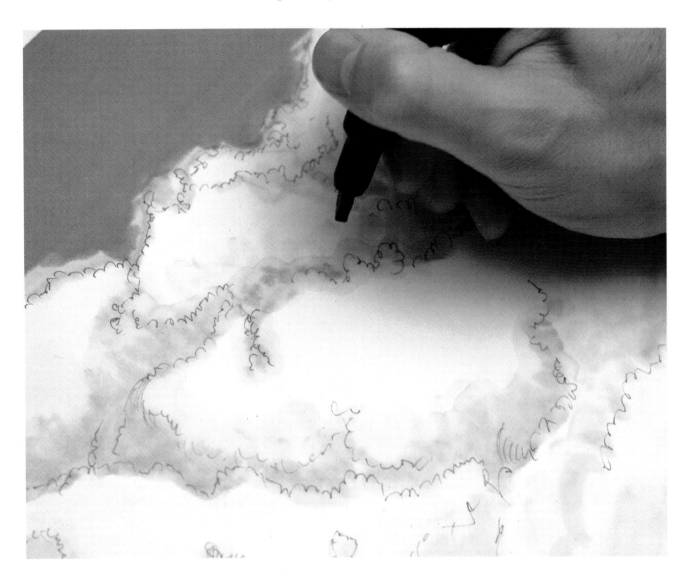

a coat of sapphire blue. I moved the marker in light, sweeping movements. In depictions of clouds, everything should be light and fluffy.

To give the art more color depth, I went back over the cloud with frost blue, quickly following up with blender. I then added pale indigo for the shadowy areas, continuously working with blender. I followed this with sapphire blue on the clouds, which gave them a completely different look.

Next, I decided to darken the sky for even more drama. I swept back over the top of the sky with a peacock blue, which has a nice green undertone, and progressed to crystal blue and then sapphire blue as I got nearer to the clouds. I finished the piece using a marker airbrush, with which I accentuated the cloud shapes further.

Skies are anything but a flat patch of blue or gray. In reality, they are made up of many color gradations, and this is how you should portray them in your art. For this sky, I began with horizontal sweeps of sapphire and pale indigo. Sweeps of crystal blue followed, and then I added sapphire—a lighter color than the other blues used—around the edges of the clouds so that the transition between sky and clouds would look natural. I drew the clouds with a free-form hand motion to capture their misty edges.

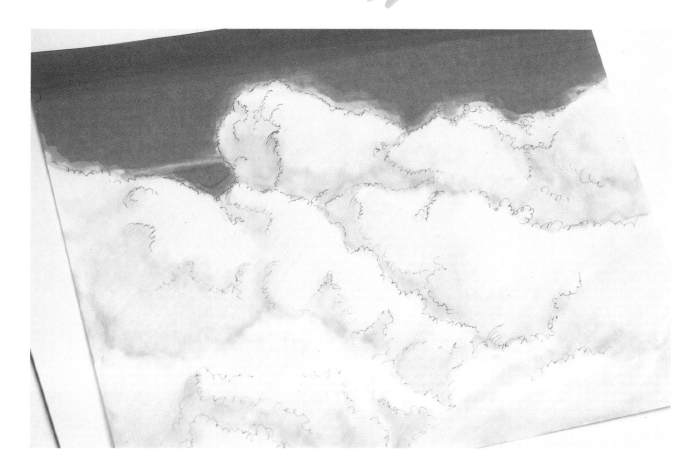

If you don't need a realistic-looking background, an alternative to rendering all the details of a sky is to use a bright, deep blue sheet of colored paper in a shade best suited to your artwork as a background. Not only will this save time but also anything you attach will really pop from it. Of course, if you want to add a bit more dimension to the background, you can use a marker airbrush or traditional airbrush on the paper. Deepening the color of the paper with the airbrush along the top edges creates a natural-looking sky.

You don't always need to make skies blue and clouds fluffy—sometimes you may want to alter the mood to suit your product. Like water, skies are endlessly varied and changeable. Some skies have a distinctly yellow hazy quality, evocative of summer, while others may be turbulent or greenish before a storm. For a starry nighttime sky, you can use the toothbrush technique described on page 24, or you can coat the paper with sapphire blue and follow with electric blue and steel, working steadily toward the deeper cool grays #5 through #9, depending on how dark you want the skies to be. Furthermore, you can indicate a lightning bolt with gouache.

In the picture on page 105, the mood of a sultry, tropical sunset is evoked. To create this dramatic look, I used horizontal strokes of vermillion followed by light red on the top of the page. On the lower half of the page, I used a coat of deep magenta followed by light red and purple sage. Then I applied a coat of vermillion over the magenta to dull the brightness slightly. The clouds, which have a very red look about them suggestive of the last rays of sun of the day, were first coated with cadmium red. I then drew into them with purple sage and blueberry while still wet. I followed this with a marker airbrush in purple sage to soften the edges a bit.

I created the effect of the sun on the water in a manner similar to creating hair—I simply left a bit of white space on either side of the marker.

In general, to create dramatic sunsets, obtain good, evocative reference material. Surprisingly enough, flesh colors work very well in sunsets because they combine nicely with red colors to produce a yellow effect. This yellow effect should be created near the horizon line.

After studying my art, I decided to heighten the contrast between the sky and clouds. Along the topmost edge of the page, I applied peacock blue, a gorgeous, rich color with a slight green undertone. Alternating colors with blender, I also added crystal in the mid-region of the sky and more sapphire around the clouds' edges. To soften the perimeter of the clouds a bit more while also accentuating their general shapes, I used a marker airbrush in a light blue color.

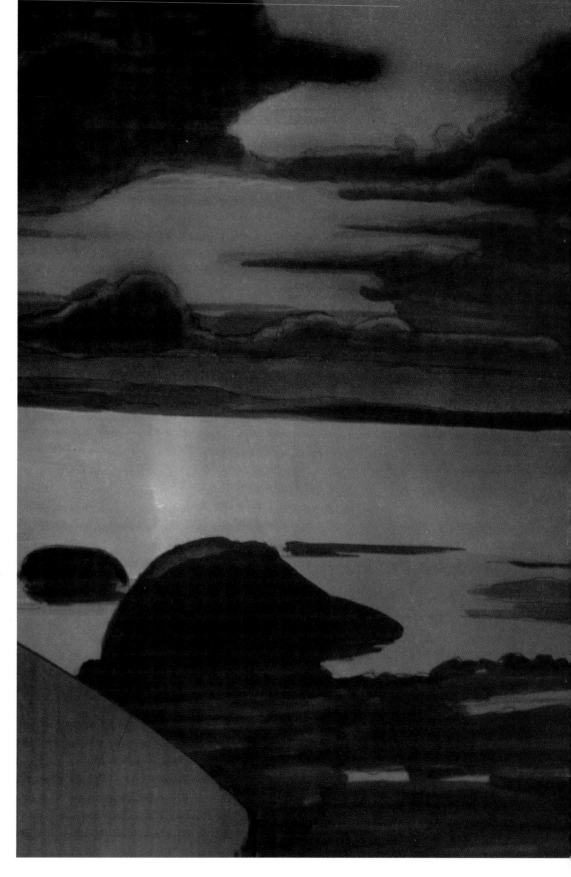

The term ''moody sky'' can mean different things to you and to art directors, so always ask what they mean by these words. Here, I evoked a sultry tropical sky through the use of a variety of rich marker colors: vermillion, deep magenta, light red, and purple sage. Near the horizon line, I combined cadmium red, purple sage, and blueberry to capture the color of the last rays of sunlight. A marker airbrush dusting of purple sage softened the clouds.

Reflections

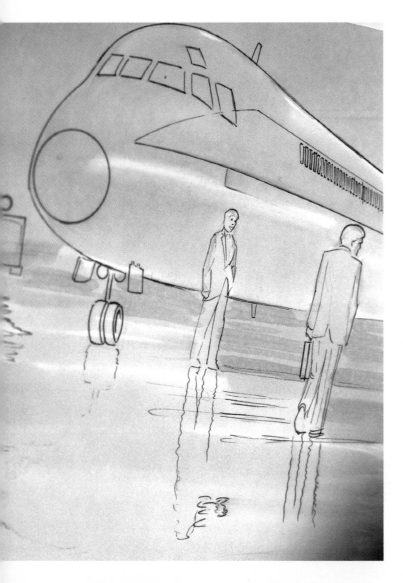

When rendering reflections, always carefully think through how you will achieve these complex effects, which require use of several different-colored markers. Also keep in mind that reflections should be oriented perpendicularly to the surface you are drawing. For this rainy nighttime scene of an airplane on a runway, I undercoated the art with pale indigo, which not only immediately imparts a dusky color but also establishes the direction of the reflection.

Here's a very contemporary scene: an airplane on a runway. It's a nighttime scene and the ground is slick. Advertising depicting vehicles on wet surfaces has become an industry standard; this is mainly done to show a company's or product's reliable performance even under adverse conditions. It's also done because reflections allow the product to be shown twice—with the image reflected onto the ground. This is a particular challenge for the comp artist.

After inking in the pencil lines and erasing them, I put down an undercoat of pale indigo. I drew the undercoat in vertical lines on the ground plane, which later in the illustration would prove quite useful in creating a reflection. Then I set out to establish a color scheme and mood with the first few strokes.

I began by using crystal blue for its watery, shimmery qualities; this color is also a good choice if you need to depict the shiny effects of floor wax. I added crystal blue to the plane to establish its reflectiveness. Then I applied steel gray on the plane and began drawing that color in vertical strokes on the ground to establish contrast, which is what creates reflections. I followed this with blender and more pale indigo to create an impressionistic effect.

I moved on to the sky and coated it with blue violet, because it was nighttime. I wanted to show some of the sky color reflected on the runway, so I drew a horizontal band of it on the ground. Next, I used a dry cool gray #7. To increase the reflective effect further, I made short horizontal strokes progressing vertically down the pavement. The high contrast between the darker colors and the pale indigo is the essence of the reflection. To finish the piece, I used white gouache for a beacon of light emanating from the airplane and dispersing light on the ground. As the light moves away from its source, it lessens in intensity, so I smudged the paint slightly to indicate this. I also applied a bit of blue gouache on the ground to further the watery reflective illusion.

To color in the ground, I applied steel gray marker in vertical strokes. I built up the reflection around this by adding blender and pale indigo, which created a dappled effect on the pavement.

The plane color was created using crystal followed by steel gray, a color that is reflected on the ground. I intensified the reflective effect on the ground by drawing horizontal bands of blue-violet, which indicate reflections of a nighttime sky, and additional short horizontal strokes of dry cool gray #7. The contrasting interplay of pale indigo, steel gray, blue-violet, and cool gray #7 creates a sense of a surface slick with water and reflecting lights.

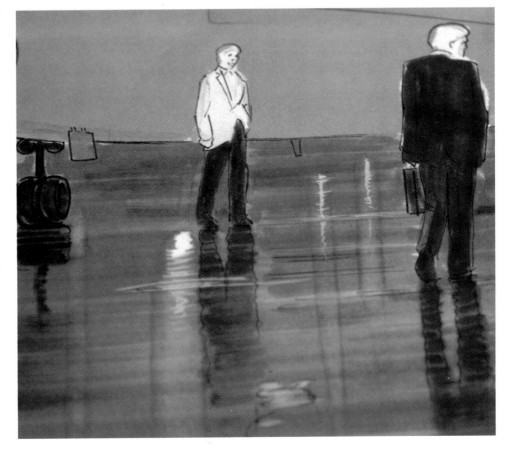

Note the layers of individual colors in horizontal strokes at the edge of the drawing. The lightness of gouache on the ground provides a contrast with the depth of the night sky, and irregular horizontal brushstrokes are an effective way to reproduce the shimmering surface of a puddle of water.

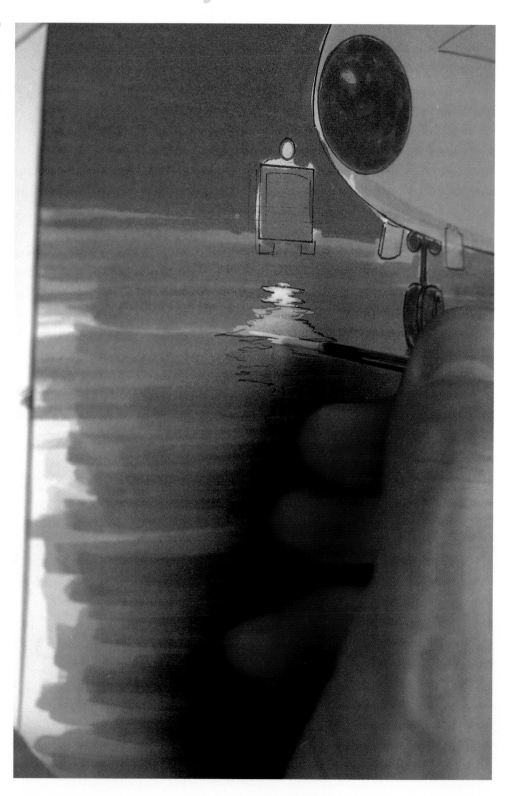

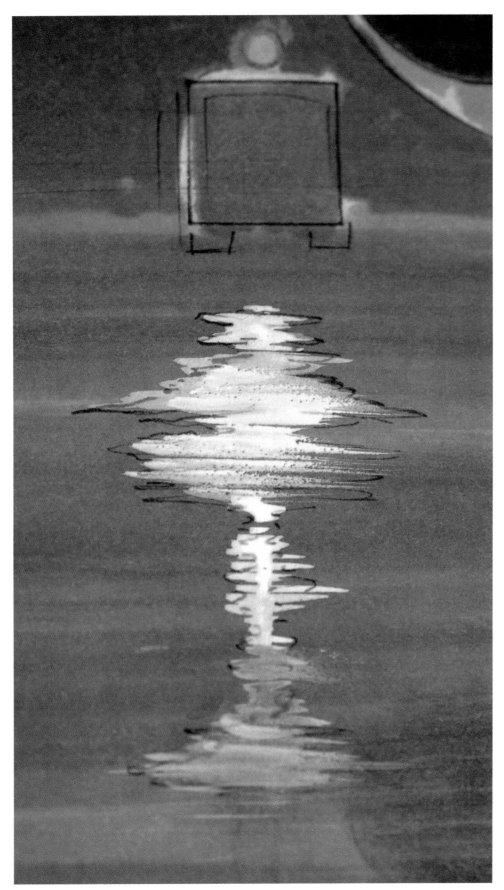

As light moves away from its source, it lessens in intensity. To create the sense of a light source here, I smudged the gouache a bit to indicate light dispersal on the water on the runway.

Small touches such as these raindrops can add a dimension of realism to artwork. Created with gouache using a fine-tip brush, these highlights are not only attractive but also further the illusion of a wet runway.

Wood Grain

Natural woods are once again being appreciated after a period of proliferation of more high-tech materials, so it is important that you know how to capture the essence of wood grain. This demonstration is particularly useful because it actually offers two different woods in one piece of art: as the colors progress from light to dark, the wood changes from a light-toned Scandinavian look to deeper tones.

Keep in mind that all natural things have an inherent rhythm and order to them. Like the interior of fruit, the shapes of leaves, or the veining of marble, the look of wood is at once irregular and regular. On the one hand, the grain is oriented in one direction, but there are also "flaws," such as knots, that give it visual interest. While creating wood grain requires some degree of precision, you must also have a feeling for its rhythm to prevent the pattern from looking stamped on.

Start with a palette of cream, light sand, wheat, and dry sand. Begin drawing parallel lines in one direction with cream and drag light sand over them. Then follow with wheat, but not as heavily; hold the marker further back, toward the edge, and "skate" lightly across the paper; this will produce a streaky effect. Follow up with a dry sand marker; don't be too thorough. You're building on the streaky effect you've created with the other colors. The effect you're looking for is linear. Start adding knots by drawing very shallow ovals.

At this point you have created a light wood, which is often used to present food products because it doesn't compete with them. If you wish to create a darker wood—standard for advertising furniture polish because it shows a high-contrast gleam—turn your paper over and coat it with golden tan to warm up the tones. You're applying color on the back so as not to dominate the wood-grain effect. Turn the paper back over to the drawing side and use a dry cherry marker to really warm up the wood—roughly parallel to the role of light sand in the previous application of color. Then, as with the wheat in the first version, come back and add dry chocolate and "skate" over the art, a technique that provides high contrast. Be careful not to make the lines too straight. If you need to create even greater wood-grain variation, which is often the case when you are covering a very large surface, add brick red on the back of the paper for real richness— I even added some on the front.

Finally, add white pencil in vertical strokes—in opposition to the wood grain—to play up the shine. You could also use a marker airbrush or airbrush to make the effect more prominent.

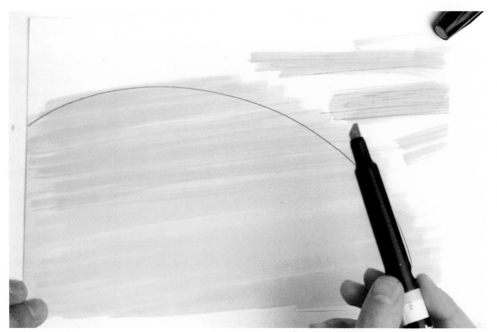

Creating realistic-looking wood grain requires an understanding of the look of natural materials. I began by applying streaks of cream on a horizontal axis. This establishes the general direction of the wood grain. I followed with a coating of light sand to deepen the tone slightly. Next, I used wheat, grasping the marker toward the bottom edge, which enabled me to "skate" across the paper with the marker, applying color more randomly and less thoroughly than I would if I held the marker normally.

I continued with a dry sand marker, holding it in the same fashion and applying color sparingly. I also used this color to create knots in the wood—extremely shallow ovals drawn in a haphazard fashion. Remember, when rendering wood, the only rule is that the grain must be oriented in the same direction; irregularities can occur within this framework. Also, the lines of grain should not be straight; they should have a wavy quality to them. Another interesting aspect of rendering wood is that you use the same techniques for light-toned, Scandinavian-type woods, as pictured above, as you would for richer-toned woods, below.

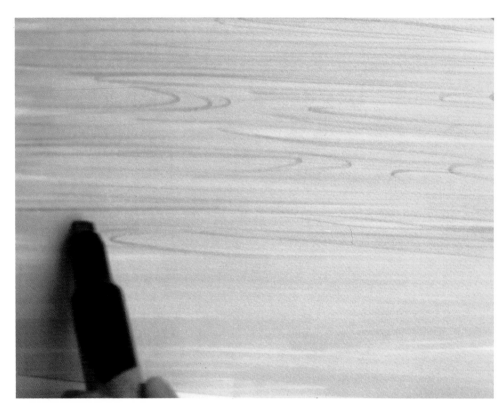

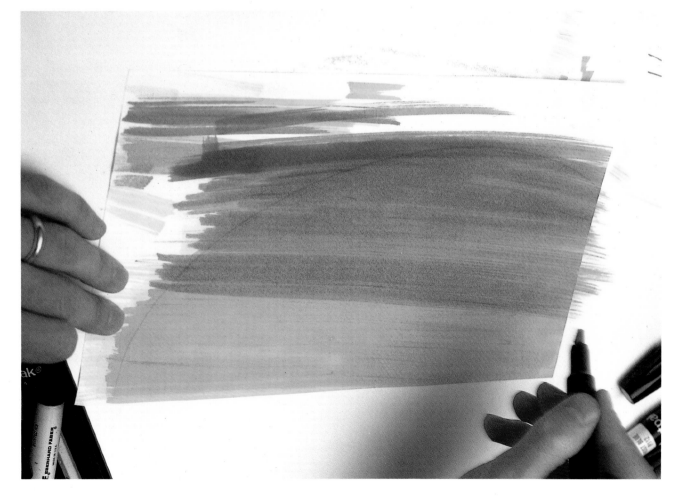

Products

Products range from edibles to cleansers to wearables to anything at all that can be sold or marketed. It's important that you know how to render products because they will be a constant theme in your work.

Label rendering can be done through a light box tracing process, but there are many other elements to consider. For example, a soft drink must look refreshing, a denim ad must convey a certain fashion-consciousness; ice cream has to look soft and creamy;

a cleaner must look like it does a good job. You have to decide on the right range of colors—based on the colors of the product itself—and get your composition right. Another recurring advertising theme of late is the "lively product," that is, one around which there is a lot of activity, be it bouncing fruit, rolling vegetables, or splashing water. You may be called upon to produce these lively effects, so you should study them to understand how they're done.

Food

Knowing how to draw and color food demands several skills from the artist: Not only must you be able to produce a realistic-looking depiction of the food, but you have to make it look, literally, good enough to eat. Food should always be rendered with an eye toward its appetizing qualities. To make the food look as convincing as possible, outline it with a pen as close in color as possible to the product.

GRAPES

With their pleasing forms, varieties of colors, and upscale vineyard associations, grapes are a staple of contemporary advertising. Because they convey a quality of luxury and abundance, grapes are often depicted alongside other products.

Rather than spending time approximating the shape of the individual grapes for this marker still life, I opted to use a circle template. I used a blue pen—because it is in between green and purple, the colors of the grapes—to ink the grapes in. The grapes behind the wine glasses were rendered in gray Pentel pen, however, because their color is diluted by the liquid.

I began with the green grapes. The first step was to apply citron to four to six grapes at a time to indicate the shape and basic color of the grapes; I followed with a fine-point blender on top of the grapes to indicate highlights. Then I used dry chartreuse—wet would have been too overpowering—to deepen the color, followed by yellow green, to tone it down slightly.

For the purple grapes, I followed a parallel formula, using different colors. I colored in four to six grapes at a time with mauve; then I touched the tops with a blender to indicate the light source. I used a red #9 Design marker to intensify the shape of the grape and shaded the bottom with a violet #8 Design marker.

I used a gray Pentel pen in between the grapes to indicate shadows. It would have been too time-consuming to draw and color stems, so I opted to render a leaf in lemon lime and dry forest green for a finished illustration look. I followed with gouache for the sheen on the glasses and on some of the grapes. To make the gouache highlight realistic, I applied it from a consistent perspective, indicating one light source. Therefore, the highlights taper from left to right.

To save time rendering these grapes, I simply used a circle template. I went over the pencil using blue ink. Black ink would have been too heavy, and you want to make food look as appetizing as possible. That's why you usually will want to ink in food in the color closest to its actual hue. I broke down the coloring-in process to four basic steps for each color of grape: Apply a base color, follow with blender for highlights, deepen and intensify the color and shape of each grape, and provide a final tint of color. For both types of grapes, I repeated the same steps on four to six fruits at a time; repetitive movements quicken your pace when creating artwork.

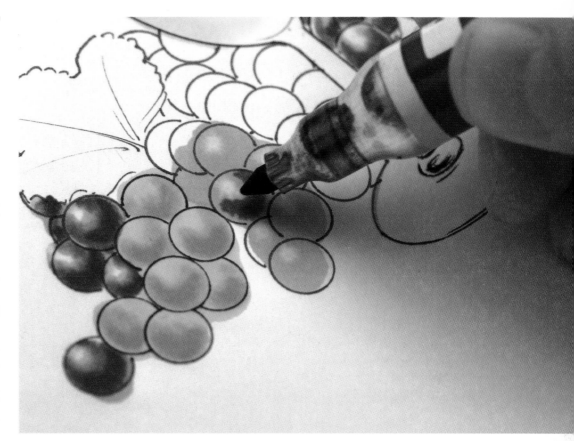

Gouache touches on this artwork lend it a sparkling, fresh quality. I was careful to make the painted-on highlights look realistic, so I oriented them toward a consistent light source, which is slightly overhead.

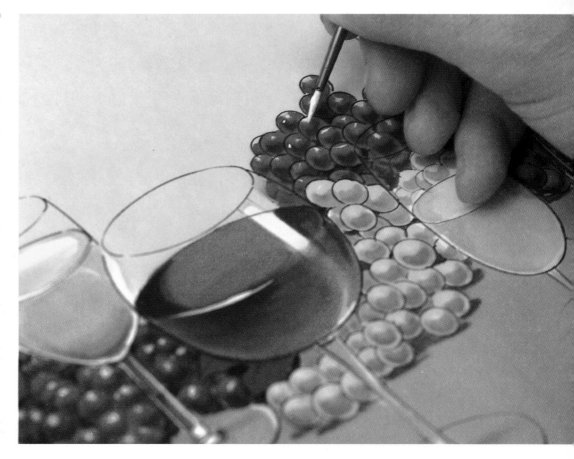

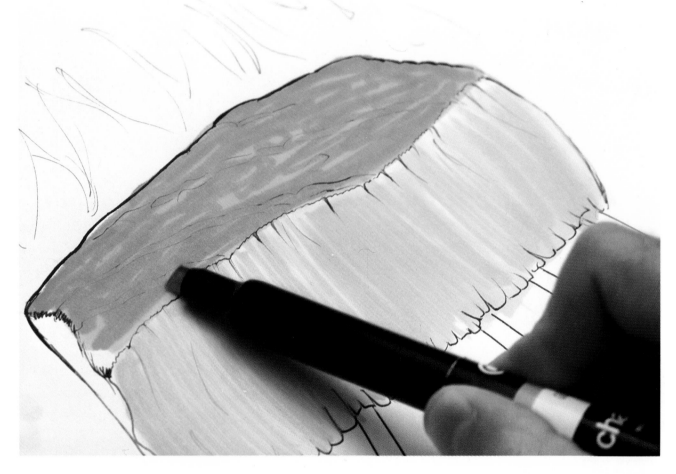

As with wood, meat has a consistent "grain" to it but also has slight irregularities and textural variations. I inked the meat in brown to establish its natural, edible qualities. To create the grain on the open-cut side of the meat, I drew with maize in vertical strokes. On top of the meat, I applied a coating of flesh marker. I followed this with golden tan, applied irregularly to establish its varied texture.

STEAK

Meat is challenging to depict. Because it is a food in a natural state—as opposed to manufactured edibles like potato chips—I have included it here. This drawing illustrates principles that can be applied to all unprocessed foods. Also, meat is such a common item in advertising that the ability to render it realistically can be an asset.

All too often, artists color meat brown, which makes it look anything but fresh. In reality, meat is composed of a number of colors and, like wood grain, has a natural order as well as irregularities that are challenging to render.

I inked this steak in with brown pen. I wanted the steak to look juicy, as if it were sizzling under an open flame, so I spent a lot of time developing the color of the open-cut side of the meat. I began coloring it in with maize in vertical strokes. I followed this with pale flesh, more maize, flesh, and salmon, also applied in vertical streaks. Next, I turned the paper over and colored horizontally across the open-cut side with flesh,

With my base coloration complete, I set to work making the open side of the meat look tantalizingly fresh and the top part look charcoal grilled. For the open side, I added pale flesh, flesh, and salmon in vertical strokes. This gave the meat a natural, pinkish tint. I created the rare-looking inner area by turning the paper over and drawing horizontally with flesh, pale orange, and vermillion. I repeated this process on the front side with dry cherry. Coloring the top area of the steak also required shifting between colors.

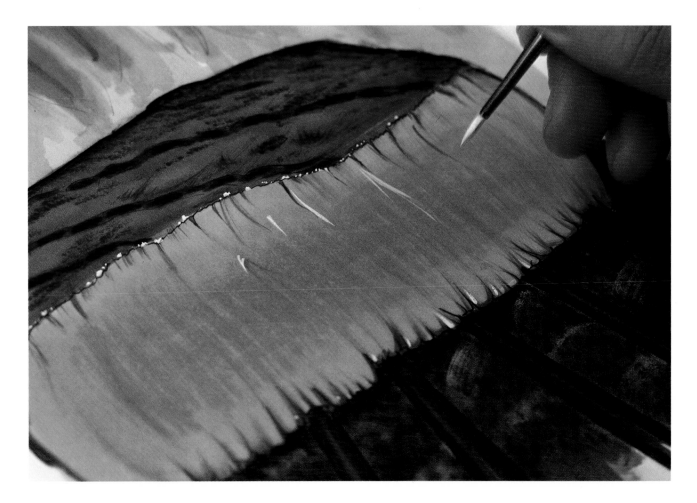

pale orange, vermillion, and yet more pale orange. I turned the paper back over and applied dry cherry horizontally across the open-cut area. This dual-direction approach—vertical and horizontal strokes—illustrates the "grain" of the meat (vertical) while also indicating the innermost rare area (horizontal).

For the cooked top part, I began with flesh. This section of the meat is a lot darker than the open side because it is somewhat seared. I followed with golden tan, drawing unevenly across. I was trying to achieve a coating that was not uniform but rather showed the irregular characteristics of the meat. Then I added dry cherry to randomly darken the top of the steak. I wanted to increase the surface complexity, so I coated the top of the steak with golden tan again, followed by cherry. I went back to golden tan again. (You may work differently, but I wanted to experiment by alternating between colors to try to achieve as many interesting mixes as possible.) Next, I added some flesh to highlight parts of the meat that weren't as singed. Dry chocolate followed to show grill marks; I dotted it

along the meat, especially along the back edge so that it would pop along the flames. Finally, to brighten the top of the steak somewhat, I turned the paper over and applied cadmium orange. Then I used white gouache to show the wet, shiny look of juice leaking out of the meat.

To create the flame, which I wanted to be deep-toned so it would stay in the background and not compete with the steak, I first applied dark yellow; I followed this with cadmium orange; to soften the orange somewhat, I again used dark yellow. I wanted to avoid having any hard edges around the flame, so I used a wet-on-wet technique for the background, which is composed of plum immediately tempered by orange. For a final softening touch, I added pale orange over the yellow of the flame.

I colored the grill and coals steel and indicated the heat on the grill by adding a streak of red down the center of its bars. I also added a bit of gouache to the steak to further illustrate the grain.

LOBSTER

For certain kinds of foods, color is all-important in creating an appetizing look. I included a lobster for this section because of the complex red coloration that results from cooking it. I needed the color to look appetizing without seeming painted-on or cartoonish. In addition, I was faced with having to indicate a sheen on the lobster while emphasizing its edible qualities.

I began by outlining the lobster in red ink. Black lines would have been far too harsh and artificial looking. Because I was using a wet-on-wet technique for the depiction, I first added copious blender to the drawing. This I quickly followed with pink, vermillion, and cadmium red all over the lobster's body. To lighten the effect slightly and unite the trio of base colors, I used red clay, which is a lovely light red.

Then I focused on adding texture to the drawing. To indicate that the lobster, because it is a crustacean, is not entirely smooth, I applied dry cherry over the top areas of the shell. To modify the strokes slightly—

you never want your drawing to look more detailed than reality—I applied more cadmium red and pink.

Satisfied that my lobster had an appetizing base coloration, I set to work adding highlights. I applied blender to subtly remove color in key areas where light would be hitting—the topmost surfaces. To balance the light effects, I added maroon and more dry cherry in the dark underside areas. While I had been using AD markers for the entire job, I opted for several Design markers—red #9, orange, and rubine, a very cold red—for more shadow variation.

To show that the lobster was recently cooked, I decided to create water droplets. I first added blender and used a black fine-tipped pen on top of it to indicate semicircular teardrop shapes in several areas of the lobster. For realism's sake, I drew the shapes randomly. Using a small brush, I traced the shapes with gouache. The background is a blustery New England-like color combination of steel and cool grays #6 and #9.

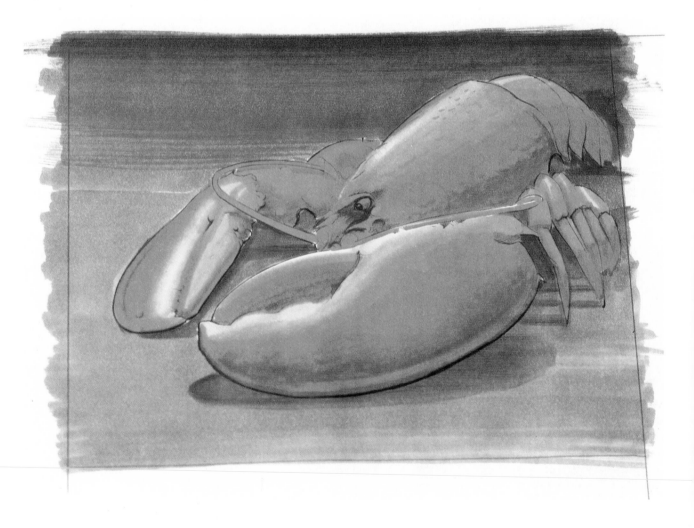

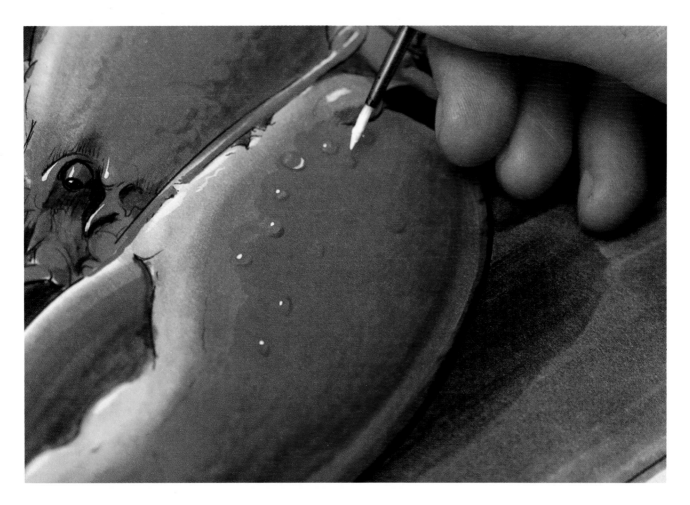

This appetizing-looking lobster was first inked in with a red pen. The seamless yet multitoned look of its body was created using a broad palette of reds. I created a smooth base coloration with a wet-on-wet technique: blender followed by pink, vermillion, cadmium red (for added spark), and dry cherry (to create the irregular look of a crustacean's shell). Because the lobster is nearly completely red, I needed to further vary these hues as much as possible. Therefore, I used blender for light effects and deep-toned reds for shadowy areas.

Freshly cooked lobsters are associated with water, so I decide to add some moisture droplets. To do so, I drew teardrop shapes with blender in random formations on the lobster and quickly went over them with a black fine-point pen. I then took a small fine-tipped brush and traced over the shapes with white gouache. The ability to create small yet highly dramatic effects such as water droplets is a skill valued by art directors because it makes such a favorable impression on prospective clients.

CRISP ITEMS

In depicting these breakfast flakes, I opted for black ink over colored ink. In this case, I really wanted to emphasize their crunchiness with crisp outlines of the flakes in the bowl. Further, I lent a surface complexity to the cereal by using a wide range of colors: maize, cream, wheat, dry pale cherry, golden tan, and sand. A touch of white pencil on the tops of the flakes emphasizes their airy, crunchy attributes.

Crispness and crunchiness are some of the most desired qualities of snack and breakfast foods. I wanted these wheat flakes to look light and crisp. To produce this effect, I used a progression of markers—maize, cream, wheat, dry pale cherry, golden tan, and sand—in a wet-on-wet technique, which creates a soft, mottled appearance. Although I would ordinarily use a brown pen to draw the flakes' outlines, I opted for a black one because they are so prominent. In this case they actually benefitted from the black because it broadened the color range, making them look all the more texturally complex. The contrast of light and dark colors is the key to the very textured look of the flakes. I added white pencil on the tops of the flakes to give them a light, airy look. The berry adds a warm contrast to the cereal and provides a focal point.

While crisp items are rendered through the skillful use of outline, smooth items are difficult to depict because you need to add some surface complexity without giving the substance hard edges. Here, I accomplished this by using maize to impart overall color to the yogurt. Then, to show that the food is substantial and creamy, I gave it some dimension by drawing a subtle shadow with dry warm gray #1. Using a cool gray would have given the food the unappetizing look of shaving cream.

Soap

When rendering soap, you want to achieve a fresh, clean look. This is usually done by surrounding the product with water and foamy bubbles, which create surf or river associations. For this vigorous depiction of liquid soap, I positioned the product as the focal point and let water radiate outward from it. The warm color of the product contrasts nicely with the coolness of the water so that there is a harmonious balance.

When rendering splashing water or any other unusual effect, you will be tempted to spend long hours adding details for maximum drama. While this is appropriate for fine art or finished illustrations, it has no place in comp work, where rapidity is valued almost as highly as the work itself. You don't want to be a pure minimalist, but you want to lean in that direction by conveying the most feeling and detail in as few marker strokes as possible.

For example, the white spaces you see in the splashing water are not white pencil or gouache but the actual bond paper showing through. Not only does this save time, it creates even more high contrast than would an applied medium. For the water itself, I used a total of only five marker colors—two of which were applied very minimally—although I could have opted for many more. And though some of the water droplets would in reality be irregular or oval, I used a template to quickly render a number of circular droplets. The point is that you want to convey the general idea of an ad with as little effort as possible. When used skillfully, just a few markers can look like many, and you don't want to upstage the product. Always keep this in mind when working on pieces on which you could conceivably spend hours working on effects that are not central to the product.

I began by inking the product in black and the water in blue. This placed emphasis on the product while establishing the general flow of the water. I colored the product next since it was central to the illustration. To preserve the transparent quality of the liquid, I used a very simple color combination: cadmium yellow followed by cadmium orange. I allowed the undercoating of cadmium yellow to show through up the center of the product.

For the water, I used a combination of frost blue, sapphire blue, and crystal blue markers. As I do when rendering smoke, I alternated between applying blender and colors in order to create a smooth, seamless wet-on-wet effect. Frost blue—the lightest and warmest of the marker colors used—is apparent around the edges of the product; because the product is a warm color, I wanted the water to shift slightly in color to look less cool near the container of soap, as if it were being reflected.

I applied the three basic colors—frost blue, sapphire blue, and crystal blue—with a light, rolling touch all over the illustration. To create highlights in the water droplets, I applied blender and then created a high-contrast accent nearby with crystal blue. Because water is reflective and has so many different facets, there was a potential for myriad gradations of color in this illustration. I played up these contrasts only as much as was necessary, however, to adhere to time limitations. To ensure that my contrasts would be equally lively all over the paper, I turned it over and squinted to assess the art. You don't always have to color in an illustration so that it's right side up and facing you. Often, I apply color on art that is upside down, turned over, or on its side. This tends to make the finished piece more interesting because it was approached from different perspectives and the marker strokes go in different directions.

To heighten the splash effect, I created radiating lines around the outer edges of the paper. I layered electric blue on top of the other marker colors to brighten this area. For the more stationary, horizontally oriented water on the bottom of the page, I used a process blue marker, which has a greenish tone that captures the look of deeper waters.

I finished the illustration by coloring in the product's pump top. First came an undercoating of electric blue with a touch of crystal blue. These colors subtly unite the product with the water. Afterward, I used black and allowed some of the electric blue to shine through. The electric blue highlight lines up with the cadmium yellow highlight of the container to suggest a consistent light source.

Here, I decided to create the frothy effect of the water by simply leaving uncolored white spaces on the paper. Next, I decided to limit the number of blue markers I used to render the water to five. Also, I used a template to quickly create most of the droplets. For the stage of the drawing documented here, I had already inked the water in blue and the product in black and colored the product using two markers. I had also used frost, sapphire, and crystal in a wet-on-wet technique in the inner area of the water droplets. I rendered the radiating lines in the outer area of the art using the same colors followed by electric blue.

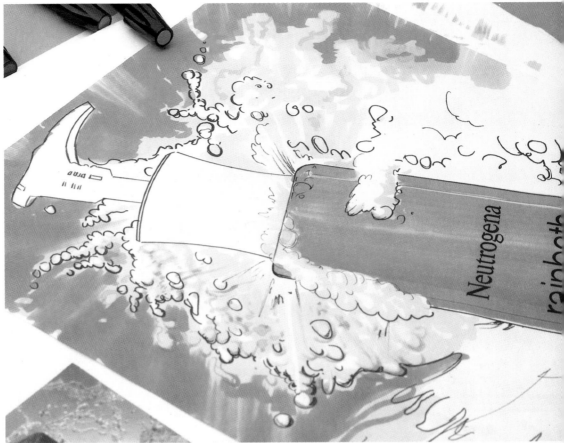

NEUTROGENA® is a registered trademark of Neutrogena Corporation.

I created highlights in the water-droplet area using blender. The white of the bond paper shines through to produce a frothy effect. As I applied color in this area, I worked in a free-handed motion to capture the water's buoyancy.

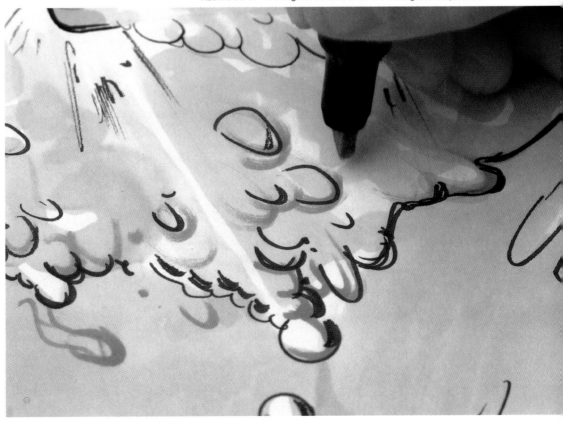

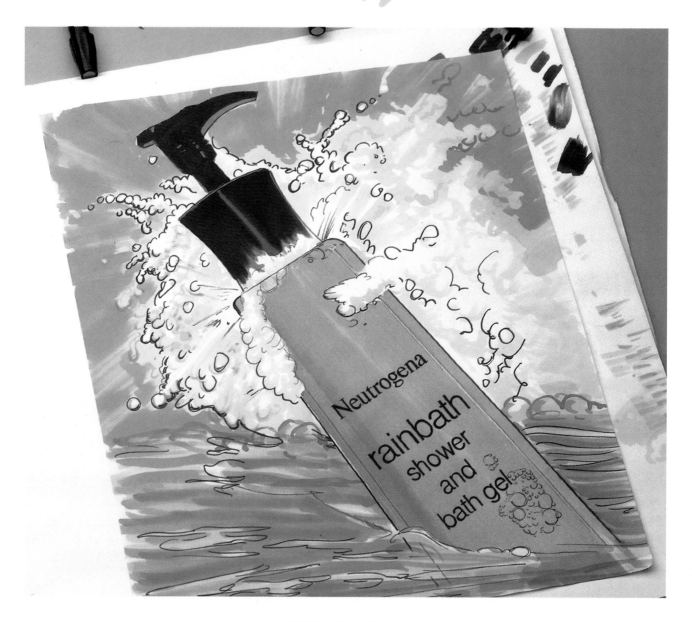

I added a process blue marker to the palette of previously used colors for the water at the bottom of the artwork. This color has a greenish tint, which makes the water in the lower area of the drawing look like it has more depth than the more turbulent water.

Denim

Here's a two-in-one demonstration—how to create denim and how to render a label so that it looks as close to the real thing as possible. It's important to know how to create denim because it's a ubiquitous motif in advertising and it's classless—it can be used to advertise upscale, trendy products and traditional, middle-market products alike.

If you have had training in figure drawing, you should put it to use when depicting people wearing any kind of clothing. You must be aware of the body underneath and how it fills out the clothing. When rendering clothing, be aware that fabric creases have a point of origin at which they are most sharp and from which they gently dissipate. As the fold becomes less pronounced, it also has less contrast from light to dark.

For these jeans, I started with a coating of blender and then used sapphire blue, ice blue, crystal blue, and electric blue, alternating blender with color. I also used Dutch blue to create shadows for the folds. I wanted the jeans to have a soft, broken-in look, so I needed to blend the colors well. I used white pencil to indicate faded areas; this medium lends itself particularly well to denim because the grainy quality of

pencil on bond paper simulates the texture of fabric.

I also wanted to indicate the seamed areas of denim where it puckers slightly and takes on a white look. Blender is a perfect tool with which to show this effect. To use it, create a representative color swatch on a separate piece of paper and add the blender over it in a swift motion. If the blender is not removing enough color, then hesitate over the swatch a second or so longer; when you have achieved the right timing to create the whitish-seam look, apply it to your artwork. Do so rhythmically so that you get a uniform effect all over the artwork.

Another important aspect of advertising art is knowing how to render labels. For this jeans illustration, I simply made a machine copy of the label and traced it on a light box with a brown Pilot fine-point pen to preserve its rugged look. Then I used blender and applied sand marker over it in a random, scribbling motion to create a variegated coloration. I continued to alternate between sand and blender and even turned the paper over to add a dimension of color on the back of the page. The result looks like the real thing, but it took only a few minutes to create.

When drawing people wearing clothing, make the garment look as if it is being filled out by a human body. You should know how to depict folds around shoulders and knees. Folds are darkest at their point of origin and gradually lighten as they flatten out. For shadowy areas of denim, add Dutch blue to the basic palette of blender, sapphire, ice blue, crystal blue, and electric blue. For more brightly lit areas, apply white pencil, which has a grainy quality that captures the weave of denim.

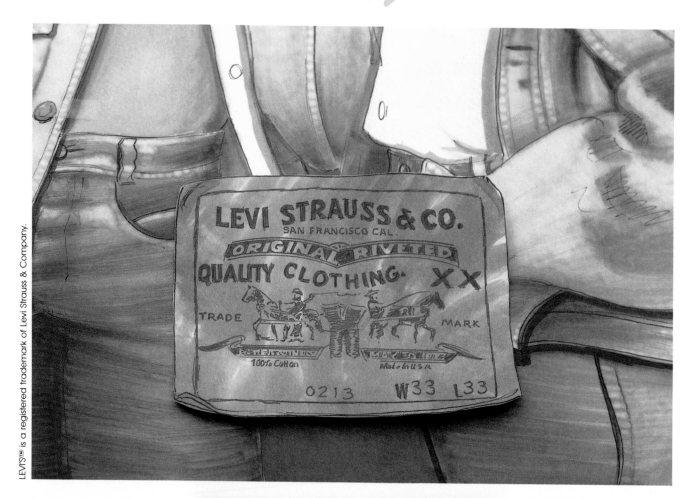

I made a label to show how this jeans demonstration would look as an ad. I wanted the label to look as close to the real thing as possible, so I made a machine copy of an actual label, inked it in with a brown pen, and then alternated between blender and sand marker to color it in. As I applied the sand color, I worked in random, scribbling motions to capture the rugged look of the label.

Denim is a popular fabric in advertising, and it is vital that you are able to render it accurately. For example, you must know how to create the puckered, faded look of denim around seams. This is extremely simple to do: Hold blender for a few moments in a spot along a seam; this will remove color and create a illusion of a faded area. Continue this process, working quickly and rhythmically, along an entire seam in your artwork. Do not attempt this technique on your art before testing it on a separate swatch of marker jeans color. Get your timing right so that you know exactly how long to hesitate with blender over artwork.

Makeup

Makeup advertising has different styles depending on what kind of makeup is being offered. This makeup ad is targeted at more affluent, professional woman; therefore, I made it attractive yet not fussy.

This art was created in under an hour and is extremely "loose," reflecting the quickly applied, selectively placed strokes characteristic of in-house art. For the most part, I didn't layer colors: the background is mauve and was applied in overlapping lines, while the shirt is a warm gray. The face is quite light—the better to show off eye and cheek makeup and lipstick shades. To create it, I used a base of pale flesh followed by flesh, blush, and peach. I shaded it with blush. Above the eyes, I applied a lavender colored pencil to complement the background.

This cosmetics advertisement emphasizes simple, straightforward makeup colors, which I used not only on the woman's face but also in her clothing and hair and in the background. I deliberately made her face a light shade to offset her lipstick and eye makeup— created using a lavender pencil similar in texture to actual eye shadow.

Hair

Highlights in hair add vitality to people in your artwork, and it's important that you know how to create them. It's also crucial that you realize that hair is always composed of a number of colors, and the more complex your make your color palette, the more likely it is that your art will look realistic. For this head of hair, I used all dry markers in the following progression: maize, cream, wheat, sand, sepia, burnt umber, and delta brown. I created the shimmery highlights simply by leaving white space.

When hair is drawn and colored skillfully, it can do wonders for increasing the believability of your artwork. The more realistic and appealing your artwork looks, the more enthusiastic the client's reaction will be.

There are just a few basic formulas for creating hair, and these are listed on page 135. (Hair tones are similar to the skin tones discussed in this book in chapter 4.) Remember, however, that all formulas are only reference points; feel free to to add your own variations, depending on what effect you want.

Here, for example, I added a dry delta brown to the formula of sand, sepia, and burnt umber dry markers. Notice the highlights in the hair; these are created by whisking dry markers up to one another but not making them touch—that is, leaving white space so irregular in form that it creates the look of a sheen. Regardless of hair color, this technique should always be used.

Learn to render a whole spectrum of expressions in your work—from elation to anger. Expressions that really convey emotion associated with use of a client's product will certainly influence him or her to go with an advertiser's campaign—which is the goal of all your art. The expressions depicted here capture feelings of happiness, satisfaction, confusion, and even downright disgust. Practice making these and other expressions in a hand-held mirror.

Expressions

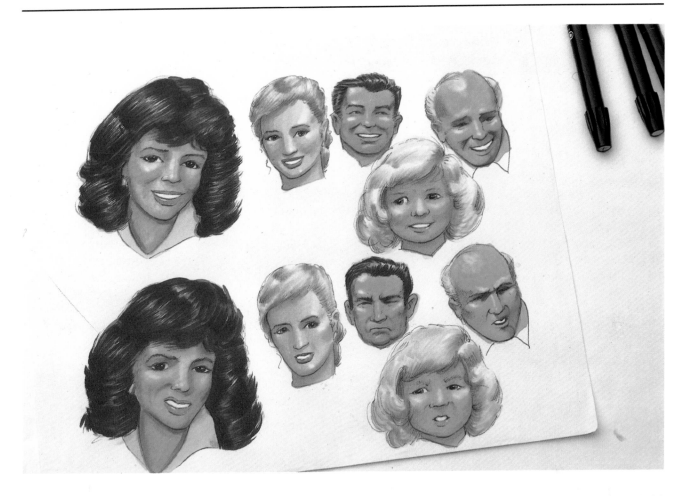

Happiness, satisfaction, excitement, discomfort, and disappointment are the main expressions conveyed in ads. The client's product, of course, is always the impetus for pleasant emotions, while the problem it corrects elicits negative expressions. You have to be able to make the entire face expressive—for example, the eyes must "smile" along with the mouth so the expression does not seem patched-on. Expressions add an extra dimension of vigor to ads that can cause a client to react instantaneously with approval. This is why a mastery of them is so crucial.

I would suggest that you keep a mirror—preferably the hand-held type—close by at all times so that you can actually make expressions yourself and copy them. Also, when you make an expression, you will be aware of facial muscles moving in a particular way, which can help you convey that motion from the inside out in your artwork. Take Polaroid photographs of

friends and make copies of them to trace on a light box. Also, keep a separate scrap file for expressions and collect magazine photographs of faces making extreme gestures.

The extent to which you should emphasize an expression is highly subjective, but I tend to accentuate them as much as possible. Don't be afraid to render extreme expressions—this makes an impression on clients. The collection of before-and-after expressions on this page range from subtle to extreme. You should be adept at showing this range in your art. For example, the blond woman is only somewhat puzzled or mildly annoyed before, while after she is very satisfied. The man with the close-cropped brown hair is enraged at first, but his expression later changes to pure delight. Practice creating your own expressions; they are essential elements of your portfolio.

Moods

Because much of advertising is emotional and relies on the emotional responses of consumers, it is important to know how to evoke moods. Commericals or print ads done in monochromes or a limited color range often successfully set dramatic moods.

For this piece, I used a normal progression of flesh tones for the woman and covered the entire back of the paper with blush to unite the background and the facial profile. I then created highlights on the woman's face with a blender. For her hair, I applied an under-coating of electric blue. This I followed with dry black, with which I drew the strands in light, rapid movements, barely touching the marker to the page, "skipping" it off and creating wispy locks. I deliberately allowed bits of the electric blue to show through. I further played up the electric blue with the woman's dark blue and Prussian blue headband. The final effect is stormy, even turbulent, with the woman and the background sharing the same striking colors.

In contrast to the light play of colors on the face of the woman and the resulting upbeat mood of the previous photograph, this woman's skin is deep toned and, consequently, the mood more dramatic. I accomplished this by coloring her face with ordinary flesh tones, but then turning over the paper and covering the entire page with blush to make the background and the face take on the same dramatic cast. It's important for an artist to know how to convey extreme moods such as this one because they are vital aspects in advertisements selling products as varied as alcohol, medicine, and perfume.

Cuteness

Kids and animals are effective for selling products because they are endearing. Their appeal could be described under the blanket term "cute." Generally, children and animals can never be too cute for an art director or client, so it's important to understand exactly what elements comprise cuteness.

CHILDREN

Kids have lighter, and generally pinker, skin tones than adults. When you render children, you must therefore eliminate a step in applying Caucasian skin tones: Proceed from pale flesh to blender to blush to peach; don't use the flesh marker before the blush, as with adults. Kids are more appealing if their faces are pudgy: Their innocence can be conveyed through large, wide-set, expressive eyes.

The crawling baby depicted on this page embodies these qualities. The red-headed child created here step-by-step also has a strong appeal. I complemented her pinkish skin tones with red hair.

As mentioned above, for facial colors I simply used pale flesh, blender, blush, and peach. I used a blender to create the facial highlights and a dry peach marker to shade and warm the face. For the child's eyes, I used a black fine-tip pen, blue marker, and gouache. The eyelid throws a shadow upward, which I rendered in dry peach.

I created a nice sheen in the little girl's hair by simply leaving white space and drawing into it with dry markers. I proceeded from maize to cream to wheat to pale cherry to dry cherry. This drawing features a particularly large head; I used wet markers because it is possible to exert greater control over them on larger surfaces. For smaller heads, I use primarily dry markers to prevent a blobby effect and to allow more texture for individual hair strands. To pop off the orange of the hair, I used a blue violet color.

I also added some gouache in key areas of the drawing, where the light was hitting the child, to give the artwork a finished look.

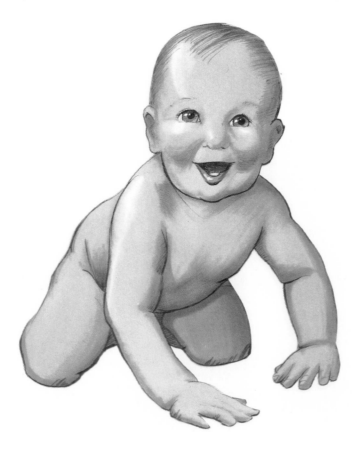

This chubby baby has an appealing pinkish coloration and innocent, expressive face. Artwork depicting such qualities should be a staple of your portfolio. Another important quality that art directors like to see is mastery in depicting the human body in motion. When drawing movement—such as crawling, jumping, or running—you must render the body from the inside out, understanding how the bones and muscles beneath the skin operate. The goal is to produce an accurate yet natural-looking drawing.

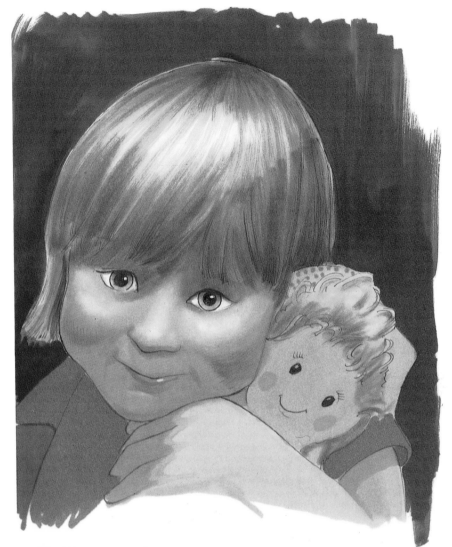

Large, wideset eyes and a pudgy face make this red-headed little girl irresistibly cute. For her facial tones, I eliminated the flesh color I would ordinarily use for adults, imparting a lighter, rosier tone to her skin.

I spent a lot of time rendering the little girl's eyes, as these are key to her appeal. I used a fine-tip black pen to outline them and fill in the pupils, a blue marker to color the iris, and gouache to add overall sparkle to the eyes. To further offset her eyes, I applied a dry peach marker on the upper eyelid and partially in the area below her eyes.

CAT

As with children, you should emphasize big, innocent eyes for animals to make them look as lovable as possible. Animals can be difficult to draw, so always have good reference material and begin by rendering the features you know best.

For this cat, a blue point Persian—the kind of regal, mysterious-looking cat that is used to sell everything from "gourmet" cat food to Oriental carpets—I worked my way down the value scale from pale indigo to black. I began with the eyes because they were so important and central to the piece. I used pale indigo in the left eye followed by a black pen for the pupil and purple sage in the right eye. The difference in eye color is due to the light source, which is not striking the cat head-on.

Then I started drawing fur, which, like hair, requires a fairly dry marker and loose strokes. Establish a pattern for the fur to fall and continue to follow the contours throughout the piece, or the fur may end up looking too chaotic. I used pale indigo as a basis for indicating the direction of the fur. I also touched a bit of flesh in the cat's ear and then applied a lot of pale indigo, letting a bit of flesh show through to indicate a thin layer of skin.

Returning to the fur, I used a dry cool gray #3, following the fur patterns I established using the pale indigo. Next, I used a dry cool gray #6 for darker areas. I also drew unevenly with a black marker along the right to further indicate the irregular outline of the fur. Then I applied mauve and purple sage as an undercoat for the right side of the cat—the side in shadow. I added crystal blue and ice blue on the back to indicate the unusual coloration of the cat. To complete the artwork, I added a bit of gouache to the eye areas.

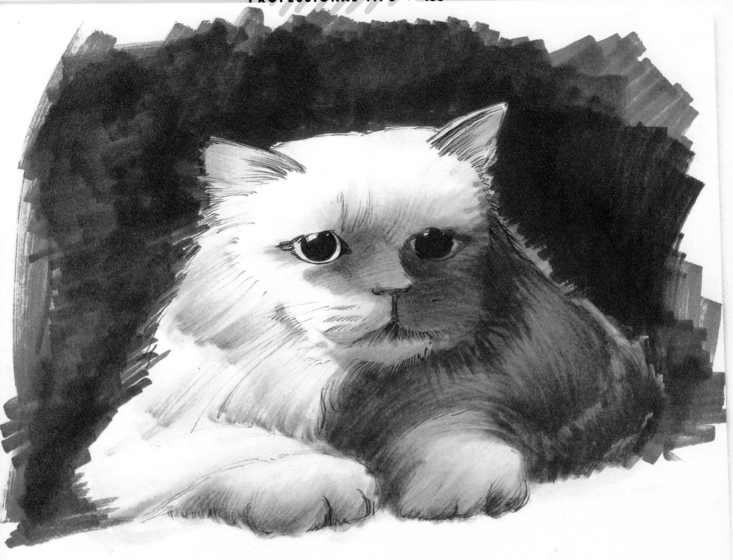

I wanted to give this regal-looking blue point Persian as much color variety as possible, so I undercoated its ear with flesh marker and went over it with pale indigo, allowing some of the flesh to show through. The result is realistic and attractive. When drawing animal fur, always follow the natural contours of animals' bodies, as you would with hair on a human head. I undercoated this cat's fur with pale indigo in loose, billowing movements. Then I used a wide range of colors to capture the fur's complex coloration. I began with dry cool gray #3, which I applied over the indigo. Then I emphasized the shadowy areas of the cat, using dry cool gray #6, mauve, and purple sage. To impart a subtle blue tint, I turned the paper over and applied crystal and ice blue in the shadowy areas.

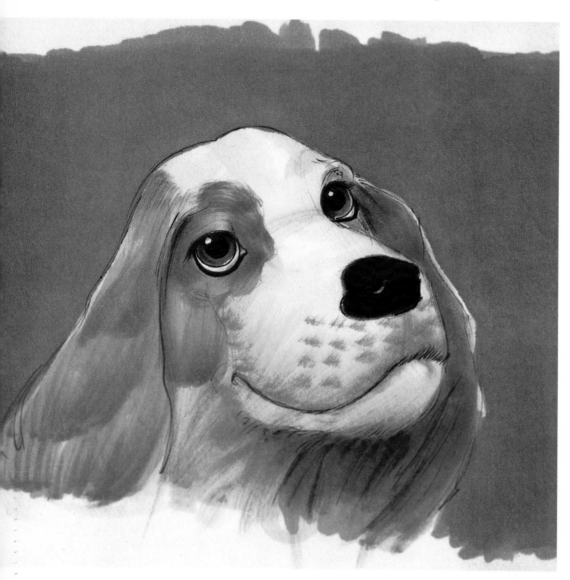

This lovable dog has large, trusting eyes, which are the basis of his cuteness. His shiny nose also plays a supporting role in making him endearing, and so I devoted a lot of time to this feature. First I undercoated him with dry maize and then used light sand and dry sand to add shadows. For his eyes, I used cherry and dry chocolate. I made his eyes stand out even more by outlining and extending the top eyelid with dry chocolate. Then I added a crystal undercoating to the dog's nose. I used deeper brown tones to create the dog's markings—which further emphasize his soulful eyes by encircling them—and coated his nose with black marker. I was careful to allow some of the crystal to show through to make the nose look very wet and shiny.

DOG

With his large, soulful eyes and big, wet nose, this cocker spaniel embodies cuteness. I played up his endearing qualities to the point of caricature, which is exactly what art directors want to see in your work. In advertising, messages carry more impact when conveyed through strong, familiar images such as this one. I rendered this dog rather quickly because he is a generic cute dog. If the project were an animatic, however, and the art director specified a really appealing, memorable dog, I would gather as much visual reference as possible to cull the most attractive aspects of a number of dogs in one.

I began by giving him a maize undercoat of dry marker. As with the cat, I used the maize as a guideline for indicating how the fur would fall. Then I used light sand to differentiate areas and dry sand to indicate the deeper tones.

For the eyes, I used cherry followed by dry chocolate to give a rich depth and glow. Also, to help the eyes look bigger and more soulful, I indicated a shadow below the bottom of the top eyelid.

I applied an undercoating of crystal blue to the dog's nose and then went back over it with black marker, allowing a bit of crystal blue to peek through. As with the blue-black hair often seen in ads, this undercoating indicates a sheen.

To balance the color of the fur with the vividness of the nose, I colored his body with dry cherry to warm him up a bit and further indicate shadows. Finally, to pop color off the dog, I added a brick red background.

SUBJECTS SIMPLIFIED

The subjects detailed in the list below are often called for in comp, storyboard, and animatic work. While rendering them is challenging, these formulas for AD markers provide shortcuts for achieving the

right color combinations. Simply use the markers in the order given. Eventually, rendering these subjects will become second nature.

SUBJECT	MARKER COLORS
red hair (dry markers)	maize + cream + pale cherry + golden tan + cherry
blond hair (dry markers)	maize + cream + pale sepia + sepia
light brown hair (dry markers)	light sand + sand + sepia
dark brown hair (dry markers)	sand + sepia + burnt umber
jet-black hair (dry markers)	dry crystal blue + dry black
black hair (black people)	black
white skin	pale flesh + blender + flesh + blush + peach
black skin	flesh + golden tan + cherry + chocolate
light-toned wood grain	cream + light sand + wheat + dry sand
deep-toned wood grain	cream + light sand + wheat + dry sand + dry cherry + dry chocolate + brick red
denim	ice blue + crystal blue + electric blue

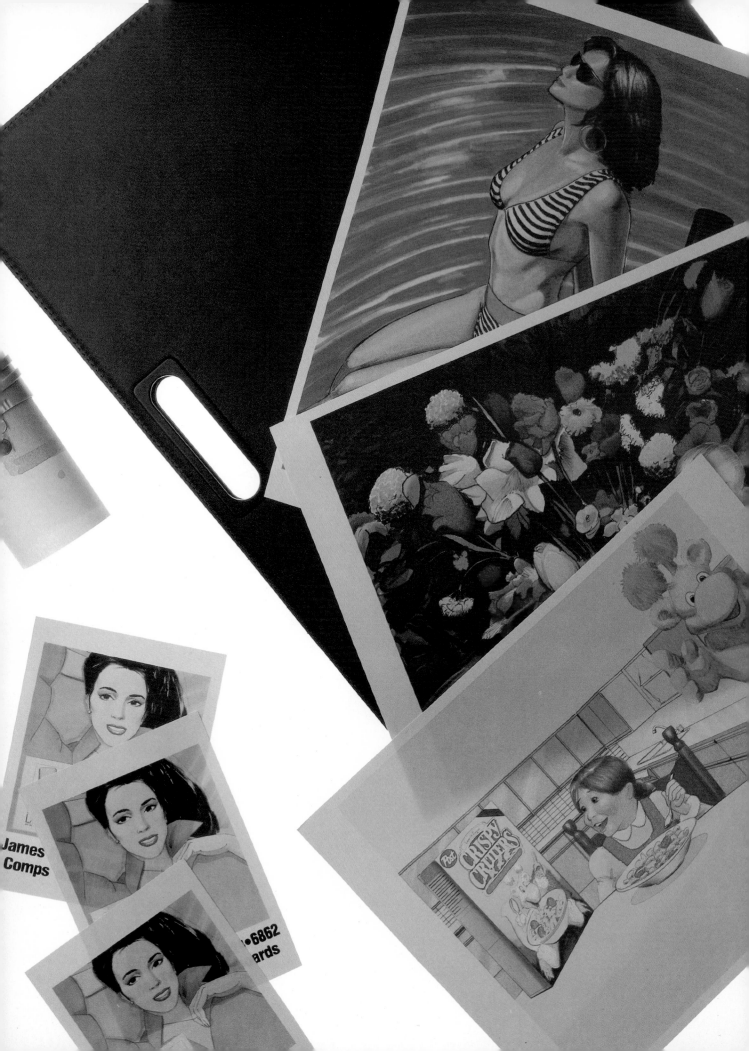

INSIDER OBSERVATIONS

While learning an assortment of both basic and advanced techniques and being proficient in comps, storyboards, and animatics may seem like enough of a challenge, you must still deal with the responsibilities of seeking clients, marketing your work, and perhaps even running a business.

In the advertising world, persistence is essential. You must doggedly make the rounds of art directors and do regular promotional mailings to remind people of your work and your name. You may have an agent, or "rep," and this can ease part of the burden of making client contacts. You will have to constantly compete with other artists and sometimes have to pull all-nighters. Even if you decide to work in-house, the deadlines and pressures will be great.

This section is intended to acquaint you with the workaday realities of being an advertising illustrator and to provide insights into dealing with situations professionally.

BECOMING A PROFESSIONAL

An art school education or pure talent isn't enough these days to get your foot in the door or make you a successful comp artist. You must be extremely competitive and savvy and keep constantly on top of trends in the business, which in turn will determine how you stock your portfolio and how you position your work in the marketplace.

This chapter is a primer on how to enter the field and promote yourself. It also discusses what types of work art directors like to see in portfolios and considers the pros and cons of working as a full-time employee versus going freelance.

Even after reading this chapter, you will encounter unanticipated situations. You will have to learn by trial and error. Still, the valuable advice of the experienced professionals interviewed here should help set your career as a comp artist on course.

Obtaining the Necessary Skills

While the instructions provided in this book will certainly prove useful, today's comp artist needs some art school training before embarking on a career.

Lisa Emmett Arnold, a freelance illustrator as well as an instructor in comps, storyboards, and animatics at Parsons School of Design in New York for five years, has observed students of varying capabilities in her classes. One of the biggest misconceptions students have, she says, is "they don't realize how hard they're going to have to work. People have told them that [the advertising field] is an easy way to make money. But they don't realize that it [involves] long hours and that you have to put a lot of time in actually drawing."

The prerequisite to entering the field, Emmett Arnold stresses, is learning how to draw. Simple as it sounds, without an understanding of how to render a whole range of subjects, it is not possible to work in advertising as an illustrator, because in order to render subjects quickly, you must understand them fully. Unfortunately, a common perception of preproduction art among students is that this field lends itself to a cartoonish style rather than one that demands a solid foundation in drawing. However, you must recognize and accept the fact that only top-notch artists who understand a broad spectrum of techniques succeed in the field.

Emmett Arnold sees people of different backgrounds entering the business today. Her classes include art directors who want to improve their drawing skills and illustrators who have not worked in advertising but would like to branch out into the field. She adds, "I get marvelous results from painters" who are tired of making little or no money. Anyone with an aptitude for art is a candidate for entering the business.

Advertising agencies and studios will sometimes hire comp artists who do not have vast amounts of experience and train them. Of course, these novice artists are not paid top dollar and must work very intensively and for long hours. However, they are given a start on their careers in this way and are usually eager to learn as much as possible in a professional setting.

While there are opportunities out there for those with the desire to enter the industry, you must also be well suited to it. There are enormous pressures involved; some artists actually thrive on them and produce work prolifically as a result of them. Emmett Arnold says, "You have to be able to handle pressure; you have to put in long hours; you have to pull all-nighters because very often the deadlines are very, very tight. It's the nature of the business—especially if you're a freelancer—to stay up all night and sleep the next day."

Finding Your Personal Style

The difference between fine art and commercial art is that for the former you are being completely creative while for the latter you are given specifications by an art director as to how your work should look. However, as a commercial artist, you still must infuse your work with your own personal stamp and creativity—this is what makes you valuable. If art directors merely wanted illustrators to produce identical work, then the advertising industry would eventually take on a flat, spiritless look.

Therefore, in creating your work, you must balance the ideas of the art director with your own skills and bring as much energy to the art as you possibly can without omitting or altering important features that the art director has requested. Keep in mind that the artwork has to be easily understood by a client, so it can't be too detailed and personalized. For example, sometimes storyboard presentations are made in a large room filled with clients, so the story line must be very clear, even from a distance.

While reference material is necessary, you can't rely on it completely. If you always take the time to trace preexisting images, you are going to lose valuable hours, and one of the most important qualities of a comp, storyboard, and animatic artist is speed. You have to draw fast, because there's an enormous amount of work you have to turn out quickly.

When you're working in-house, your pieces will have to be looser because you will not be able to rely on a scrap file as much. The phrase "loose but tight" is often employed by art directors to describe the idea that feeling is conveyed in a piece of artwork without a lot of fussy details. Your basic ability to draw accurately but quickly—to capture the essential qualities of your subjects in a quick marker rendering—will be valued highly in the industry. Your personal style will come through when you display—and exploit—this ability.

As your career progresses, so, inevitably, will your style. New York–based freelance artist Polly Law has worked in the industry for a number of years. While she can render a whole range of subjects, she has developed specialties: food, products, and moods. For Law's food comps, she works out textures and color combinations that will make everything look as appealing and appetizing as possible. Sometimes she actually reworks the composition of the ad. "My art directors generally don't give me tight layouts. They give me a rough layout, and if I don't think the food or objects are presented as well as they could be, I'll ask them if I could change it. And I'll tell them how I would present it," she says. Sometimes, art directors will give Law the go-ahead to alter their sketches of a comp to make it look as good as it possibly can; other times, they'll insist on having the composition remain as originally planned.

To create moods in her work, Law emphasizes color and lighting. Colors can be light or dark, as long as the subject matter is rendered in an original and compelling style.

Law believes that developing a specialty is inevitable: "I think it happens no matter what. It will happen through a process of natural selection. The more you're out in the industry, the more jobs you'll get. You start out with samples in your portfolio and eventually you will replace them with copies of actual jobs. And those jobs generate more jobs along the same line. It builds on itself." She notes that many artists have specialties, such as cars or beauty and fashion, and can make a good living rendering these subjects exclusively.

Building a Portfolio

Your portfolio, or "book," can be your single most important asset—or it can misrepresent your talent and pigeonhole you as an artist who only can draw a few types of subjects. For these reasons, you must carefully plan how you are going to fill your portfolio.

Oftentimes art directors or art reps are too busy to meet with you personally and you will have to drop off your book. In such cases, your portfolio will have to speak for itself. Of primary importance is this rule: Do not include original art in your portfolio—use C-prints or very high-quality color photocopies. Should your book somehow get lost in the shuffle, you don't want your art to disappear forever.

Art or creative directors prefer to see a mix of subjects displayed in your portfolio. They should be carefully chosen, however. You don't need to put in every piece of work you have ever created. Many recent art-school graduates overstock their books with beautifully and carefully rendered artworks that don't reflect the kind of fast-paced work required in the industry. Streamline your portfolio to reflect your strengths.

Many art directors say they like to see an original example of a standard motif—for example, an unusual die-cut or innovative use of color or typography. This is so that they are assured an illustrator can improvise within a traditional layout, since they must be creative in a situation that has so many dictates.

Lisa Emmett Arnold, who has also worked as an art director, recommends, "If you're going out for story-boards or comps, [include] six to eight of your best comps and ten to twelve of your best storyboards in the most professional presentation possible: neat, well-packaged, easy to flip through, and slick. The competition is rough." She also suggests a variety of subjects: food, cars, fashion, beauty, liquor, and families participating in group activities—going on a picnic, riding in a car, sitting on a lawn, playing basketball—involving some product.

If there's an area of the industry that particularly interests you, you should do research into what types of

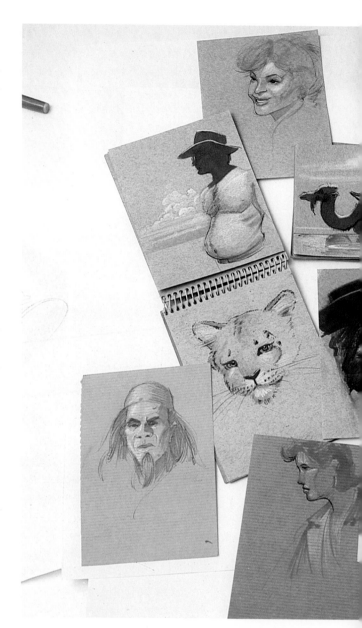

subjects need to be represented. Art directors like to see an awareness of their end of the industry.

Marc Italia, director of The Freelance Store in New York City, a firm that represents self-employed artists, demands certain standards for portfolios. First, he wants to see a variety of subjects represented. "Anatomy is probably the most important thing," he stresses. "An

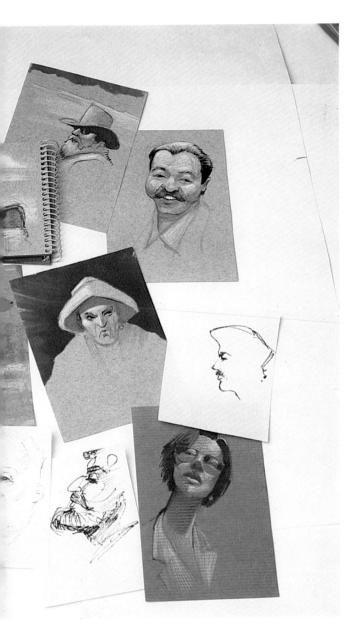

cause sometimes you may have to knock twenty-four frames out in a couple of days. It's really tough for someone out of school to get to the point where they're so fast that they're able to capture all the important features and feelings."

Expounding on the topic of artists who have recently graduated from art school, Italia notes that many have never been exposed to the industry or educated as to what a comp artist does. However, he proposes a solution: "I think they should go out and see what a comp artist does and build their portfolio around that." This could involve asking art-school teachers to help arrange a group trip to an agency or studio or even calling such firms directly and asking for a quick tour.

He also recommends that fledgling advertising artists find out how long it takes a professional artist to do particular assignments and then try to match that speed. The pieces that you create in a simulated deadline situation will better represent you because they will reflect how you draw under pressure. "You have to diversify yourself to the point where you're not just able to do it for yourself, but should someone give you an assignment, you should be able to do it on the spot." For working artists, Italia recommends trying to get high-quality color copies made of artwork before it gets whisked away, never to be seen again.

artist can draw so that [the art] is loose and it may be ambiguous, but it still has to [be] anatomically correct.... Faces, of course, are very important, as well as expressions. If you're doing a commercial, you may need to convey emotion. Sometimes that may be what will sell the spot to the client." Italia also points to the importance of an artist's ability to work quickly, "be-

These pages from my artist's sketchbook illustrate a point about creating art for your portfolio that cannot be emphasized enough: Be original. Whenever I have a free moment, whether sitting in an airport or waiting in a restaurant, I like to sketch those around me. Sketches like these are a great place to begin working on original pieces to include in your portfolio rather than copies of photographs, or finished ads from magazines. If your drawing is practiced and skilled enough, you should be able to reproduce an anatomically correct figure, a dramatically-lit scene, or an expressive face at a moment's notice, and the pieces you create for your portfolio should reflect that ability.

Strange as it sounds, many art directors base their conclusions about an artist's appropriateness for a particular job on whether something similar to it is represented in the portfolio. Italia opines, "You have to show that you're able to do a wide variety of things, still keeping it consistent within your style. Basically, art directors look for consistency and diversity.... They have to be able to trust you and know [how] the product is going to turn out judging from your portfolio."

For freelance artist Polly Law, the examples in her portfolio strongly reflect her strengths. "If you're putting together a general portfolio, you should go with what you do best," she advises. As an example, she says, if you can't render dramatic lighting without the aid of a reference, you shouldn't copy a photograph of this subject and include it in your book. "I think it's wrong to copy a photograph that's dramatically lit and then not be able to come through with the goods later on."

In reviewing portfolios for the Graphic Artists Guild's Placement Center, Law has observed one recurrent mistake among many novice artists. They tend to copy ads from magazines and present them as comps they've rendered. In fact, one popular liquor ad, which is a photograph, seems to be rendered in virtually every portfolio Law reviews. She points out that some artist actually created the original comp for that ad, and that person is being shortchanged through other people using it. Beyond this consideration, Law points out that simply copying an ad for a portfolio indicates a certain amateurishness: "I've learned through experience that the comp and the finished photograph are never identical. And putting a copy of a photograph in your book only tells someone that you can copy photographs. So I would suggest that people make up their own ad, even if it's just a simple composition of a bottle and a glass, with whatever liquid is in the bottle in the glass, on a dark background."

Pieces like these, while not as polished as the finished comps illustrated elsewhere in this book, serve an important purpose in your portfolio. I keep loose pieces of art like this in my portfolio to emphasize my ability to work quickly in-house. Novices will often only show art directors painstakingly rendered artwork, but, in order to be considered a professional, include less-finished work with rapid marker strokes to represent your skill with fast renderings.

Working Freelance or In-house

There are two main ways you can go as an artist nowadays. You can work in-house or go freelance. The choice for you will probably be determined by how much you need to learn.

Some professionals recommend beginning your career by working full time in an advertising agency or studio. As an employee, you are exposed to the full spectrum of the business. This approach not only provides you with an insider's introduction to the industry but also often provides you with mentors—more experienced artists who can give you invaluable advice and tips that will make your artwork stand out. Even if you are in a cramped studio situation with other artists who are just starting out, there will still be an interchange of ideas and techniques that everyone can profit by. You will also have the luxury of a wide range of materials and tools at your disposal, and you can experiment to find what works best for you without making costly expenditures. Finally, working within the industry at the onset of your career provides you with contacts should you decide to go freelance later.

Marc Italia doesn't feel that you have to take this route, however. "If you've been in the industry for ten years and you've established one hundred clients, then it's definitely going to be easy for you to become a freelance artist and be self-sufficient and probably make twice the money a staff artist would make. But if you have the talents and you have the portfolio rounded off, it's conceivable that you could be a freelance artist from the start."

Nowadays, the comp artist also has the option of entering the field of promotions, as either a freelance comp artist or an in-house art director. Ross Hudson, creative director of the promotions division at Ogilvy & Mather, says, "Promotions is that field in between advertising and a graphic design studio. It applies principles of the advertising strategy, marketing abilities, and research.... What it does differently than an advertising agency creative department ... is develop expertise in an area."

Hudson points out that an advertising agency creative division's marketing strategy is responsible for such services as heralding a new product or developing the image of that new product or service. However, he says, promotions take a much more focused set of responsibilities: "Promotions is a specific retail-market creature. It is short term, [lasting] often for a week or two weeks—no longer generally than one quarter out of the year." Promotions is concerned with the bottom line in terms of sales of a service or product. It employs such retail industry materials as cents-off coupons, sample-pack or two-for-one premiums, posters, counter cards, and sweepstakes offers. Such "point-of-purchase" materials as these sway the consumer to make a purchase.

Promotions work is all comp-oriented, and these comps often differ in subject matter from traditional advertising comps. While an advertising comp would be a layout of an ad, a promotions comp might depict an in-store environment to show the display of materials, as well as the materials themselves and the design and look of them. The subject matter ranges from very simple to very complex—there's often a lot of information that needs to be conveyed.

Says Hudson, "The primary difference between promotions and advertising is that we are probably always going to be a project-based industry, whereas advertising is probably going to be for the foreseeable future a committed-contract business." While an advertiser might contract to do several commercials over the course of a year, a promotions department would receive short-term assignments, the nature of which may change sharply in midproject.

Hudson adds, "We will often turn a project around in two weeks or less. Clients want [artwork] right away.... It's very intensive.... We go through severe droughts and then we get incredibly busy."

For the artist, this means intensive periods of work. Promotions is a good branch of the industry to start out in. Says Hudson, "Because our budgets are not as

lucrative as in the advertising field, we are compelled to hire individuals who are younger [and who] we can train and hire at a lower salary … and give them the start they may not get somewhere else."

The promotions field is growing, and many of the larger advertising agencies are adding promotions departments. It is also becoming a more creative field as more clients understand the important role of promotions and how it can supplement advertising in sales of a product.

Marketing Your Work

Should you decide to become a freelancer, you will need to have an aggressive marketing campaign for your work. This involves mailings, follow-up phone calls, and making the rounds with or dropping off your portfolio at agencies and studios.

If you're newly a freelancer, Lisa Emmett Arnold recommends an ambitious strategy for getting your name around: "Fifty percent of it is tenacity: You have to be persistent—you can't get discouraged. You have to make a mailing list; you have to send out a mailer. There's no sense in showing your portfolio unless you have a card to leave behind…. You have to have some kind of sample of your work [on your card] if you want to be remembered. It's not even worth it to go out on one interview unless you have that."

Because art directors get so many publicity pieces sent to them in the mail, you must spell out and visually represent exactly what you do—storyboards, comps, and/or animatics—on your card. Of course, include your name, phone number, and specialty. If you're just starting out, Emmett Arnold recommends sending out about one hundred "test cards" in black and white,

because colored cards are expensive. From these, she says, you will get the feedback you need to create another card to improve the response.

You can buy a list of art directors and advertising agencies or you can go to the library and look through the *Standard Directory of Advertisers* (commonly known as the "red book"). Polly Law suggests targeting certain agencies for your mailer based on their gross income. After you have established this, she advises, go through the advertisers' lists of products and select those accounts that you would like to work on. Then you must call the agencies and ask who the art directors are for specific accounts. Although it is expensive, Law also recommends advertising in directories, such as *Creative Black Book* and *American Showcase*, or *RSVP*. You might also want to get a bulk-mailing permit.

After you have sent out your mailer, follow up with phone calls to make an appointment with the art director or art buyer for a personal interview or to drop off your portfolio. You will not have time to visit every ad agency or studio, so the mailer is all-important.

Making Contacts and Dealing with People

Art gets commissioned and purchased in different ways. Depending on what kind of job you are working on, you may have to deal with a variety of individuals.

Artist Polly Law has one general caveat: Be professional and polite at all times. Do not drop off your book if you're dressed sloppily; you may be mistaken for a messenger and referred to the mailroom. Also, be courteous to everyone with whom you come into contact, including receptionists. They hold the "keys to the kingdom," and you're leaving your portfolio in their hands. It never hurts to be courteous—that's all part of being a professional.

ART DIRECTORS

Usually you will be dealing one-on-one with an art director. Many times artists are confused by an art director's instructions but are afraid to ask questions. Your job is to help the art director look better. He or she is under a great deal of pressure and sometimes may be preoccupied and not explain an assignment fully.

Realize that if an art director gives a vague description of an effect, you must clarify exactly what is meant. Problems can arise through the use of such terms as a "moody sky" or "overhead angle." These can mean different things to different people—it's up to you to understand the art director's point of view.

If the art director is not available, you may have to deal with a staff copywriter, which can be problematic. Non-visually-oriented people might not phrase instructions in the proper way, so you must ask many questions and be particularly careful in these situations.

ART BUYERS

In a smaller agency, an art director might have several different titles, "art buyer" being one of them. But many large agencies have several art buyers who serve specific functions—one might acquire illustration, while another buys photography and still another handles cartoons. In a major agency, there may be twenty-five or more art buyers. Usually, they have no art-

direction background. Their purpose is to facilitate buying artwork for the art director. If, for instance, an art director is looking for a cartoonist or a certain style of comp art, the art buyer might have twenty-five or fifty names on file that can be referred to the art director. The art buyer also often handles fee discussions in procuring art for the art director.

PRODUCERS

Aside from art directors, you may work with agency producers. A producer generally expedites work, coordinating different aspects of the work and making sure that everything runs smoothly. If you get animatics work, you will also deal with producers at video houses. Ellen Olbrys, a producer at Charlex—the New York–based commercial, special effects, and animatics specialists—describes how an artist is brought to a project. "Usually the [ad] agency producer gets the storyboard from the agency art director. If the agency art director has a preferred art studio or artist to work with, they contact that party or [tell] the producer [to contact the artist]." The agency then asks Olbrys if she is familiar with the artist's work, which is often the case.

Olbrys continues, "When the original meeting takes place, the artist, the producer from the agency, and I all sit down together and look at the storyboard and plan [the animatic] out." At this point, Olbrys instructs the artist how to draw the different elements of the animatic and explains what the action will be.

Some advertising agencies don't do a lot of test work, and they might request that the animatic house bring an artist directly to the job. Says Olbrys, "In that case, I always recommend people I know best because those are the ones that I know I can count on to do what needs to be done for the job.

"Usually the artist and the production company see the storyboards at about the same time. What a lot of agencies are forced to do by their clients is to competitively bid the production and the artwork—usually not so much the artwork because one artist's style is

going to be totally different from another's, and if you want one person, another is not going to be right."

David Rothenberg, an editor at Charlex, notes, "It helps the artist come across as professional by doing the job right." This means listening carefully to the specifications for the animatic during the meeting with the producers from the animatics house and the advertising agency. If you're ever unclear about instructions, Olbrys stresses, ask questions. If you are expected to produce artwork from a mere verbal description, you should insist on a sketch of what is needed.

ARTIST REPS

Another liaison in the chain of art purchase is the artist rep. This is the person who, either exclusively or non-exclusively, represents your work. A rep will generally extract a commission of about 25 percent. While certainly not a necessity, the rep is very valuable for broadening your industry contacts and saves you a lot of time running around to show your work.

Marc Italia of The Freelance Store explains how deals are made. Usually, an art director from an advertising agency calls and briefs him on certain details of the job. Based on this information, Italia selects an appropriate freelancer from his stable of artists. "I have a variety of comp artists," comments Italia. "Some may specialize in doing packaging or they're good with lettering and three-dimensional renderings, whereas others are good with people."

"Usually, I make the initial contact," Italia notes. "Unless I need to be involved with it, [though], I'll just hand it over to the artist. Art directors will usually give me a general rundown of what the assignment is about. They'll go into details with the artist."

Of the advantages of having a rep, Italia comments, "Generally speaking, the artist spends less time out there interviewing and more time working. Even though he makes 25 percent less, he'll probably make more, just based on volume."

ARTIST ORGANIZATIONS

Joining an art society or guild can provide many benefits. If you're a freelancer, you can obtain health insurance through the organization. In addition, most organizations sponsor workshops and seminars on business-related topics and provide a forum for you to express your concerns about the industry. Such organizations—which include the Graphic Artists Guild, the American Institute of Graphic Artists, and the Society of Illustrators—can also help you meet other artists. Sometimes, they even have a job bank. And most publish newsletters that can keep you apprised of industry issues. Consult the appendix of this volume for national organizations.

ON THE JOB

The comp, storyboard, and animatic artist, while employed in an unusual and very demanding line of work, is also responsible for business organization. The business aspect is particularly critical if you freelance. You must set up your business in an organized way with bookkeeping that is easy to understand and maintain. The less time you spend fumbling through unorganized file drawers and scavenging for lost receipts, the more time you can devote to making your business lucrative.

You should also be aware of copyright issues to ensure that you are not infringing on other artists' work in creating your art. Keep in mind that even if you draw on a visual reference created in another medium, such as photography or oil paint, you can still violate copyright law if you copy a picture too closely.

Health considerations are also an important issue, although they generally aren't discussed at art schools or among artists. Not enough artists are aware of the risks posed by the repeated or improper use of many art supplies. This is due, in part, to an unwillingness to face unpleasant facts. But there is good news: By taking precautions in using art supplies, such as using a strong exhaust fan to remove fumes and wearing a face mask while using an airbrush, you can greatly reduce health hazards.

Business Aspects

You will need to keep a ledger or book that records work-related financial transactions. *The Art of Filing* by Carla Messman (St. Paul, Minn.: United Arts) recommends that you divide your records into income and expenses and, of course, keep separate files for business and personal expenditures.

Also, you must save all receipts, checks, and credit-card slips for work-related purchases so that you can deduct them on your income taxes. Among expenditures that can be deducted are studio equipment, materials, and supplies; studio rent costs (or if you work at home, the percentage of your rent related to the studio); telephone and gas bills related to work; telephone answering service; tax-preparation fees; professional-organization dues; professionally oriented books and periodicals; self-promotion expenditures, such as lunches with art directors, postage fees for mailings, or the cost of C-prints for your portfolio; transportation related to work; and courses taken to improve your illustration skills.

If you prepare your income taxes yourself, buy a good manual to help you understand the tax laws as they relate to artists. Helpful books include *Legal Guide for the Visual Artist* by Tad Crawford (New York: Madison Square Press) and the aforementioned *The Art of Filing.* If you do hire an accountant, use one who is well versed in the industry and who understands the type of business you run.

With regard to hiring an accountant for the expanded duties of helping you organize your business and assisting you year-round, Lisa Emmett Arnold advises not to hire one the first year of self-employment because you may not make enough money to warrant the expenditure. She points out that building a freelance career can be a slow process and recommends that you put some time at the very beginning of your freelance career into organizing your own books and records. Says Emmett Arnold, "A lot of artists, unfortunately, just love to draw and don't realize the business aspect of [the industry]—and it is becoming more and more of a business. You have to be terribly disciplined." Resolve to learn as much as you can about tax laws,

accounting, finances, and running a business.

Among other paperwork needs is the purchase order. Always obtain one from a client as proof that you have received an assignment. That way, should it be canceled, expenses related to it can be recovered. Also ask for job numbers for projects so that if you don't receive payment, you can simply supply the job number to the accounting department. Include the job number on your invoice.

You should also work up a sign-in/sign-out form for your portfolio so that you can have someone at a studio or agency sign it when you drop it off. That way, if your portfolio is somehow misplaced, you will know who to talk to regarding its whereabouts.

Time Estimates and Deadlines

Another important thing to keep in mind is that whether you are working in-house or in a home studio, you have to accept the strict deadlines given you. If you can, however, always try to ask for a few hours more—for example, see if you can deliver a job in the afternoon as opposed to morning.

You can make a tremendous amount of money very quickly if you are willing to work odd hours. For example, you might get a call in the late afternoon asking you to come into a studio in the early evening for a job that must be completed by the next morning. You could end up working until dawn, but you will no doubt be paid handsomely for it. If you are able to work well at unusual hours, it can be a great asset.

The industry tends to have valleys and peaks in terms of availability of work, depending on trends of advertisers spending money. These are hard to gauge in advance, but once you're working you'll get a general feel for it. Generally speaking, the summertime is a slow period. If you have a rep, he or she can tip you off to work droughts—it's at times like these that you will probably want to take vacations. It's very difficult to make advance plans, so when you see an opportunity to take some time off, do so.

Determining Fees

Artist rates vary depending on location and type of employer. Check with a local artist organization to see if it has worked out a rate scale. It's a good idea to join the Graphic Artists Guild, so that you can talk to your peers about how much they are charging. Be aware of the range of prices being charged so that you're not working in a vacuum. Obtain a copy of the Graphic Artists Guild's *Pricing and Ethical Guidelines*.

Perhaps the most important thing to remember is not to simply offer a fee without an understanding of the kind of work you're going to be doing. Let the employer cite a rate first; usually it will be acceptable, but if you feel it's low, say so. Sometimes you will receive a flat fee and other times you'll be working on an hourly rate. Generally, the flat fee applies to jobs that you must work on intensively for a few hours and for which you had little advance notice.

Health Concerns

Most art-supply manufacturers will provide you with a Materials Safety Data Sheet (MSDS) upon request. It is highly recommended that you obtain an MSDS for the art supplies you commonly use. Often, the information on markers, solvents, and other art supplies does not fully reflect the types of risks you could be exposing yourself to. That is why using MSDSs is so important. However, the harmfulness of substances listed on them is not always entirely clear. This is because the sheets are often prepared for use by chemists and industrial hygienists, who are familiar with their terminology. The importance of MSDSs for the artist is that they allow you to find out what you're working with and give you instructions for emergency procedures when these substances are ingested or spilled. To use the data sheets optimally, have alternative sources of technical information for interpreting the hazards.

On the sheet you will usually find nine sections. The order of subjects addressed is generally as presented here. The first section provides the manufacturer's name and address as well as an emergency phone number. It also specifies what product it profiles.

The second section, labeled "Hazardous Ingredients," lists hazardous components first by their common names and then by their chemical names. The Occupational Safety and Health Administration (OSHA) sets standards for use of chemicals in art supplies, and this section gives the OSHA's permissible-exposure-limit (PEL) number. These numbers are based on industrial uses. Many of OSHA's levels haven't been significantly revised since they were established in the early 1970s, but this doesn't mean the findings aren't valid.

In addition to OSHA information, this section also gives the American Conference of Governmental and Industrial Hygienist's (ACGIH) threshold-limit-value (TLV) number. TLVs—which are expressed as parts per million (PPM) and can also be expressed as parts per billion (PPB)—indicate the amount of substance in the air that you can breathe in every standard working day for a lifetime and not be adversely affected by. TLVs are not known for every chemical, so sometimes the form won't list one. An ACGIH committee revises its listings yearly. These can differ from OSHA's levels and are not necessarily more stringent.

The second section also lists exposure limits for chemicals. Some of the ingredient information is proprietary—meaning that the manufacturers have developed unique formulas for their supplies—and manufacturers sometimes use this as a reason for not providing a full breakdown of chemical ingredients in their products. Even though this is the case, whatever information is listed will still be invaluable for narrowing down your choices in toxic versus nontoxic supplies.

Although artists refer to alcohol-based markers and solvent-based markers, both types are technically grouped together as solvent-based markers. Among solvent bases are alcohol, ketones, hydrocarbons, and aromatics. One prominent marker ingredient you will find listed in solvent-based markers on the MSDS is xylene, a toxic aromatic hydrocarbon that can be absorbed through the skin and is known to affect the upper respiratory system, central nervous system, liver, gastrointestinal system, and blood. Should you use a marker containing this substance, your studio should be extremely well ventilated. Glycol ethers comprise another class of harmful solvent-marker ingredients. Symptoms of toxic exposure include skin irritation, loss of appetite, narcosis, and even kidney failure.

Among the alcohol bases, opt for denatured ethanol, an alcohol that has been rated the least toxic in its class by the Center for Occupational Hazards in New York. You want to avoid alcohol-based markers containing diacetone alcohol, which has been rated the most toxic in its class.

Just as pregnant women should not drink alcohol during pregnancy, they shouldn't use solvent-based markers. This leaves them with the other category of markers, the water-based. However, this type isn't entirely without its drawbacks, although these markers are less toxic than the solvent varieties. In actuality, some water bases do have trace amounts of solvent, so you should obtain MSDSs for a variety of brands.

With regard to paint, you will be using mostly white water-based gouache. This is considered safe as long as you don't get the pigment in cuts or ingest it—it does contain xylene and gluteraldehyde (a toxic irritant). Your brand is likely to contain phenol (which can be absorbed by skin and then move through bloodstream) or formaldehyde (which can cause respiratory problems) as well. However, some of the other colors contain such materials as soluble lead, soluble manganese, lead chromate, and other mysterious-sounding substances that could produce nervous-system damage, temporary paralysis, and kidney or bone marrow damage if ingested or if too much is inhaled. Because you will be using gouache in conjunction with an airbrush, the possibility for inhaling the pigments is increased. If you are going to do a great deal of airbrush work, you might want to wear a protective mask. You should definitely obtain an MSDS for the brand of gouache you use.

The third section of the MSDS, "Physical Data," provides a chemical-reaction profile of the substance, describing its appearance and odor and whether it is soluble in water. The fourth section, "Fire and Explosion Hazard Data," details what to do if one of these events should occur. The fifth section, "Health Hazard Data," lists signs and symptoms of exposure and medical conditions aggravated by exposure and briefly describes procedures to take if you inhale the product too deeply, if it comes into contact with your eyes or skin, or if you ingest it. Some MSDS forms recommend in this section that pregnant women not use the product because exposure could cause birth defects. Generally speaking, however, manufacturers avoid listing long-term risks; that is why you should learn whatever you can about the ingredients of your art supplies. (An excellent source for information is the Center for Occupational Hazards in New York City, a nonprofit agency whose publication "Understanding and Using Materials Safety Data Sheets" is extremely informative. You can also do research at your local library or ask a chemist to help you interpret an MSDS.)

"Reactivity Data"—the sixth section of the MSDS—describes what materials the product is not compatible with as well as hazardous decomposition products. "Spill or Leak Procedures" follows; generally, marker ink is in a reservoir and can't be spilled. Some artists actually cut open their markers to draw with them, in which case the possibility of toxic exposure is increased. Opening markers is not recommended.

The eighth section, "Special Protection Information," gives recommendations for protective clothing and hygienic procedures. For markers, you will need to wash your hands after use. You will also need to have window exhaust fans to ensure adequate ventilation. A very basic precaution is to cap markers when they are not in use. The final section, "Special Precautions," generally provides storage-temperature information and precautions, which should be taken very seriously.

Among the basic precautions that you should practice when working with art supplies are not to drink, eat, or smoke while working; not to touch substances directly; and not to use an open flame. If there are children or pets around, make sure that everything is out of their reach. Keep the number of your local Poison Control Center posted openly in your studio; or you can call the Rocky Mountain Poison Control Center at (303) 629-1123.

Copyright Issues

Because all the work you will be doing is "work for hire"—that is, material that is commissioned by an employer—you do not hold the copyright on it. Therefore, it is not really within your legal rights to show this work in your portfolio should you manage to retrieve it after a client has seen it. However, many artists do, and this practice has not been known to present problems. It is strongly recommended, however, that you create your own artwork for your portfolio.

With regard to the reference file, the issue of copyright infringement becomes more applicable. Tad Crawford writes in *Legal Guide for the Visual Artist,* "Remember that the test for infringement is as follows: Will an ordinary observer, looking at the two works, believe that one has been copied from the other?"

For the advertising artist, this means that you need to alter your reference enough so that there is a discernible difference between the the original reference material and your work. While you will need to rely on your reference file, you should emphasize your drawing abilities—not your tracing abilities—in your artwork. Your reference file should be treated as a source of inspiration. You do not need to slavishly copy photographs or slides to make your work look good.

Copyright is a very complicated subject, and you should at least be aware of these issues. To learn more, write for the Copyright Information Kit (see Sources).

Sources

Organizations

ARTS COUNCIL OF GREAT BRITAIN
105 Piccadilly
London
W1V 0AU
01-629 9495

ART WORKERS GUILD
6 Queen Square
London
WC1N 3AR
01-837 3474

ASSOCIATION OF ART INSTITUTIONS
9 Broad Street
Hereford
HR4 9AP
0432 266653

ASSOCIATION OF ARTISTS AND DESIGNERS
IN WALES
Gaskill Buildings
Collingdon Road
Cardiff
CF1 5ES
0222 487607

ASSOCIATION OF ILLUSTRATORS
1 Colville Place
London
W1P 1HN
01-636 4100

BRITISH COPYRIGHT COUNCIL
Copyright House
29-33 Berners Street
London
W1P 3DB
01-580 5544

CHARTERED SOCIETY OF DESIGNERS
29 Bedford Square
London
WC1B 3EG
01-631 1510

DESIGN COUNCIL
28 Haymarket
London
SW1Y 4SU
01-839 8000

DESIGN COUNCIL, SCOTLAND
72 Vincent Street
Glasgow
G2 5TN
041 221 6121

DESIGN COUNCIL, WALES
Pearl Assurance House
Greyfriars Road, Cardiff
CF1 3JN
0222 395 811

DESIGNERS AND ARTS DIRECTORS
ASSOCIATION OF LONDON
12 Carlton House Terrace
London
SW1Y 5AH
01-839 2964/5

ROYAL COLLEGE OF ART
Kensington Gore
London
SW7 2EU
01-584 5020

ROYAL SOCIETY OF ARTS
6-8 John Adam Street
London WC2N 6EZ
01-930 5115

SCOTTISH ARTS COUNCIL
19 Charlotte Square
Edinburgh
EH2 4DF
031 226 6051

SOCIETY OF DESIGNERS IN IRELAND
8 Merrion Square
Dublin 2

WELSH ARTS COUNCIL
Museum Place
Cardiff
CF1 3NX
0222 394711

Periodicals

Campaign
22 Lancaster Gate
London
W2 3LY
01-402 4200

Designweek
St Giles House
50 Poland St
London
W1V 4AX
01-439 4222

Drawing and Graphics Today
Kingslea Press Ltd
18-19 Ludgate Hill
Birmingham
B3 1DW
021 236 8112

Design Studies
PO Box 63
Westbury House
Bury St
Guildford
GU2 5BH
0483 300966

**Journal of the Royal
Society of Art**
8 John Adam St
London
WC2N 6EZ
01-930 5115

Illustrator
1 Colville Place
London
W1P 1HN
01-636 4100

Graphics World
7 Brewer St
Maidstone
ME14 1RV
0622 50882

Design Magazine
Design Council
28 Haymarket
London
SW1Y 4SU
01-839 8000

Designer
29 Bedford Square
London
WC1B 3EG
01-631 1510

Designers' Journal
9 Queen Anne's Gate
London
SW1H 9BY
01-222 4333

Major Art Suppliers

Aberdeen

SIME MALLOCH LTD
45 School Hill
Aberdeen
AB1 4BG
0224 641652

Aberystwyth

THE ART SHOP
5 Pier Street
Aberystwyth
Dyfed
SY23 2LJ
0970 612260

Bath

F. J. HARRIS & SON (BATH) LTD
13-14 Green Street
Bath
BA1 2JZ
0225 62116

Bedford

THE ART CENTRE
1 Clair Court
Lime Street
Bedford
MK40 1LD
0234 44784

Birmingham

THE EVERYMAN STATIONERY
& ARTISTS SUPPLY CO LTD
1st Floor Cannon House
Priory Queensway
Birmingham B4 6BS
021 236 6609

SPECTRUM DRAFTING SUPPLIES LTD
20 Colemore Row
Birmingham
B3 2QD
021 233 1780

Blackpool

GRANTHAMS
28 King Street
Blackpool
Lancashire
FY1 3DL
0253 662677

Bournemouth

D. J. BROOKING
3 Carbery Row
Southbourne Road
Bournemouth
Dorset
BH6 3QR
0202 424416

Bracknell

BRACKNELL PRINT ROOM
Miller House
87 Broadway
Bracknell
Berkshire
RG12 1AR
0344 52778

Brighton

ARTSCENE
34 Bond Street
Brighton
BN1 1RQ
0273 734400

Bristol

BRISTOL FINE ART
72-74 Park Row
Bristol
BS1 5LE
0272 260344

Cambridge

W. HEFFER & SON LTD
21 Kings Street
Cambridge
CB1 1LH
0223 358241

Canterbury

E. W. CRUMP
10 Best Lane
Canterbury
Kent
CT1 2JB
0227 450725

Cardiff

HARRISON BROTHERS
181 City Road
Cardiff
CF2 3JB
0222 490119

Chester

A E DUTTON & SONS LTD
55 Frodsham Street
Chester
CH1 3JJ
0244 20198

Colchester

JOHAE ART CENTRE
9 St Johns Street
Colchester
Essex
CO2 7AN
0206 57929

Coventry

COVENTRY ART SUPPLIES
168 Spon Street
Coventry
CV1 3BB
0203 27186

Crewe

STUDIO 10
59-61 Earle Street
Crewe
0270 588985

Darlington

THE ART SHOP
12 Bondale
Darlington
Co Durham
0325 465484

Dublin

EASON & SON LTD
T/A Dublin Art Shop
65 & 80 Middle Abbey Street
Dublin
01-733811

Dundee

BURNS & HARRIS LTD
163-165 Overgate
Dundee
DD1 1QF
0382 22591

Edinburgh

JOHN MATHIESON & CO LTD
48 Frederick Street
Edinburgh
EH2 1GX
031 225 6798

ALEXANDERS
58 South Clerk Street
Edinburgh
EH8 9PS
031 667 5257

Exeter

FRED KEETCH
21 Cathedral Yard
Exeter
EX1 1HR
0392 74312

Guernsey

FRAMECRAFT
The Art Shop
Les Islets
St Peters Port

Glasgow

MILLERS (CITY ART SHOP) LTD
11-15 Clarendon Place
St George's Cross
Glasgow
G20 7PZ
041 331 2303

Guildford

GUILDFORD ART SUPPLIES
St Mary's House
Quarry Street
Guildford
Surrey
GU1 3UA
0483 572686

Harrogate

CENTAGRAPH
18 Station Parade
Harrogate
HG1 1UE
0423 66327

Lancaster

STUDIO ARTS
50 North Road
Lancaster
LA1 1AT
0524 65325

Leeds

W. F. GADSBY LTD
33 New Brigate
Leeds
LS2 8JD
0532 456326

JAMES DINSDALE LTD
22/24 King Charles Street
Leeds
LS1 6LZ
0532 456312

Leicester

W. FRANK GADSBY LTD
22 Market Place
Leicester
LE1 5GF
0533 22410

Liverpool

R. JACKSON & SON
20 Slater Street
Liverpool
L1 4BS
051-709 2647

London

CANNON GRAPHICS
69-85 Old Street
London
EC1V 9HX
01-608 2011

CARTER GRAPHIC SUPPLIES
254 Upper Richmond Road
London
SW15 6QT
01-785 9797

CHARLES & CO
45 Pembridge Road
W11 3NG
01-727 6306

CHELSEA ART STORES LTD
314 Kings Road
London
SW3 5UH
01-532 0837

LONDON GRAPHICS CENTRE
107-115 Long Acre
London
WC2E 9NT
01-240 0235

C. J. GRAPHICS SUPPLIES
2-3 Great Pulteney Street
London
W1R 3DF
01-437 7022

WHEATSHEAF GRAPHICS
50 Grays Inn Road
London
WC1R 5LB
01-405 9935

Luton

BAYLIS WRIGHT
50 Park Street
Luton
0582 22186

Manchester

J. DAVEY & SON LTD
70 Bridge Street
Deansgate
Manchester
M3 2RJ
061 834 8941

Middlesborough

WARDS GRAPHIC CENTRE
145 Linthorpe Road
Middlesborough
Cleveland
0642 222531

Newbury

NEWBURY FINE ART LTD
87 Bartholomew Street
Newbury
Berkshire
RG14 5EE
0635 43171

Newcastle

NEWCASTLE ARTS CENTRE
57 Westgate Road
Newcastle
Tyne & Wear
091 261 5999

Nottingham

THE ARTISTS SHOP
185 Mansfield Road
Nottingham
NG1 2NF
0602 474421

Oban

ALBA
6 Albany Street
Oban
Argyll
P34 4AL
0631 63645

Oxford

BROAD CANVAS
20 Broad Street
Oxford
OX1 3AS
0865 244025

Peterborough

COLEMANS
12 Cowgate
Peterborough
Cambridgeshire
0723 43201

Plymouth

ARCADIA
32-36 Eastlake Walk
Drake Circus
Plymouth
Devon
0752 220184

Portsmouth

ART CENTRE
424 London Road
Hilsea
Portsmouth
PO2 9LB
0705 692614

Reading

FINE ARTWORKER
9 Gun Street
Reading
RG1 2JR
0734 596363

St Albans

A. BOVILLE WRIGHT
51 Spencer Street
St Albans
Hertfordshire
0727 56897

Sheffield

ANDREWS GRAPHICS LTD
4 Holly Lane
Sheffield
S1 4QF
0742 721496

Southampton

ARTWORKER
Frobisher House
Nelson Gate
Southampton
0703 229103

Swansea

SWANSEA OFFSET SUPPLIES
6 St Helen's Road
Swansea SA1 4AN
0792 54617

Truro

NEW BRIDGE GALLERY
21 New Bridge Street
Truro
Cornwall
0872 75006

Uxbridge

A. BOVILLE WRIGHT
127-128 High Street
Uxbridge UB8 1DJ
0895 38331

Warrington

COPYDRAFT SERVICES LTD
11-13 Winwick Street
Warrington
WA1 1XR
0925 37934

Wolverhampton

IDEAS
24 Wulfrun Way
Wolverhampton
West Midlands WV1 3NG
0902 28787

Worcester

P.S.W. DRAWING OFFICE & GRAPHIC SUPPLIES
43 Foregate Street
Worcester
WR1 1EE
0905 613849

York

THE ART SHOP
St James Fine Art Ltd
24 Stonegate
York
YO1 2AS
0904 22768

INDEX

R

Rapidograph pens, 24

razor blades, 29

references, visual, 30–33

reflections, depiction of, 42, 46, 48, 106–9. *See also* water droplets

respirators, 95

Rocky Mountain Poison Control Center, 151

Rothenberg, David, 77, 78, 147

RSVP (directory), 145

rubber cement, 26, 27

ruling pens, 24

S

scaling, in animatics, 77–78

Scotch Magic Transparent tape, 27

skies, rendering of, 102–5, 106. *See also* clouds

slide projectors, 35

smoke, rendering of, 60, 61

snack foods, rendering of, 118–19

soap, rendering of, 120–21

Society of Illustrators, 147

solvent-based markers, 12, 35, 150

special effects, 24, 25

specialities, in drawing, 139, 140, 141, 147

spray adhesives, 27

spray color, 96

Standard Directory of Advertisers, 145

steak, rendering of, 114–15

storyboards, 22, 39, 52–75

 color selection, 53, 54

 defined, 52

 drawing and inking, 52, 53

 frame sequence, 55–75

 frame sizes, 52

 process, 52

studio space, organization of, 20

sunsets, depiction of, 104

T

technical pens, 24

television commercials. *See* animatics; storyboards

templates, 28, 29

threshold-limit-value (TLV) number, of substances, 150

time estimates, for jobs, 149

toothbrushes, special effects with, 24–25

toxic fumes, from art supplies, 95, 150–51

tracing

 and copyright issues, 37, 152

light boxes for, 37

transfer lettering products, 98–99

TV pads, 22

type

 placing of. *See* "greeking"

 prepared. *See* transfer lettering

U

"Understanding and Using Materials Safety Date Sheets" (COH), 151

V

vanishing point. *See* perspective

video cameras, in animatics, 76, 77, 78

video cassette recorders, for visual references, 31

visual references, 30–33, 139

 copyright issues, 37, 152

 for facial expressions, 127

 file categories, 32–33

 slide libraries, 35

W

water, rendering of, 120–22. *See also* reflections

water droplets, rendering of, 116, 120

water-based markers, 12, 35, 150

wet-on-wet marker technique, 48, 55

white pencil, 41, 66, 67, 70, 73

wood grain, depiction of, 110–11, 135

"work for hire," copyright on, 152

X

xylene, 150, 151